...NAL·LIFEBOAT·IN...
...ILLIAM·HILLARY
...UGLAS FOUNDED THE R.N.L.I....
...F HIS VOLUNTE...

THE
LIFEBOAT

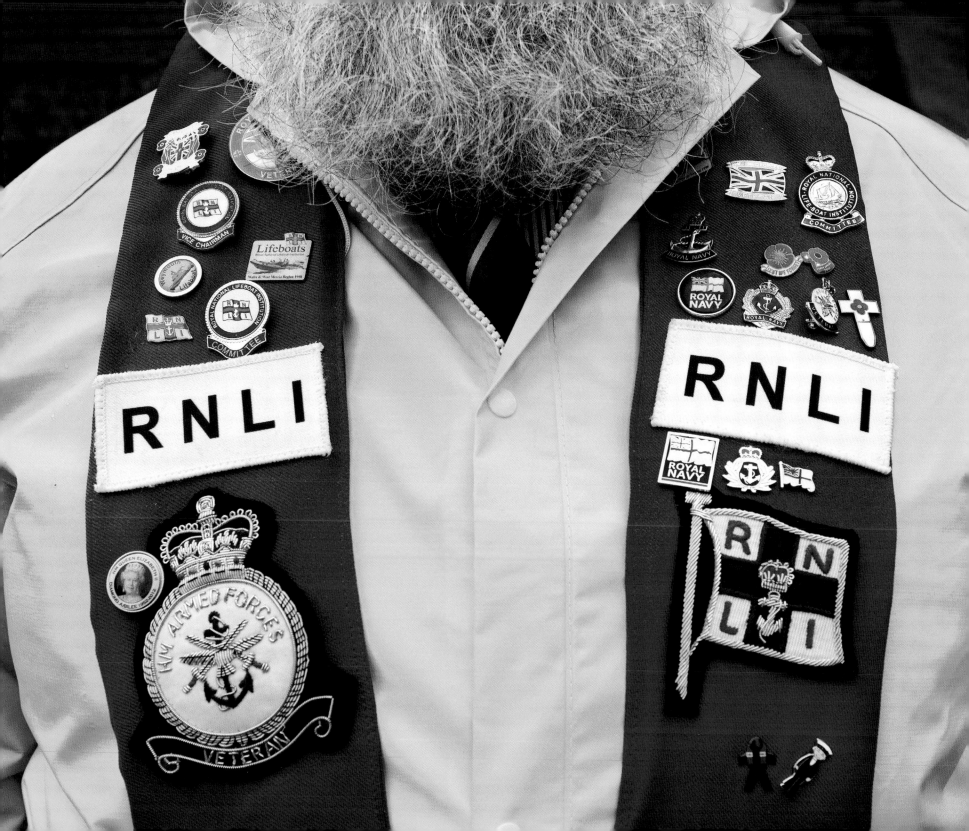

A year in the life of the RNLI —
a photographic tribute to every-day
courage on our coasts

Lifeboats

THE
LIFEBOAT
COURAGE ON OUR COASTS

NIGEL MILLARD

Edited and written by Huw Lewis-Jones

Foreword by HRH Prince William, Duke of Cambridge

CONWAY

Photographs and illustrations © RNLI 2013

Volume and text © Conway Publishing 2013

First published in Great Britain in 2013 by

Conway

A Division of Anova Books Ltd

10 Southcombe Street

London W14 0RA

www.anovabooks.com

www.conwaypublishing.com

Twitter: @conwaybooks

Reprinted 2013

A minimum of £1 from the sale of this book will be paid in support of the RNLI.

RNLI name and logo are trademarks of RNLI used by Anova Books Company Limited under licence from RNLI (Sales) Limited.

Payments are made to RNLI (Sales) Limited, which pays all its taxable profits to the RNLI, a charity registered in England and Wales (209603) and Scotland (SC037736). Charity number CHY 2678 in the Republic of Ireland.

Many of the photographs in this book will be exhibited at a series of city-centre exhibitions in the course of 2013 and 2014. Please check the RNLI website for details.

www.RNLI.org

Distributed in the US and Canada by Sterling Publishing Co. Ltd

387 Park Avenue South, New York, NY 10016-8810

British Library Cataloguing in Publication Data:

A catalogue record for this book is available from the British Library.

ISBN 9781844862177

Printed by L.E.G.O., Italy.

To receive regular email updates on forthcoming Conway titles, email conway@anovabooks.com with Conway Update in the subject field.

This page: In unusually mild conditions for the Outer Hebrides, Barra Island Severn class lifeboat *Edna Windsor* performs a search, running in close to the shore.

Previous spread: In an uncertain economic climate, RNLI voluntary fundraisers work tirelessly to keep the charity afloat. In Birmingham city centre, veteran Marcus Westwood is proud to do his bit. The RNLI still receives no direct money from Government, nor is it controlled by the State, and its legion of fundraisers are every bit as important as the crews on the boats.

Pages 8-9: In the busy waters of the Solent, the Cowes inshore lifeboat *Sheena Louise* is on hand during the ever-popular Round the Island Race. This Atlantic 85 came on service here in 2012 and is capable of reaching 35 knots.

Page 10: Sennen Cove is the most westerly station on the English mainland, found in a small village tucked into the bay about a mile north-east of Land's End. Today, Sennen have a Tamar class, the *City of London III*, and the crew here frequently feel the full force of the Atlantic Ocean.

Endpapers: Beside the promenade at Douglas is a large memorial in honour of RNLI endeavour. It depicts the lifeboat and her voluntary crew, commanded by Sir William Hillary, going to the aid of the *St George*, which had struck the rocks of St Mary's Isle in 1830. These words, cast in bronze, face the sea.

CONTENTS

FOREWORD
HRH Prince William, Duke of Cambridge

I will never forget the first time I witnessed a Royal National Lifeboat Institution lifeboat crew in action. Their professionalism, their skills and their commitment were something to behold – it's hard to believe they are volunteers. These men and women make themselves available every day and night, all year, all around the coast of the United Kingdom and Republic of Ireland. They give up their time to train for difficult and dangerous rescues, and carry them out with great courage.

In my role as a Search and Rescue helicopter pilot, based at RAF Valley, I have worked alongside the lifeboat crews of North Wales on several occasions. It was, therefore, an honour to be asked to officially name the new RNLI lifeboat at Anglesey's Trearddur Bay in 2011. The charity's lifeboats were also a very welcome sight during the Diamond Jubilee Thames Pageant in 2012 when we celebrated the 60 years of extraordinary commitment shown by The Queen. Her Majesty has been the Patron of the RNLI for six decades and I know how proud Her Majesty is to see the charity go from strength to strength.

Each of the RNLI's lifesavers, fundraisers, lifeboats stations and rescues has their own unique story. This book features many of those stories, with a stunning selection of images captured by award-winning photographer and lifeboat crew member, Nigel Millard. He has been supported on his journey by the expert eye of historian and author Huw Lewis-Jones. The photographs you will find in these pages unite superb photographic skills and elegant writing with Nigel's unique perspective as a sea rescuer. Everyone involved with the RNLI plays a part in saving lives at sea, and this book is a fitting tribute to them.

In purchasing this book, you have made a contribution to that lifesaving cause too – the RNLI is a charity that depends on the public's generosity to equip and train its lifesavers. It is a heart-warming thought that such generosity and courage is shown every day on and off our shores. Long may it continue.

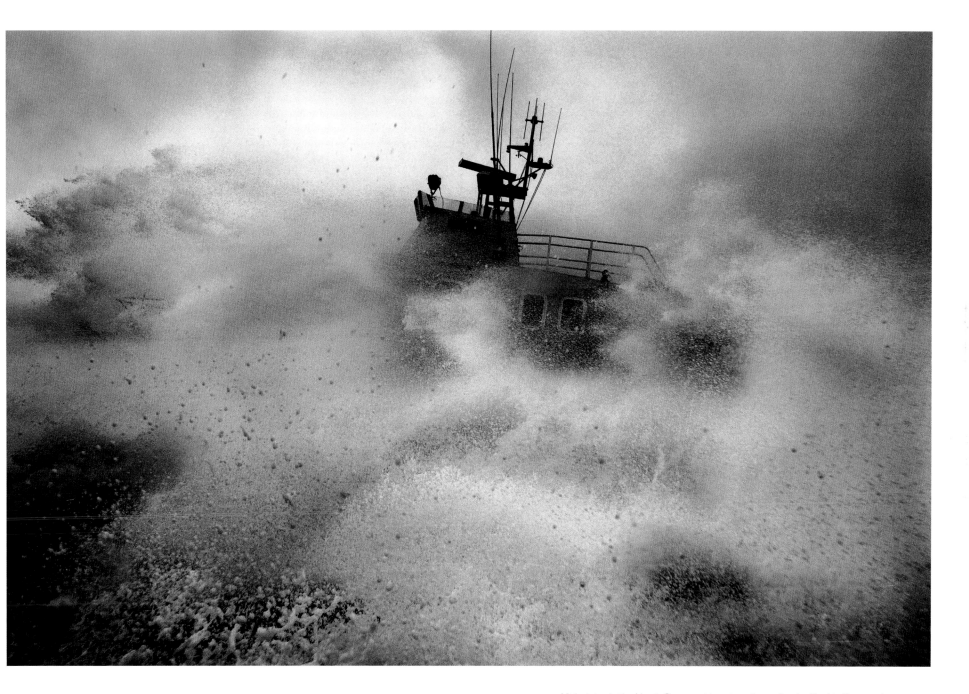

Mid winter in the North Sea provides a tough test for the Buckie Severn class lifeboat *William Blannin*. The first lifeboat came to Buckie in 1860 and volunteers have been saving lives here off the Moray coast ever since, whatever the weather.

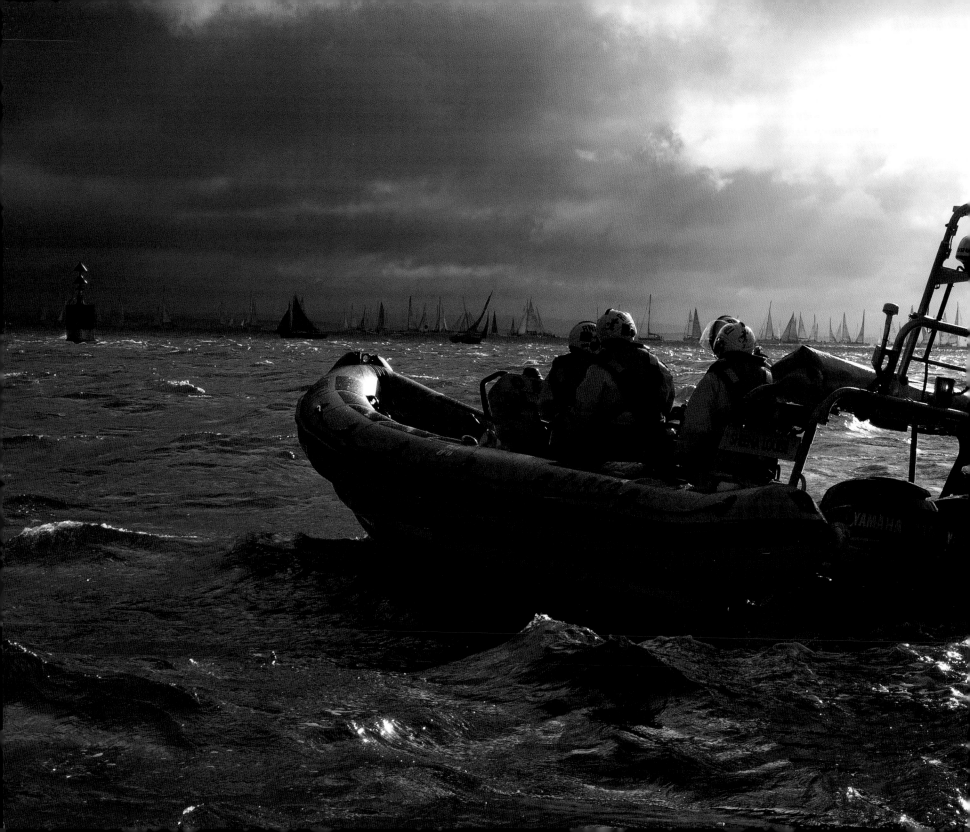

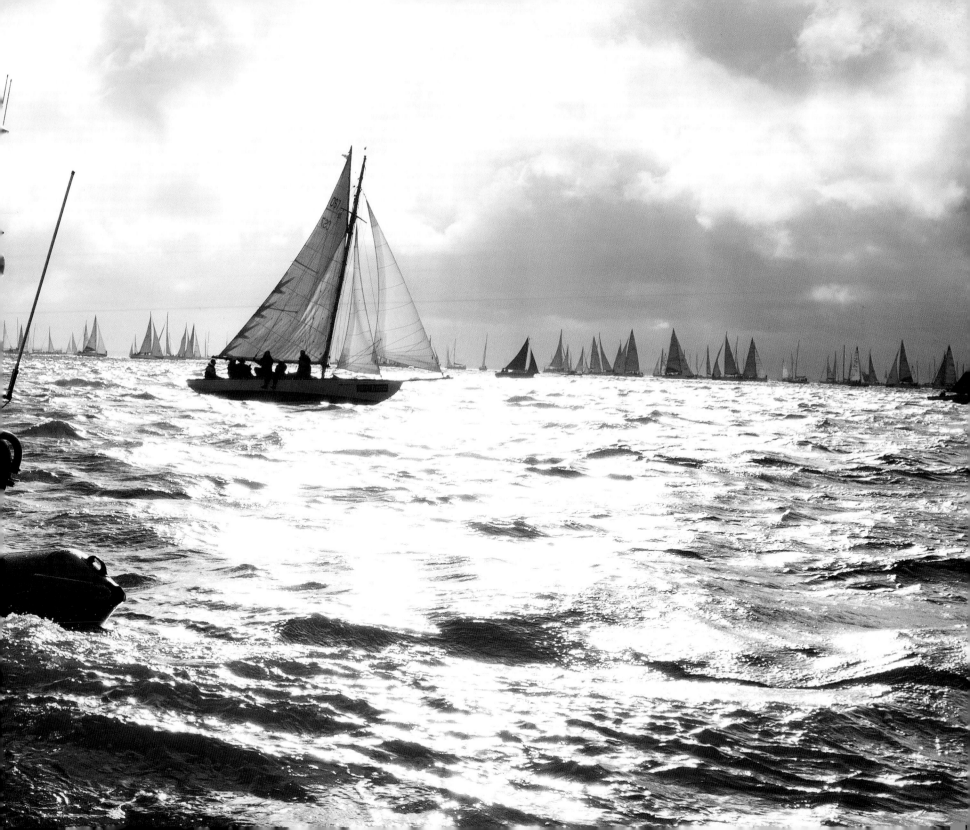

"With courage nothing is impossible...."

Sir William Hillary, founder of the RNLI

INTRODUCTION

The Royal National Lifeboat Institution is the charity that saves lives at sea. For nearly 200 years its volunteers have shown courage and selflessness in facing storm and shipwreck to offer assistance to those in need. Never taken for granted, these qualities of service transcend the centuries to ring as true now as in the earliest days of the lifeboats.

This unprecedented new book is a photographic celebration of every-day bravery, compassion, and outstanding commitment in the toughest of conditions. From the Cornish and Irish coasts to the Shetland Isles, we join crewman and photographer Nigel Millard as he travels the length of Britain and Ireland, living and working with his fellow lifeboatmen and women and accompanying them on their rescue missions.

In 2012 alone some 7,964 people were rescued by lifeboat crews and a further 16,418 were assisted by the service's new lifeguard units, with lifeboats launching on average almost 23 times a day. This book honours the dedication of generations of hard-working people who generously give their time to those in danger and their families who wait for news while the lifeboats are out — a visual tribute to the sea and those who go to it. All around our coasts, wherever sea meets the land, and every day of the year, the men and women of the RNLI are on duty's call.

+ + +

The sea surrounds us all. In Britain you are never more than seventy miles from salt water. It has shaped and defined us as an island nation; it runs deep with heritage and human endeavour, but so too does tragedy and heartache, for the sea is a cruel companion. Men have been going down to the sea in boats for centuries and, just as the dawn breaks and the tides turn, so too many men have not returned.

The sea is boundless and beautiful, sustaining life, a common resource for all, and yet also violent, unpredictable and merciless. There will always be danger here. That said, it is not the sea that presents the most risk to life and limb but the coast itself. Small islands at the edge of an immense ocean, Britain and Ireland lie in the path of some of the worst weather in the world. The rugged west coast is an uncompromising lee shore and the seas surrounding us are unforgiving in their challenge to mariners. The relatively shallow, but wild, North Sea generates waves more than seventy feet in height during its worst winter storms; the fierce tides of the Irish Sea can fool the unwary; the English Channel, a benign seascape you might think, is one that leads to the hazardous Dover Strait, one of the world's busiest waterways.

In the days of sail, ships were often helpless as they were driven toward land in ferocious storms, while communities were powerless to assist. In the early nineteenth century there was an average of 1,800 shipwrecks a year round our coasts and this danger was to some extent accepted as part of life onboard. In the wake of a series of tragic disasters and loss of life so close to shore, money was sometimes raised to support local life-saving boats and the idea of a voluntary service was born. It began with Sir William Hillary in Douglas on the Isle of Man and in time, and with considerable effort, the impulse spread across the country. Naturally, this is where our photographic story will begin.

Two hundred years ago there were no RNLI stations. There are now some 235 stations around Britain and Ireland, with lifeboats ready to be put to sea at a moment's notice, day or night, rain or shine. Since 2001, the RNLI has provided a seasonal lifeguard service too; their reach now extends to 200 beaches. No matter how sophisticated modern shipping has become, the challenges on the coasts that crews now watch over

Former lifeboat coxswain Hewitt Clark shows us his Gold Medal, awarded for gallantry in 1997. These medals are among the few prizes that lifeboat crews might receive in saving the lives of others, often at great risk to themselves. None ask to be rewarded in this way. Every day of the year they are willing to do the same, without hesitation.

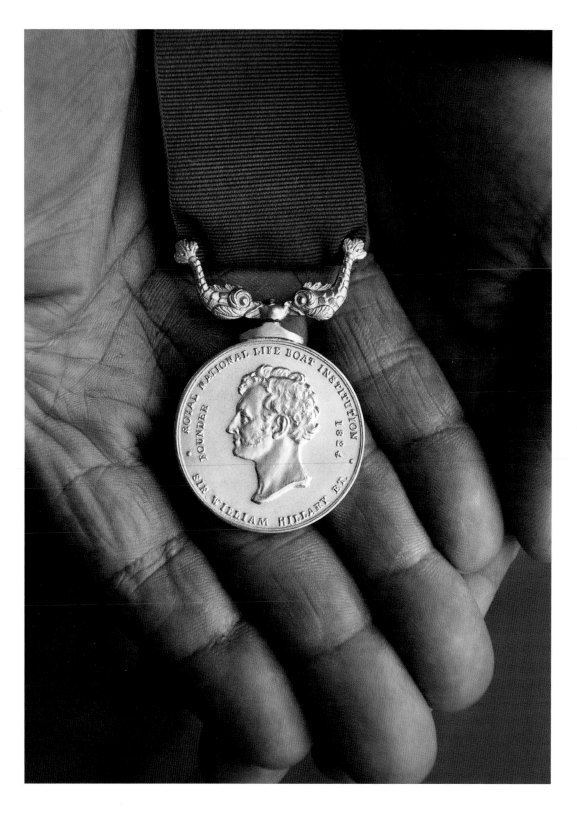

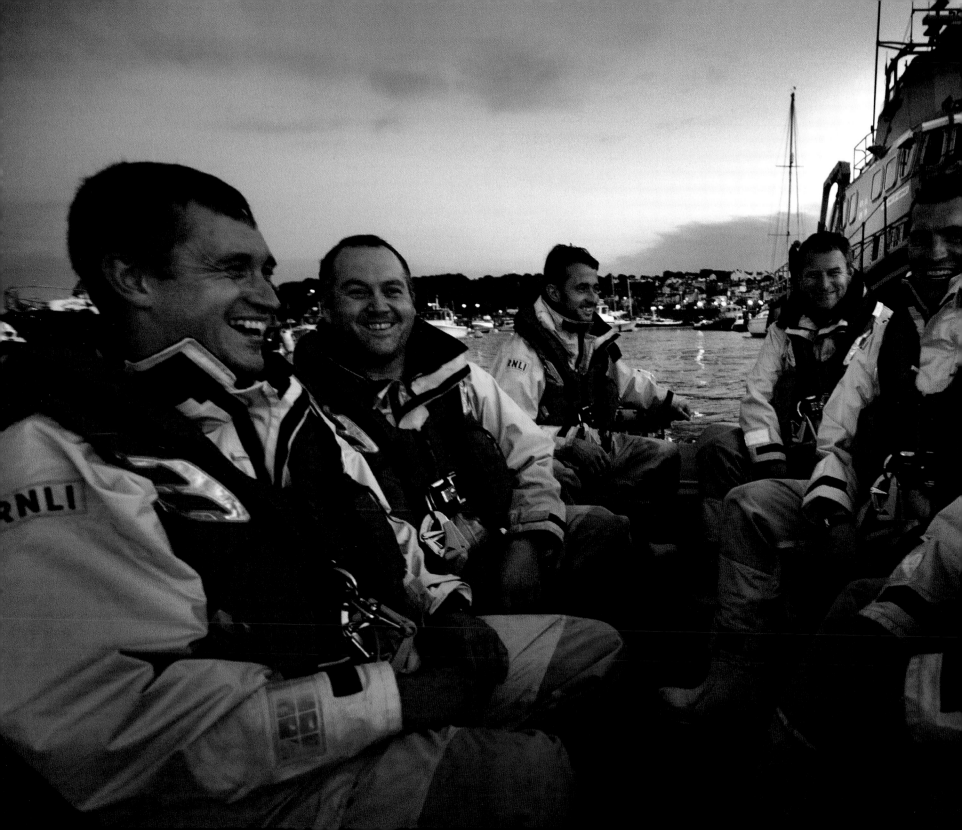

are as extreme as they are varied. They may have to go to the rescue of a cargo ship that has lost control of its steering, gone aground on rocks in a storm, or whose freight has shifted in high seas making the vessel almost impossible to manoeuvre. They may provide aid to a million-pound racing yacht whose keel has snapped, or to a small pleasure boat that has been driven on to a sandbank or whose motor has failed and is drifting into difficulty.

They may search through the night for the crew of a fishing trawler that has sunk beneath their feet, or a helicopter that has ditched into the winter sea, or land a doctor on a remote island beset by gales and fierce storms. They may rescue a child in a rubber dinghy that has been pushed beyond reach of shore by a summer breeze, a kayaker who has not returned home and is missing somewhere offshore, or a family trapped in their home as a river has burst its banks. Perhaps a sudden storm has sprung up and a fleet of boats are unable to cross a dangerous harbour bar; perhaps a rising tide has cut off a group of friends who were enjoying a quiet cove but now fear for their safety as the waves wash ever closer toward them.

All of these things, and much more, have been the daily challenge of crews around the country this year, as in each year before. More often than not, the lifeboat puts out to sea when other boats are seeking shelter in harbour. The RNLI crews never refuse a call. It is at this moment that the lifeboat is needed most. In the fishing villages, ports, holiday resorts and harbour towns of Britain and Ireland, where lifeboats are stationed, the memory and legacy of the service is preserved in countless such occasions when the lives of others have been in danger at sea and where crews have given of themselves for the sake of others. When the highest has been demanded, the highest has been given.

+ + +

The Lifeboat is the story of the RNLI and its crews in its vibrant present – not a history book but a modern celebration of the work of a charity that sums up much that is best in Britain and Ireland. In an age when human failings seem always to be in the news, the RNLI is a welcome reminder that we are all capable of better things. The story of the service is one of duty and devotion, yet also hard work and little reward. It's a story of sleepless nights and weary returns. It's a story of giving to others before oneself.

Crewing a lifeboat takes mental and physical strength, and at times even heroism. Occasionally

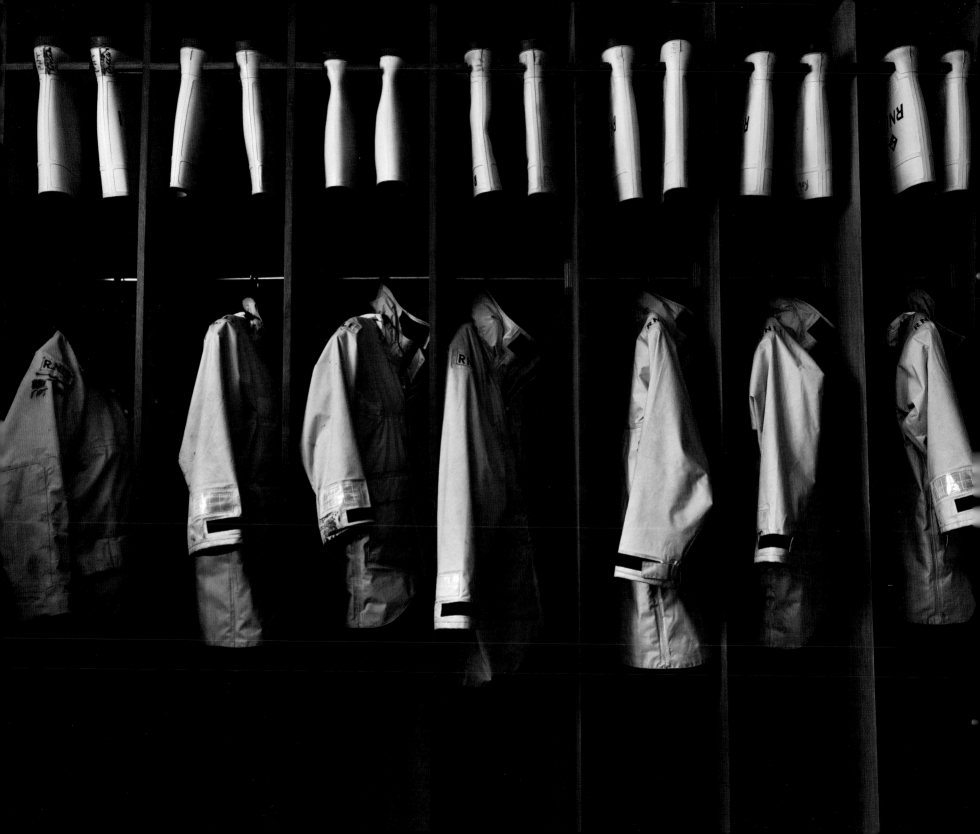

the RNLI rewards its crews with medals for this outstanding bravery. With 150 Gold Medals since 1824, a book such as this clearly can't come close to covering all of this gallant action. The legendary names in lifeboat history — men like Blogg of Cromer, Evans of Moelfre, Fish of Ramsgate, Sliney of Ballycotton, Clark of Lerwick — provide an example that continues to inspire crews around the country, but we can only touch on their achievements here. Nor, was it possible for us to visit all of the RNLI stations over the course of this project. We have done what we can. Our respect for those that serve is ongoing, so there is no need for a full stop. Another book, we hope, another time.

In an Olympic year we might naturally have thought of other medal winners, yet many RNLI volunteers played a role in the events. Some carried the Olympic Flame in the build-up to the opening ceremony and as the Games got under way others stepped up safety cover, providing medical support for the sailing events in Weymouth Bay, with lifeguards also watching over the Olympic triathlon and swimming races on the Serpentine in London. The RNLI also played its part during the special jubilee year of celebrations for Queen Elizabeth II, Patron of the charity since her succession to the

throne. In addition to Eastbourne's new lifeboat, appropriately the *Diamond Jubilee*, over twenty inshore lifeboats provided safety cover for the 1,000-boat flotilla on the Thames.

More difficult to summarise in a book like this are those moments in the RNLI story of profound despair. Some of these losses happened in the early life of the Institution, in the days when horses, not tractors pulled carriages to the shore; in the days when oars, rather than engines, propelled lifeboats to the rescue. Others have occurred in living memory and the sadness is still keenly felt. From The Mumbles in south Wales to Longhope in the Orkneys; from Fraserburgh in the north east of Scotland to Penlee in the south west of England, all have been touched by tragedy. Yet, despite these incidents and conscious of the rich heritage of service, new crews continue to put to sea, day after day, undaunted and undeterred. In recording this enduring spirit, this book is a reflection of the gratitude that many of us feel toward these communities. Drop a coin in the collecting box next time you pass a boathouse, for the crews may be out at sea this very moment.

The work of the RNLI has inspired many books over the years — this one is different in that

it describes the modern present through specially commissioned photography. We have aimed to show things that are unique, but also typical of the day-to-day life of the service. We take you behind the scenes, out on shouts and exercises, and you are welcomed into the homes and the lives of the crews. It becomes obvious, far more than mere cliché, that the RNLI truly is a family; a community of modest, kindred souls looking to the sea, united by a cause in which they believe strongly.

Over the course of five years, Nigel Millard has made a series of journeys around Britain and Ireland, often chasing bad weather, yet all the while offering his support to the crews he has worked alongside. As his editor, I have joined in as best I could, learning what it takes to be a lifeboatman with different crews across the country; learning from the very best. After tough days at sea, and many miles on the road, I've returned safely home to Cornwall to get back to writing books. Meanwhile, Nigel has returned home to Brixham in Devon, and each time has rejoined his local lifeboat crew, on call at a moment's notice. And then, bags packed, he's soon off for the next trip away.

This book has been created to follow a rough circumnavigation of Britain and Ireland, beginning

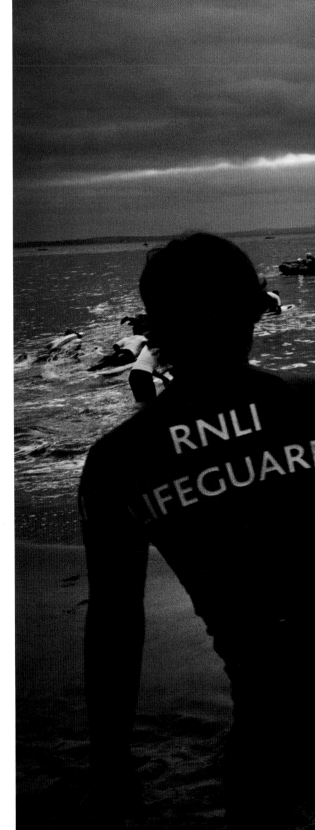

in the Isle of Man and working clockwise around our coasts. Summarising our experiences at these RNLI stations, by selecting just a few images each, we hope to give a taste of what it's like to be a member of a lifeboat's crew. Though many years in the making, Nigel's efforts of course show just a snapshot of RNLI activity. We do not tell a complete or definitive story – that would be impossible – but what we have tried to show is both the variety of experience and those things that bind crews together; the shared purpose, the common ground, the united spirit.

Through hurricane force winds, or summer calm, hanging from helicopters, or wallowing in the waves in a waterproof suit, Nigel has gone to great lengths in the pursuit of the perfect photograph. And by perfect, we mean, the photograph that speaks truest to its subject. His journey was one started in tribute, which has now grown through his admiration for the crews he meets, but the ambition has always been of realism as much as the dramatic moment and the challenge of the elements. So, this year in the life of the lifeboat does not focus solely on the terrible and the dangerous – on the drama of a demanding rescue – but also the watching, the waiting, the training, the fundraising, the false

alarms, the well-needed time off. This is a story of extraordinary effort and the unexceptional too, for a lifeboat crew doesn't long for action and disaster to test out their mettle. A quiet year is in every respect a good year.

This is also a story of manpower, logistics and organisation: of building, servicing, maintaining, and running boats and stations to the highest standards. Little can be done to change our unforgiving marine environment, but what the RNLI can do is provide its crews and lifeguards with the very best kit, training and craft for the challenges they could face at any time. From the busiest stations on the River Thames in the heart of London, to the newest in Cowes on the Isle of Wight and Leverburgh in the Scottish Hebrides, to the old boathouses, full of the memories of heroes long past, Nigel's photographs take us inside the RNLI as never before. We discover a network of stations lining our coasts, operating a range of high-powered vessels from small inshore rescue craft through to hovercrafts, from 5m inflatables to 17m all-weather Severn class lifeboats, each ready for the next distress call. Be it a lone yachtsman, a family on holiday, or the whole crew of a 50,000-ton foreign freighter, from sandbank and salt marsh,

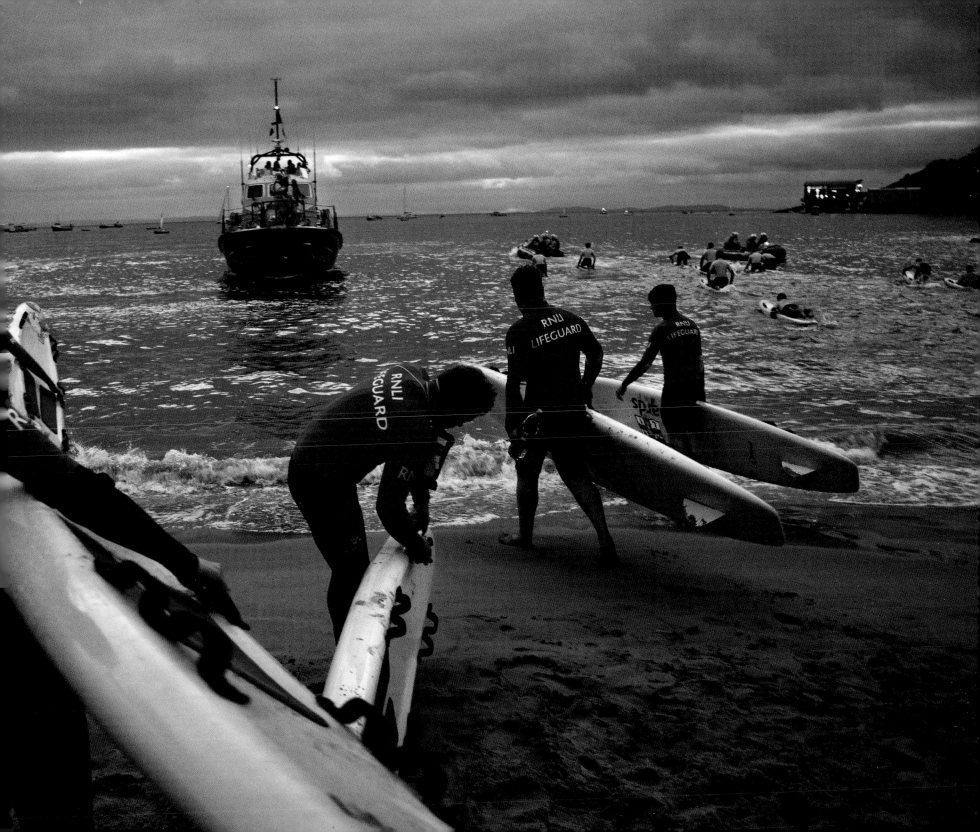

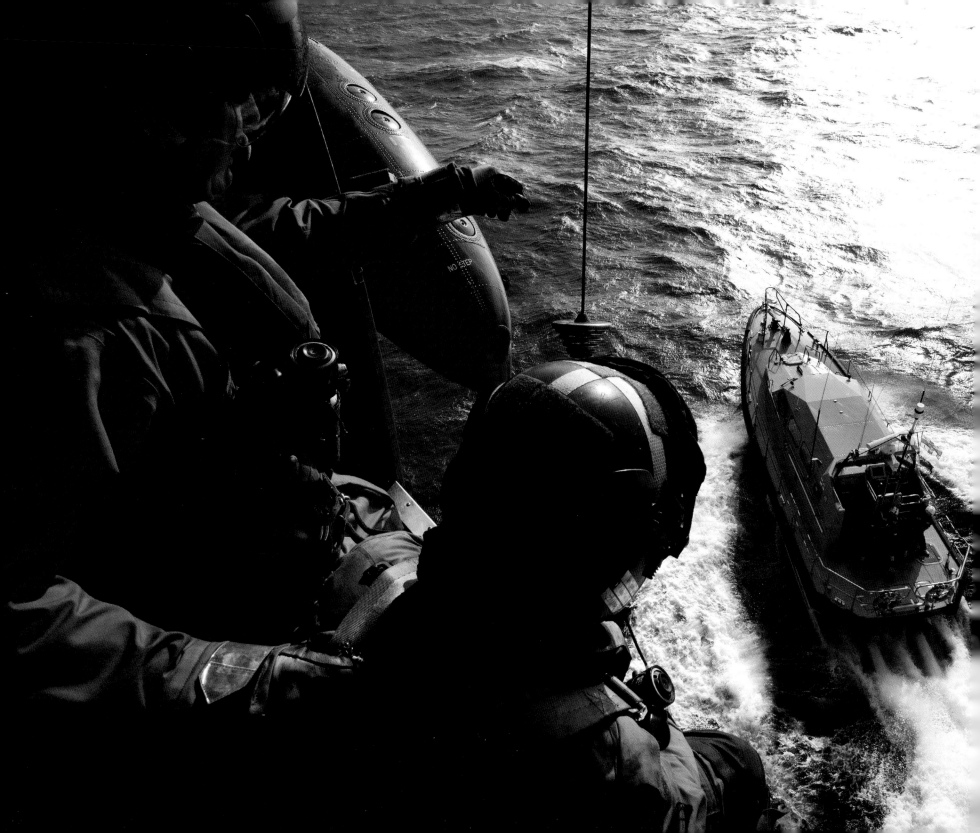

Crew of RNAS Culdrose helicopter Rescue 193 look on as the RNLI's new Shannon class prototype lifeboat is put through her paces. The charity will need to build over 50 new Shannons within the next ten years to replace the older classes of lifeboat. That will mean all RNLI all-weather lifeboats will be capable of 25 knots. The charity estimates that the Shannon class will rescue over 56,000 people and save the lives of over 1,500 in its lifetime.

across mudflat, to reef or rugged cliff, the RNLI is up to the task in all conditions.

Yet, it all comes down to something supremely simple, the most precious gift of all: the willingness to risk your life for another. For many men and women this has become second nature, something freely given, something done without thinking. This book is dedicated to this spirit of service. Without it, our nations would be much poorer indeed.

In small coastal towns the lifeboat station is as much a central part of the community as the local church or the pub. Frequently crews have come from generations of the same family, with fathers passing on their knowledge to brothers, sons and now daughters too. Coxswains are often men who have worked at sea — as skippers, fishermen, tug masters and pilots — but now this is by no means the rule. It used to be the case that crews were also largely composed of mariners, but again things have changed hugely over the years. In this book you'll meet carpenters, landlords, builders, teachers, accountants, butchers and bankers, farmers and firemen, nurses and postmen, marine biologists and window cleaners, office workers and shop assistants, oil riggers and landscape gardeners, even a zoo-keeper. Clearly, all walks of life now answer the call.

The careers of the crew may be wildly different but there is much that these men and women share. They are dependable, trustworthy, and brave — a word so often used, but in this sense so perfectly suited. Most find it hard to tell you why they do it. They are bound together in the face of adversity, sharing humour and team spirit when things get tough, and yet united, most simply, by a sense of giving the best of themselves. Actions speak louder than words. They are ordinary men and women who have it in themselves to offer the extraordinary. They are the special few who are willing to risk everything when the shout goes up.

Though the RNLI has evolved, through its technologies and reach, its sense of purpose and vision — to end preventable loss of life at sea — is as clear as it was in the very beginning. This is a simple story of a voluntary rescue service, of men and women happy to race to the assistance of strangers at all hours of day or night should ever the need arise. Few more words are necessary. We hope these photographs show something of this spirit. We are encouraged never to forget the bravery, skill and sacrifice of the people of the RNLI. They are heroes all.

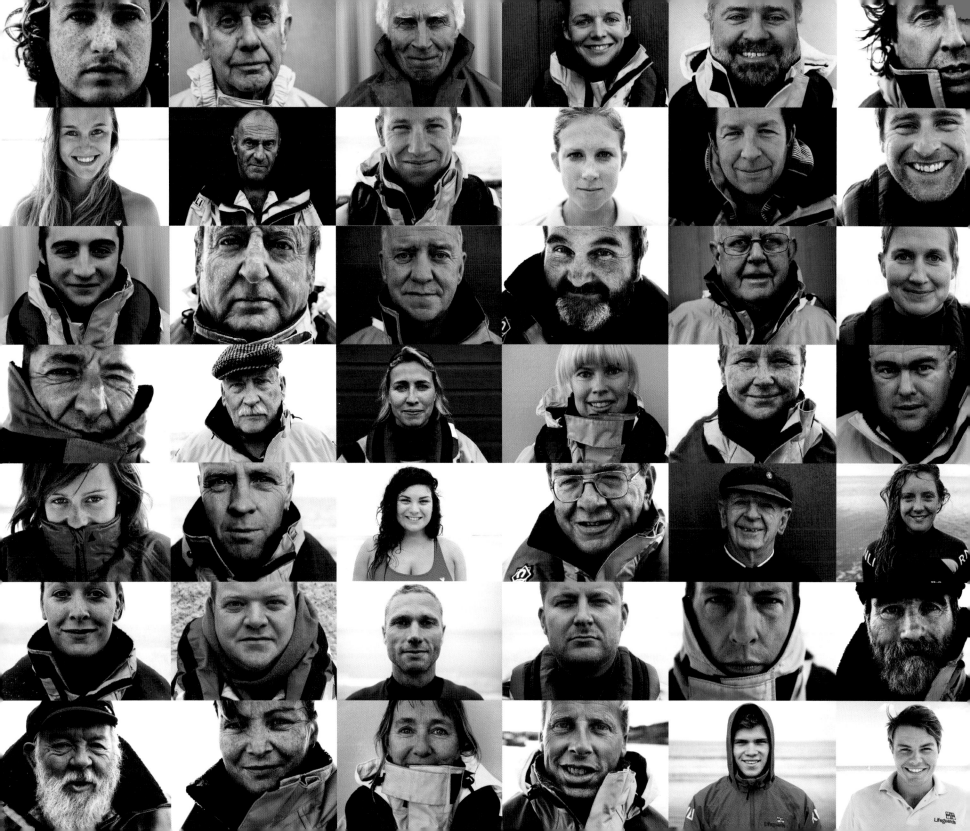

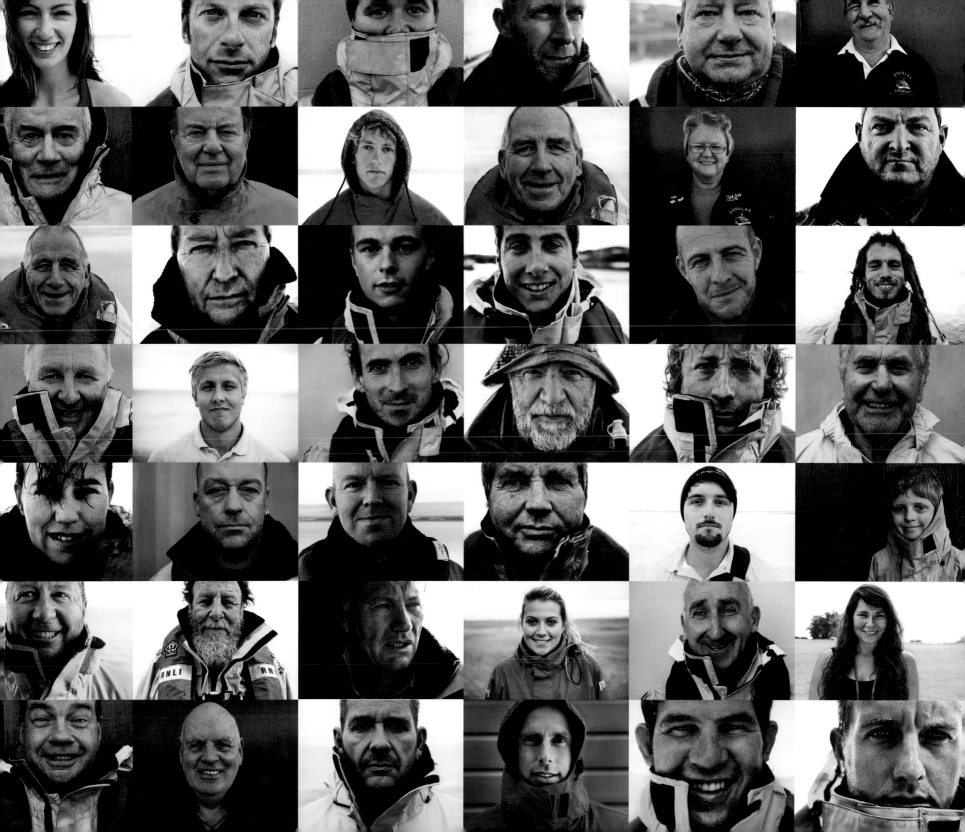

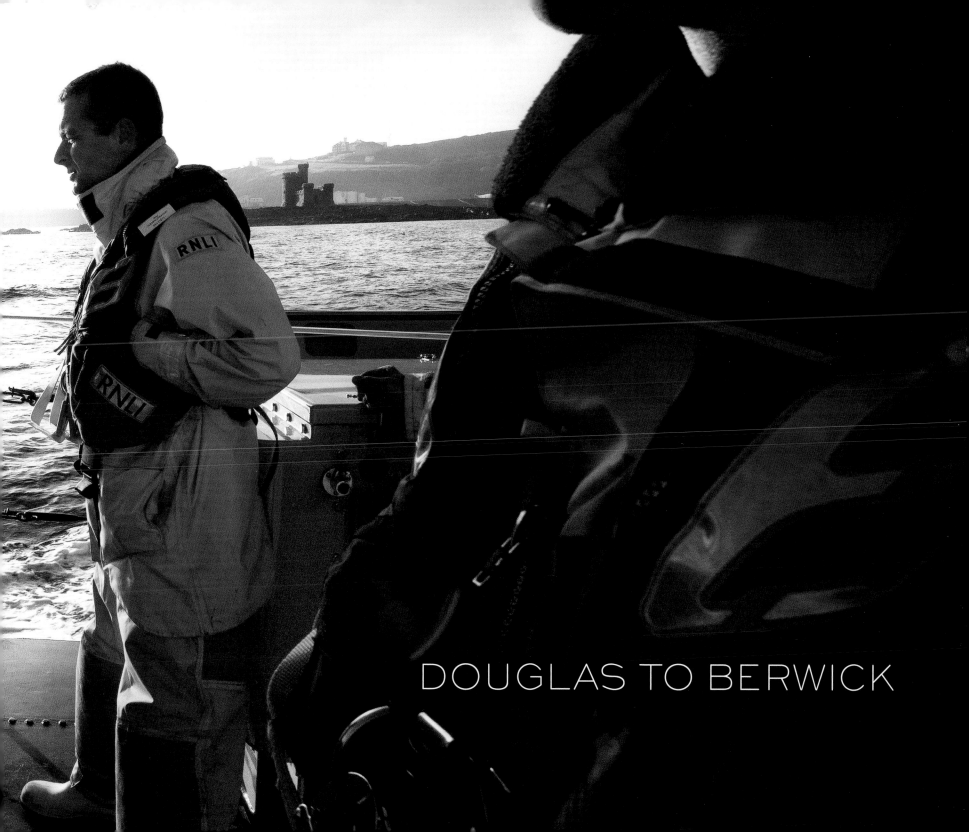

DOUGLAS TO BERWICK

CHAPTER ONE
DOUGLAS TO BERWICK

The sun shone from a cloudless sky. A herring fleet of 400 wooden vessels left Douglas harbour in mirror-like seas to cast their nets a few miles to the north. It was 21 September 1787, a glorious autumn afternoon, yet conditions were deceptive. Shortly after night fell, the wind veered and the calm was broken by a rising storm from the south. As the waves grew, within deepening troughs, the fleet fled for safety. Some of the seven-man crews turned north for Ramsey, preferring the ordeal of a twelve-mile trip to what lay to the south. But most turned for Douglas, knowing even as they did so that the tide had ebbed and the harbour would be dry. They would have to wait out to sea among the waves until the tide turned.

Entering Douglas Bay, the crews were guided by a host of twinkling lanterns, held by crowds of families and friends who had come down to the shore from their homes, waiting anxiously for loved ones to return. Though only a few hundred yards separated them from the boats, in between was a hostile sea and rocky shoals that could smash a man's bones. At the entrance to the harbour, tucked in beneath the cliffs of Douglas Head, was a single candle lantern suspended from a pole, shaking in the wind. It was the only guidance light there because the year before a storm had swept away the pierhead and the lighthouse that stood upon it.

For a time the fleet did its best to ride out the storm, with bows turned toward the incoming rollers and anchor cables cast out ahead, but as the tide turned the size of the waves increased and staying in position became impossible. The boats decided to make a run for the harbour. At first it was an orderly procession, then mayhem ensued. All of a sudden the harbour flame went out. The crews could not have known it, but the mast of one of the first boats to attempt an entry into the harbour had hit the lantern and sent it crashing into the sea. The fleet broke up, some turned toward lights on the shore, others collided with each other or were smashed against the rocks. The tumble of surf swallowed the boats within minutes.

On the beach the watching crowds could hear the screams of the men above the roar of the wind. And so, one by one, the fishermen drowned. For the Isle of Man it was a night of mind-numbing tragedy, yet with the dawn came the real horror. Bodies floated in the harbour and wreckage lay strewn along the shoreline. Though few had heart to count the dead, the final tally was 161 lives with some 60 boats ruined. Hardly a family escaped the disaster; a friend drowned or injured, a father, son, or brother lost. Those who survived, and the generation that followed, carried the painful memory of that grim event in their hearts. For years afterwards the fishermen that were left stayed in port on the anniversary of that night: 21 September. It would be one day when the sea would never again claim a Manx man.

Tragedies like this had occurred elsewhere around the coasts of Britain and little could be done in response. Some said this was the inevitable price a maritime nation might have to pay, an occupational hazard for those wishing to make a life from the sea. Yet, in time, there were people for whom this was not enough – people who were no longer willing to stand idly by, unable to help, lacking the means or methods to react to an unfolding disaster. Tragedies like this encouraged those minded to do something about it, and some communities responded by gathering the money and the human will to set up a local lifeboat.

Our story begins on the Isle of Man, and at Douglas in particular, where the rocks in the bay and the treacherous Irish Sea had been hazards to seafarers for centuries. Here the RNLI story begins too with an eccentric baronet who had come to live

on the island and, having witnessed tragedy here, became determined to make a difference.

After a colourful life as soldier, traveller, entrepreneur and man-of-letters, Sir William Hillary had settled at Douglas, where a small local lifeboat station had been established as early as 1802. His house overlooked the stormy waters of the bay and he would witness several terrible shipwrecks there. He became a regular member of the Douglas crew, yet soon came to realise that more was needed to help mariners around the country as a whole.

Hillary made his appeal for a national lifeboat service in a small pamphlet published in Douglas in 1823, entitled *An Appeal to the British Nation on the Humanity and Policy of forming a National Institution for the Preservation of Lives and Property from Shipwreck*. He set out in detail how a national lifeboat service might be run. The following year he took his campaign to London, where some influential city bankers and prominent members of Parliament took an interest in the cause. After much effort, a meeting was finally held in the City of London Tavern on 4 March 1824, with the Archbishop of Canterbury presiding, and it resolved to found a body to be known as the National Institution for the Preservation of Life from Shipwreck, relying – as it does to this day – wholly on voluntary contributions. Thirty years later, with Queen Victoria's blessing, its name was changed to that of the Royal National Lifeboat Institution.

As well as establishing its own lifeboat stations, the new charity also began to award Gold and Silver Medals for acts of outstanding bravery at sea, whether performed in a lifeboat, a shore-boat, or even from the shore itself. A Bronze medal was instituted later, in 1917. For his part, Hillary continued to volunteer on the local Douglas lifeboat. On one notable service in 1830 he

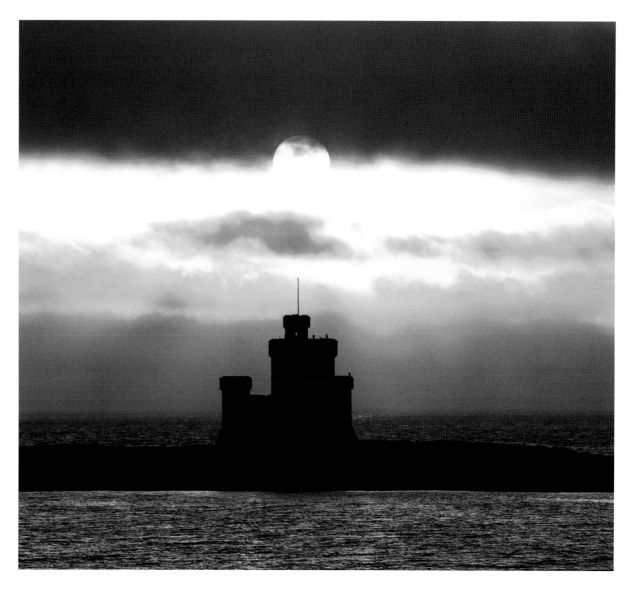

gathered a crew and went to the aid of the mail steamer *St George*, which had been driven onto the rocks of St Mary's Isle. Though he was washed overboard and fractured six ribs, he stuck with the task and eventually succeeded in rescuing 22 survivors.

In its early years, the Institution was a fledgling affair – with limited funds, piecemeal coverage and

fewer than 40 lifeboats, all propelled by sails and oars. Today the RNLI has annual running costs of over £140 million with more than 330 operational lifeboats covering almost 20,000 miles of coastline. The size and ambition of the service has increased dramatically over the years and though the skills required today are different, the commitment to the cause is stronger than ever.

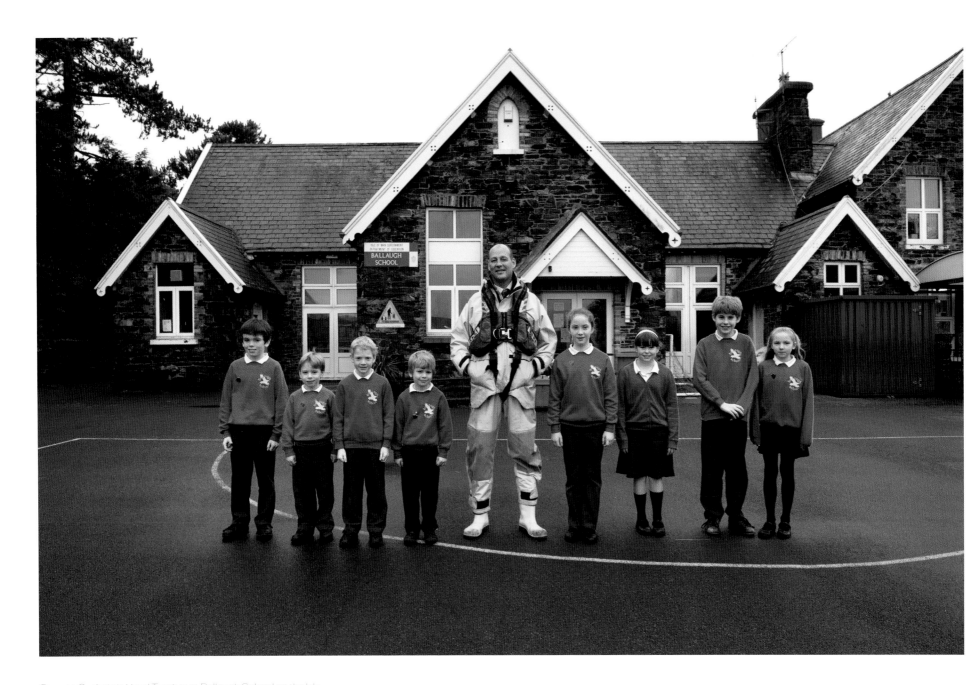

Graeme Cushnie is Head Teacher at Ballaugh School on the Isle of Man and has volunteered as a crewman on the Douglas lifeboat for over twenty years. His pupils are right to feel proud of him.

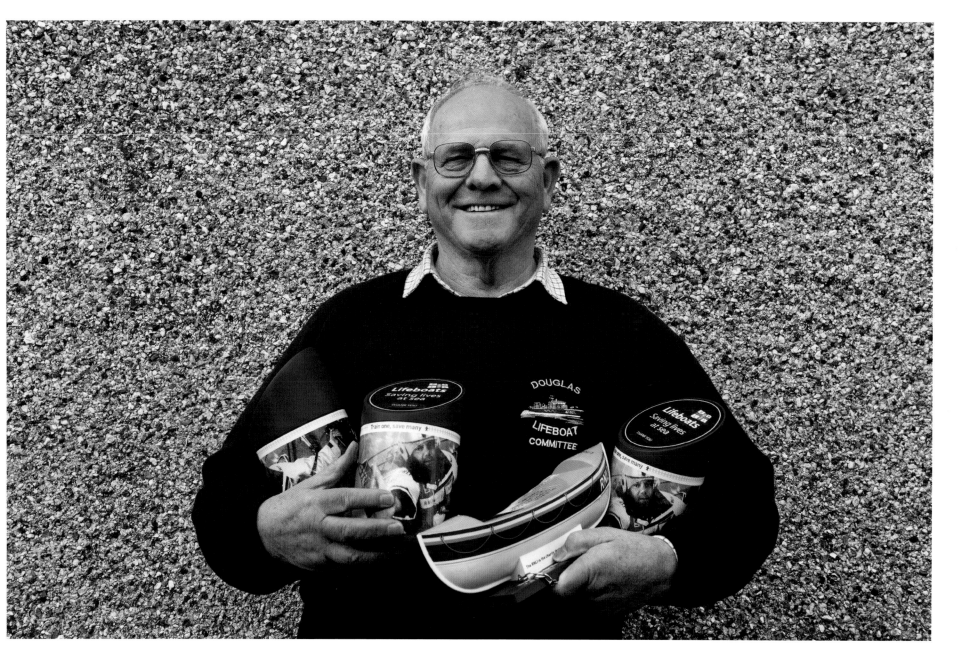

Maxwell Callister is a volunteer Fundraising Collection Box Officer and he shows us the tools of his trade, before heading into town to gather in more well-needed donations. Maxi first got involved with the RNLI because he had previously been in the Royal Navy as well as being interested in yachting, and he has now supported the lifeboat here for more than two decades. 'I've enjoyed every day of it', he says. 'Helping the lads is reward enough for me.'

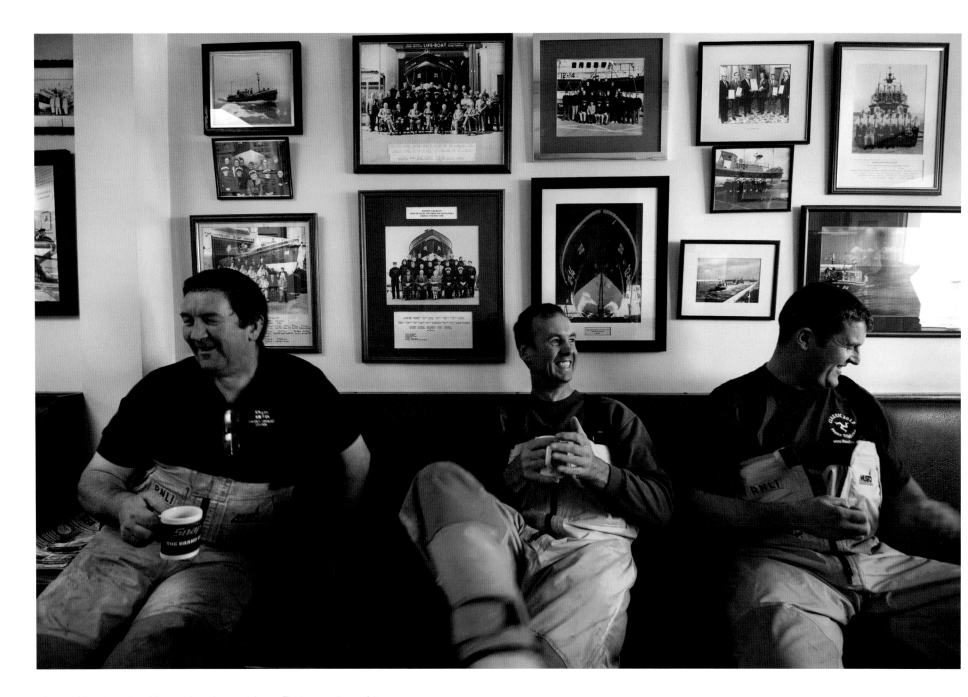

After washing down their Mersey class *Ann and James Ritchie*, members of the crew at Ramsey enjoy a brew in the boathouse. On the walls are photographs from its illustrious history. One of five lifeboat stations on the Isle of Man, Ramsey has celebrated nearly 130 years of saving lives at sea.

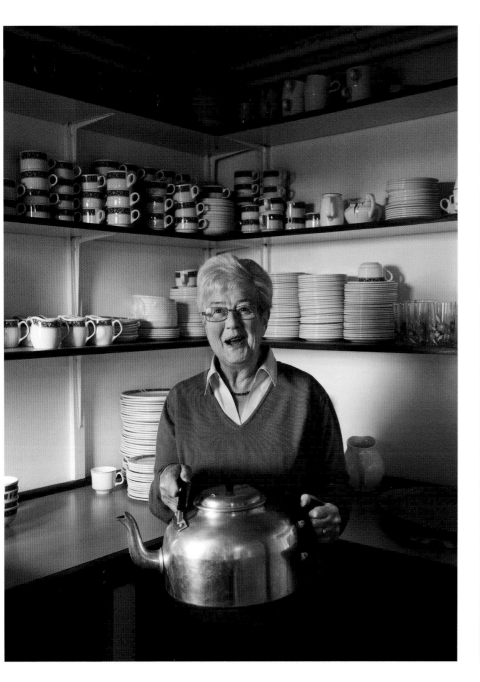

Marion Payne, long-serving member of the Port St Mary Ladies Guild, prepares the tea at a local craft fair. Five hundred cups, and many cakes later, the team of fundraisers have done the RNLI proud.

Elsewhere on the Isle of Man, Rebecca Killip supports the lifeboat in her own way: by knitting cuddly lifeboatman mascots. They're a regular feature on lifeboats across the country.

Left: Sheltered against the breakwater, the all-weather lifeboat at Port St Mary is the Trent class *Gough Ritchie II*, saving lives ever since she came on station here in 1998. In fact, on the first leg of her delivery trip to the Isle of Man from RNLI headquarters in Poole, she rescued four divers who had gone missing off the Eddystone Lighthouse, bringing them safely into Salcombe. Port St Mary also operates an inshore D class lifeboat here, the *Spirit of Leicester*, which was supported by funds raised in that city almost 200 miles away.

Opposite page: David 'Richie' Richards has been coxswain at Port St Mary for over a decade now, having been on the crew since 1986. 'It's just a normal part of my life now. When I left the merchant navy and came ashore it seemed a natural thing to do, to offer my help. We've a great bunch of lads here who are all willing to come with me in the tough weather, and we've got a great boat too.'

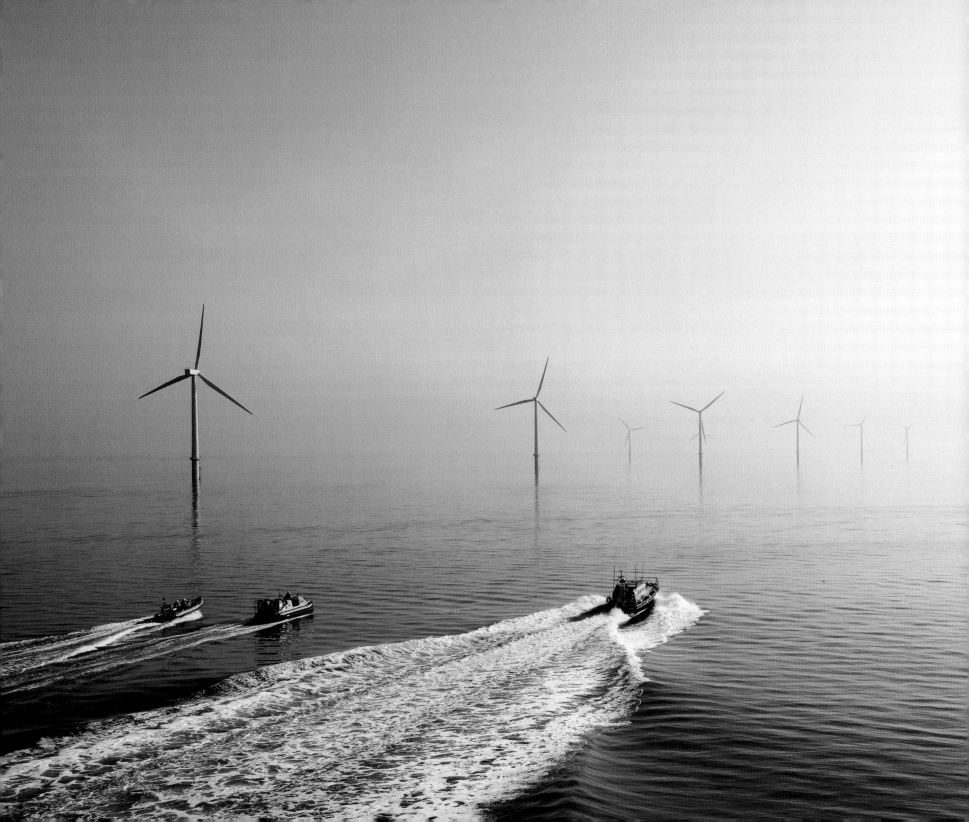

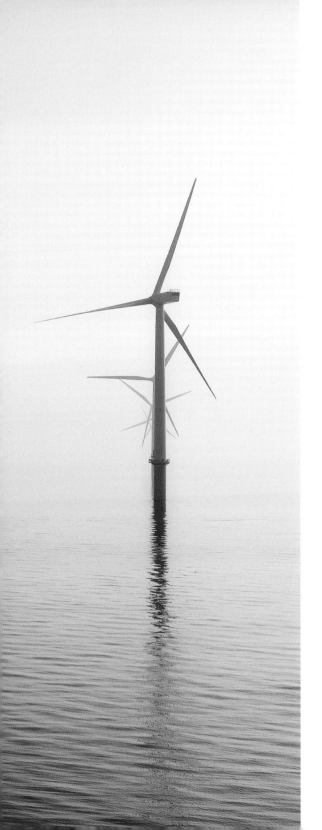

Hoylake and West Kirby, on the north-west corner of the Wirral Peninsular, lie beside the Dee estuary, with the hills of North Wales a distant backdrop. Yet the Sands of Dee can be treacherous and many modern visitors come to grief here, caught out by the speed of the incoming tide. The Hoylake Mersey class lifeboat *Lady of Hilbre* races out across the sands to reach the waters edge.

There are three basic ways of launching a lifeboat: down a slipway, from a mooring afloat, or from a carriage or trolley manoeuvred across the shore to the sea. Launching afloat is a comparatively simple process. The crew kit up, board the boat, and cast off, but of course it depends on a safe, sheltered anchorage, a harbour, or even a floating boathouse. When there is no deep water potential — in anchorages that dry out at low tide, for example — or in areas that are too exposed, or too flat, for a slipway, then beach launching becomes necessary. In these instances, the lifeboat is loaded onto a specialised carriage and pushed into the sea by a robust, purpose-built, semi-submersible caterpillar-tractor — the new generation of horse power!

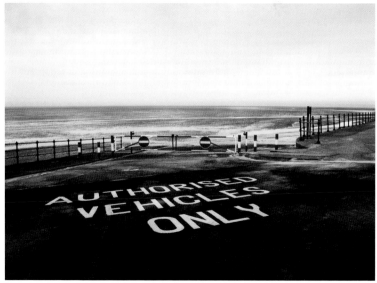

Left: Across the Irish Sea to England, we head out to the Burbo Bank wind farm with the Hoylake lifeboat and a hovercraft and Atlantic 75 from New Brighton. Today, the RNLI provides a 24-hour search and rescue service to 100 nautical miles out from the coast of the UK and Ireland.

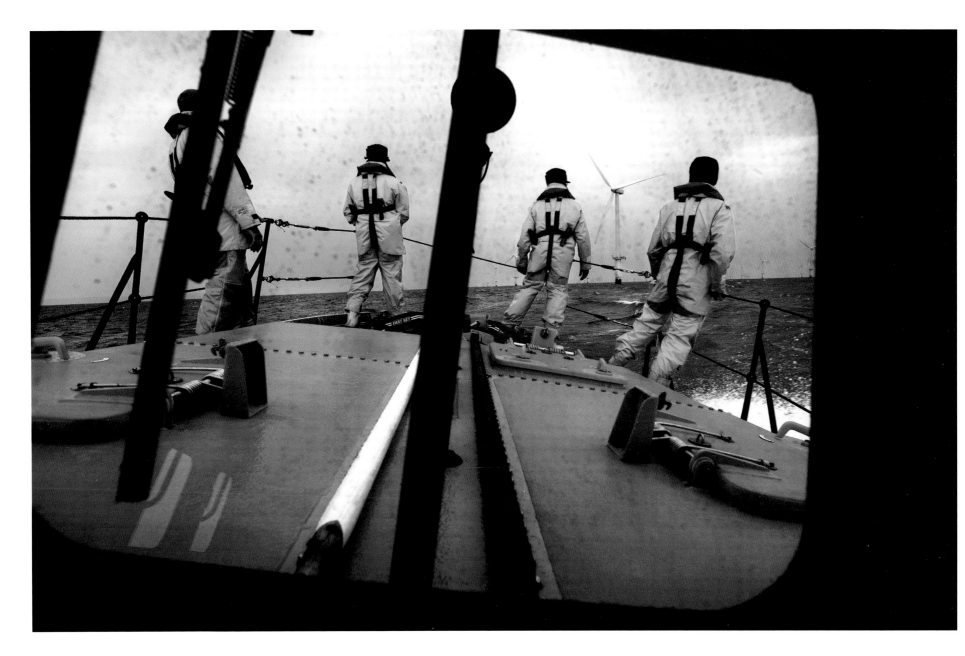

The view from the wheelhouse of the Hoylake *Lady of Hilbre*, as the crew search for a casualty in the water near the North Hoyle wind farm. The Mersey class has proved an excellent boat over the years, but at just 17 knots maximum speed, there is now room for improvement. In 2014, Hoylake will be receiving one of the first of the new water-jet powered Shannon class of lifeboats, which brings with it a capability of 25 knots (in line with other all-weather boats in the RNLI fleet) and much greater manoeuvrability.

When crew members get a call on their pager, they are expected to be at their lifeboat station within ten minutes. These days the speed of launching, especially for inshore lifeboats, is crucial to the success of a rescue. With bodies in the water, there is little time to ensure their survival. The majority of stations reckon to launch within six minutes of receiving a call. The new Shannon will make all the difference.

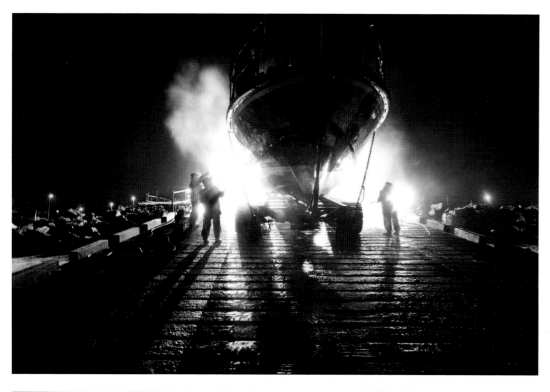

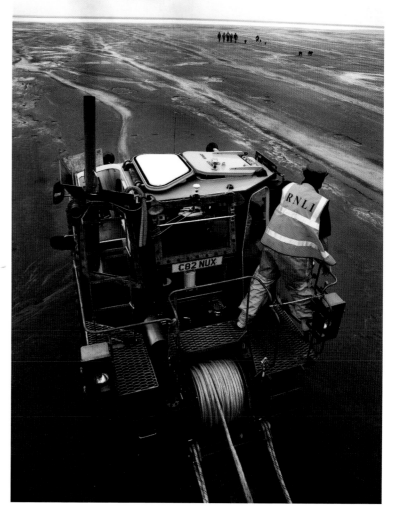

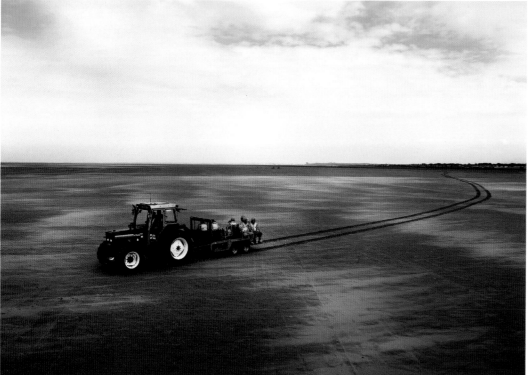

Heading to the water's edge, the shorecrew at Hoylake hitch a lift on a tractor on their way to recover the lifeboat. When time at sea is complete — be it on exercise or a shout — the procedure is the same, day or night. As soon as the boat is back at the station, it must be washed down and cleaned. Equipment is checked and used items are replaced immediately. Refuelled and resecured, the coastguard is then alerted that the lifeboat is once again ready for action.

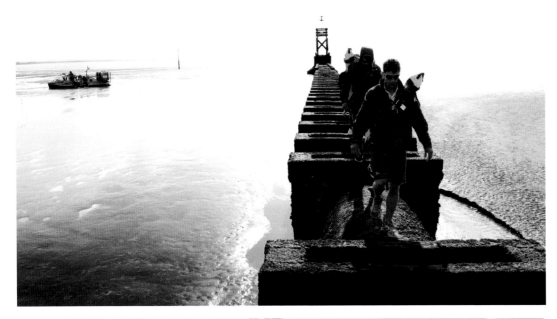

Across the Mersey estuary at Crosby, the New Brighton hovercraft *Hurley Spirit* joins a lifeguard team to carry out a rescue exercise. This is an area where mud flats, tidal gullies and pockets of quicksand can deceive the unwary and walkers are often cut off by the tide. A seaweed-covered groyne is indeed the safest route on foot across the mud for the team. The hovercraft is the ideal machine for operations in this environment.

Opposite: Amongst the shifting sand dunes at Formby, north up the coast from Liverpool, you can just make out some scattered brickwork, the ruins of an old lifeboat station. Records now suggested that there was a boat dedicated to lifesaving here as early as 1776, making it the first in Britain. In charts of the Harbour of Liverpool and the River Mersey approaches, a small footnote mentions a boathouse and boat ready to save lives. It was in charge of one Richard Scarisbrick, a sailor, of whom no picture and next to no information survives, though it is probable that he was the world's first lifeboat coxswain.

Over the following years the small buildings here, and a lighthouse that was erected nearby, would have been the last landmarks seen by many thousands of emigrants whose ships were piloted through the Formby Channel to start new lives in places like America and Australia. The RNLI took over the running of the lifeboat here in 1894 until it was closed in 1918 as other stations took up coverage in the area. Today, the exposed beach is still watched over by RNLI lifeguards, whose all-terrain-vehicle leaves its tracks in the wet sand.

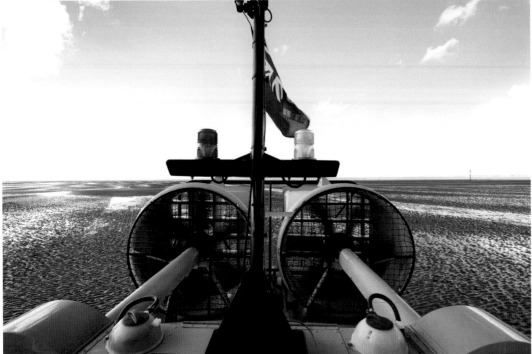

On sunny days, this coast can seem gentle, but it has seen desperate tragedy in years past. In 1886, what began as a triumphant rescue by the Lytham lifeboat in the Ribble estuary turned into the worst disaster ever experienced by the RNLI, with the loss of 27 men. It brought about major changes in the operation of the lifeboat service and the way it is funded.

On the morning of 10 December, coxswain Thomas Clarkson was just putting ashore the entire twelve-man crew of a German barque *Mexico*, which had run aground on a sandbank. They had managed to locate the wreck in total darkness, through heavy breaking seas with a northwesterly gale and strong ebb tide, and despite a near-capsize they had got alongside and pulled off the crew. It was an effort that earned Clarkson the Silver Medal. Yet, what the Lytham lifeboat crew could not have known was that two other lifeboats — one from Southport across the estuary, and the other from neighbouring St Anne's — had also answered the *Mexico's* distress signals but had both capsized in their efforts to reach the wreck. Twenty-seven volunteer lifeboat men lost their lives that terrible winter night. The St Anne's lifeboat was found, bottom up on the beach the following morning. There was no trace of the crew.

The disaster provoked national sympathy for the families but also encouraged the RNLI to question the safety of their operations, focusing minds on alternative means of powering the lifeboats other than by sail and oar. It was the first step along a sequence of events that saw steam-driven and later petrol engines introduced on lifesaving craft.

Horrified by this tragedy a Manchester businessman, Sir Charles Macara, launched a national appeal to help the orphans and widows of the lost lifeboatmen. On a wave of public sympathy, the disaster also inspired volunteers to bring the cause of the lifeboat to a greater audience — and this first happened in Manchester in October 1891 in the form of a large public collection, the first charity street fundraising of its kind. A lifeboat was pulled through the streets and passing shoppers and spectators watching from their windows were encouraged to donate money in support. They were asked to place pennies into purses attached to long poles as the boat trundled by. Manchester's 'Lifeboat Saturday' was a huge success and the idea soon caught on in other large cities throughout Britain, while the method of collecting gradually evolved into the Lifeboat Flag Day that is well-known today.

The RNLI continues to be underpinned by this strong tradition of fundraising. Manchester volunteers Tom Ridyard and Brian Thompson, like countless others across the country, are more than happy to play their part in this remarkable charitable endeavour.

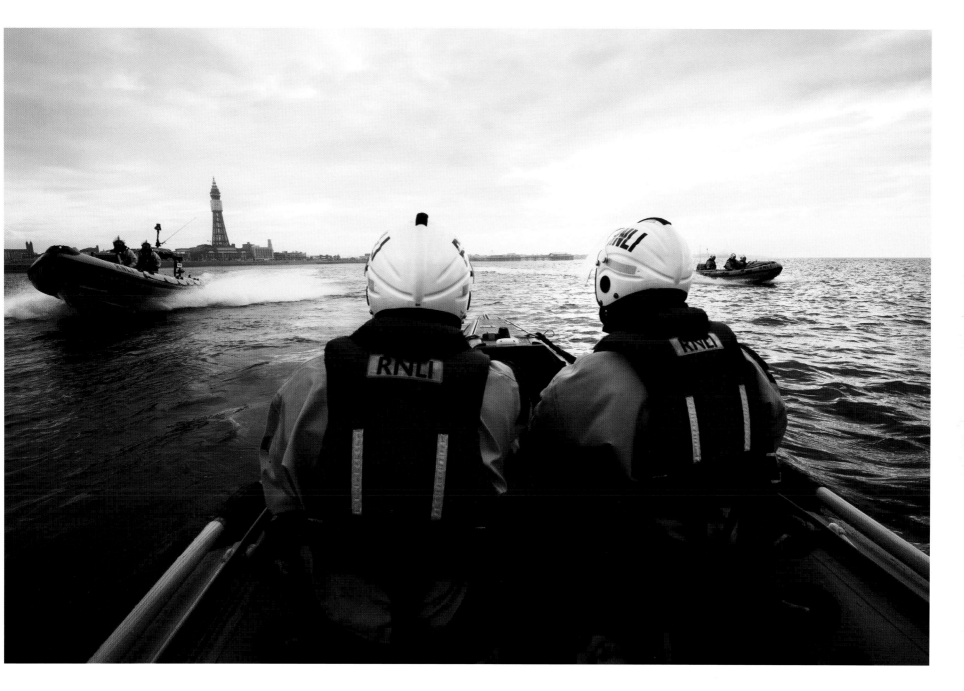

Blackpool is only one of two stations across the whole of the RNLI that has three inshore boats — an Atlantic 75 and two smaller D class lifeboats.

Today our coastal communities are sadly no longer the home of mighty fishing fleets, so volunteers that man the boats and shorecrew are drawn from all professions. Islay crewman Jonnie Fletcher, for example, works as an airport fireman. Richard Cameron, Islay crewman, works at the nearby Caol Ila whisky distillery.

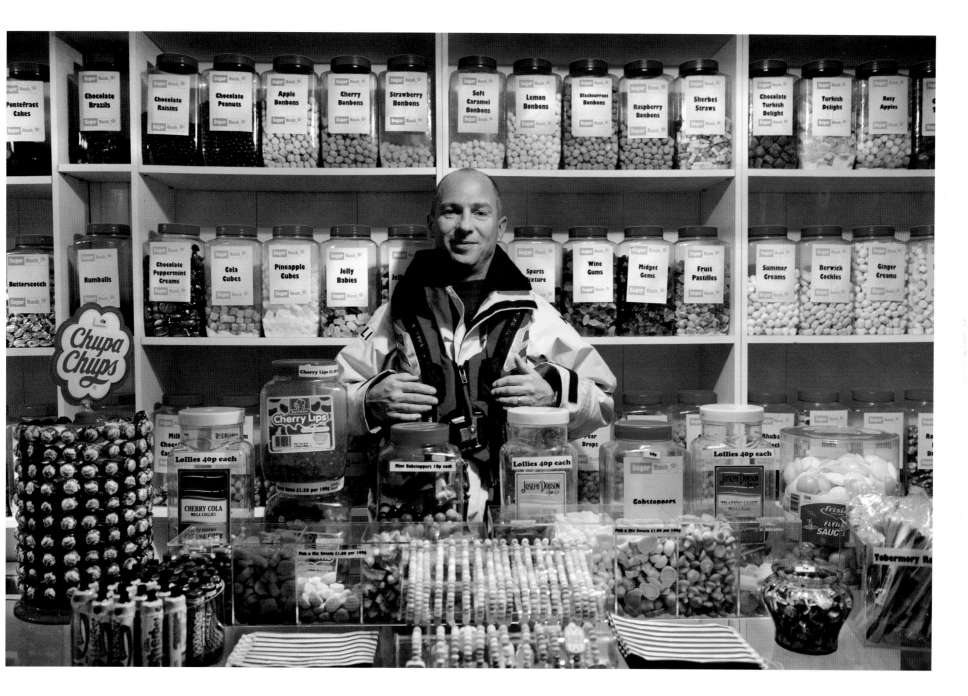

Crewman Robin Harrowsmith at Tobermory runs a sweet shop, popular with locals and tourists alike, and fans of the 'Balamory' television show too.

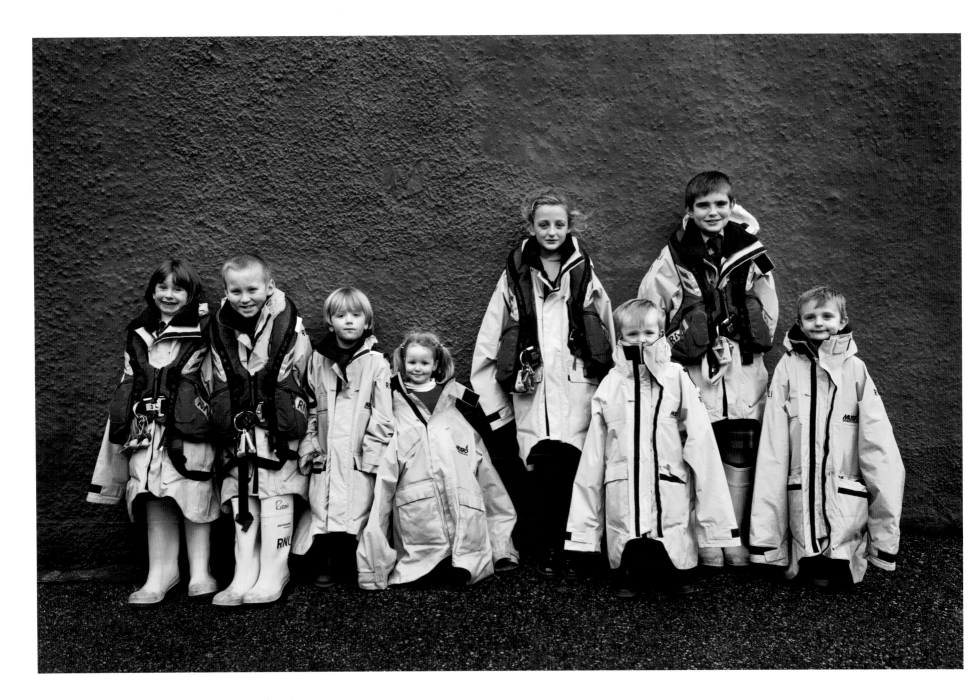

Children of the Tobermory crew try out their parent's kit. In a small community like this, it is almost certain that one of these youngsters will join the lifeboat one day. From left to right, Orla, Bobby, Oran, Evie, Nina, Hugh, Alexander and Seonaidh.

At Tobermory, the capital of the Isle of Mull in the Scottish Inner Hebrides, colourful houses line the harbourside. The Severn class *Elizabeth Fairlie Ramsey* came on station here in 2003 and has carried out a number of rescues on this difficult coastline.

Top: Across heavy seas in the sound to Barra, one of the southernmost islands in the Outer Hebrides, where Severn class lifeboat *Edna Windsor* encounters all that the worst Atlantic storms have to offer.

Bottom: In kind conditions, Barra crewmembers are using their boarding boat to escort a yacht into safe water.

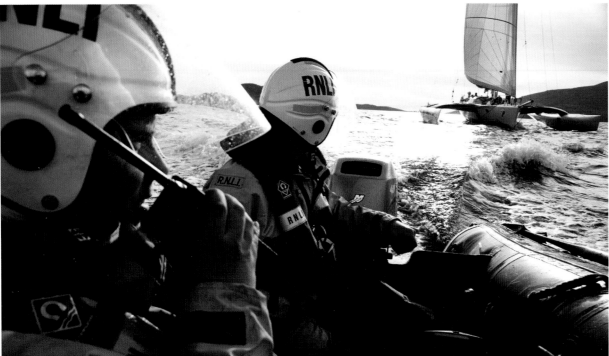

Opposite: Barra coxswain Donald MacLeod was awarded the Bronze Medal for gallantry, after his rescue of the Dutch racing yacht *Vijaya*. She had pitch-poled stern over bow in prodigious seas and her skipper was badly injured. The lifeboat had also been knocked-down 100 degrees on her port side, but came straight back up for more, and then led the yacht to safety. In the lifeboat, the crew had been strapped into their seats for over three hours. After the ordeal, MacLeod gave this typically modest summary: 'Yes, conditions were pretty poor. It was probably the worst service I've done.' One of his crew put it another way: 'If that man was going to hell and back in a boat, I'd be right behind him. We'd never doubt his leadership, one second.' Within 40 minutes of returning to the shelter of Castlebay, the lifeboat was cleaned, refuelled and ready for service once more.

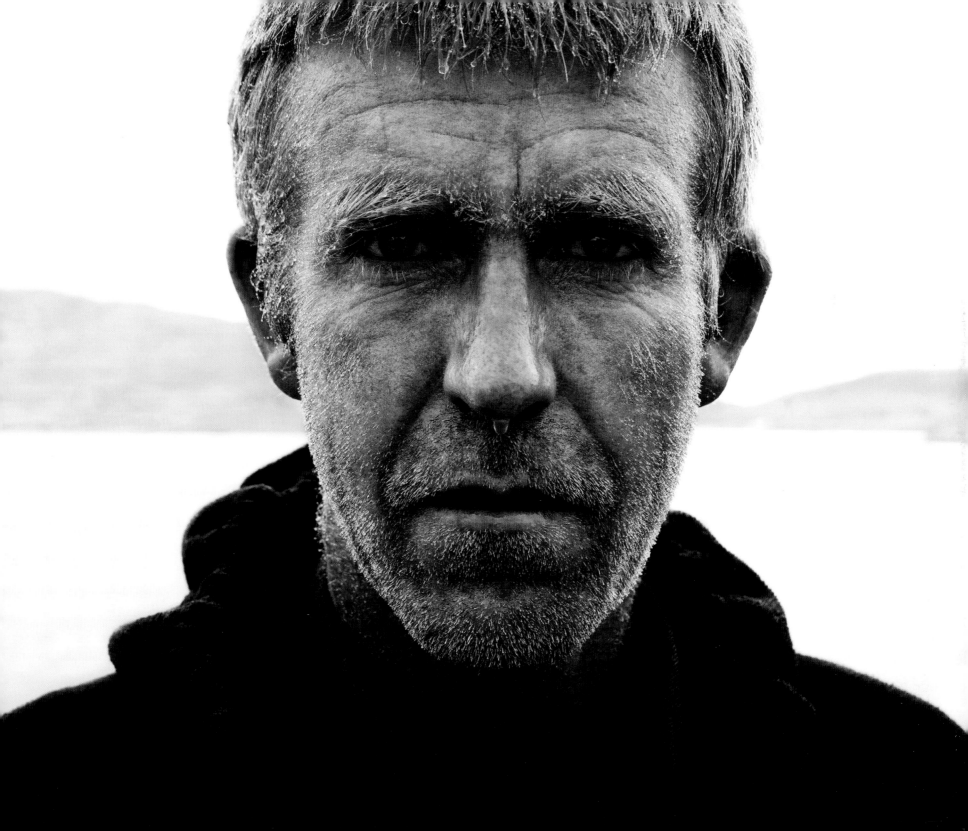

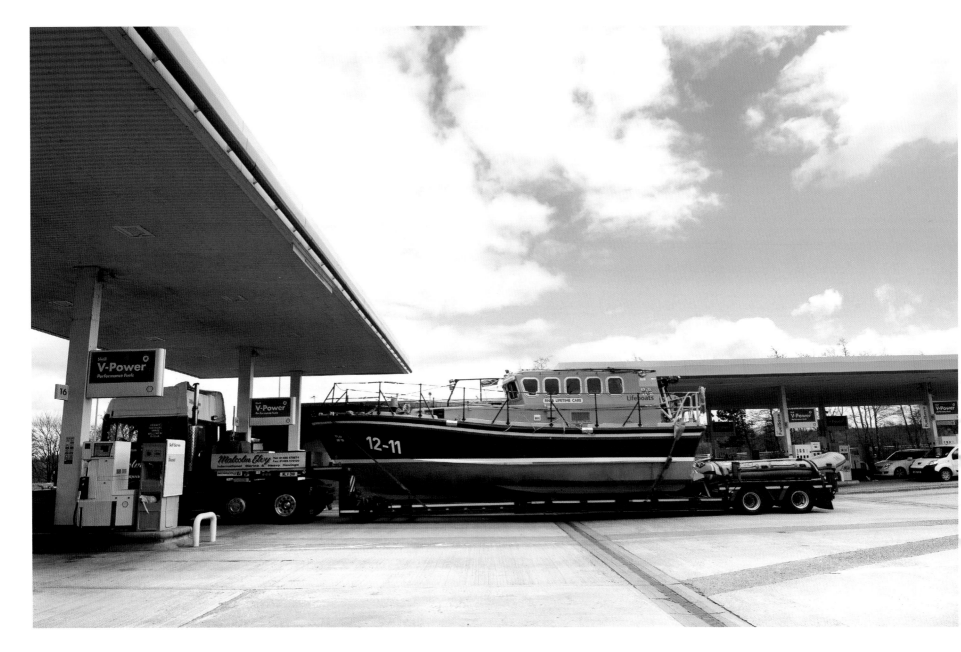

Mersey class lifeboat *Lifetime Care* is transported north to a temporary home on the Isle of Harris. This is just one of many hundreds of major boat movements every year, by sea and land, that sees the relief fleet used to ensure continuous rescue cover as other lifeboats come off station for repairs or planned maintenance. In 2012 the fuel bill alone, including these extensive and vital overland logistics, was over £1 million. It is no wonder then that fundraising is so necessary to keep the RNLI moving.

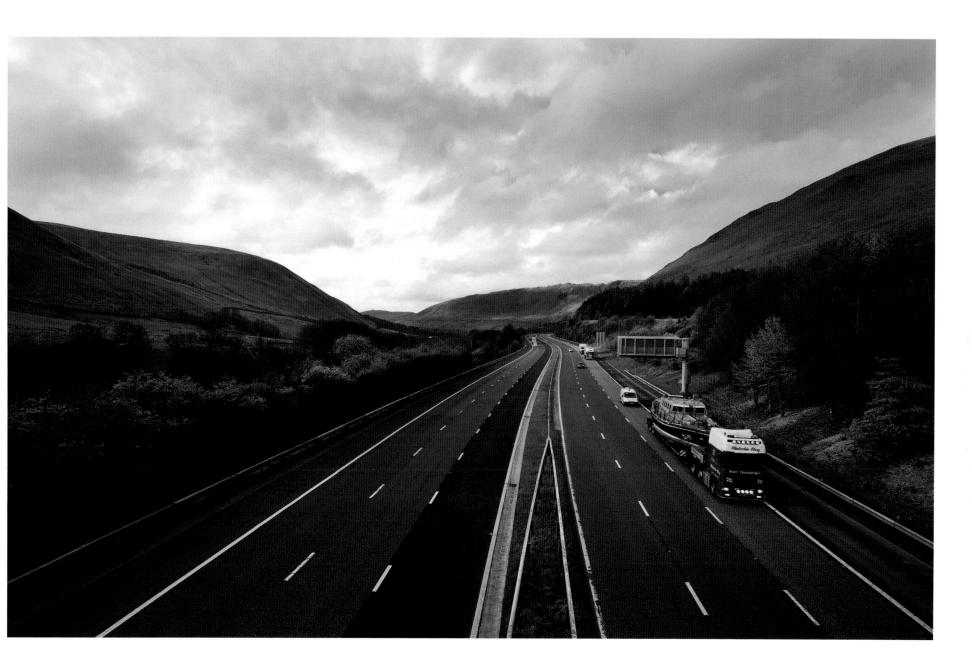

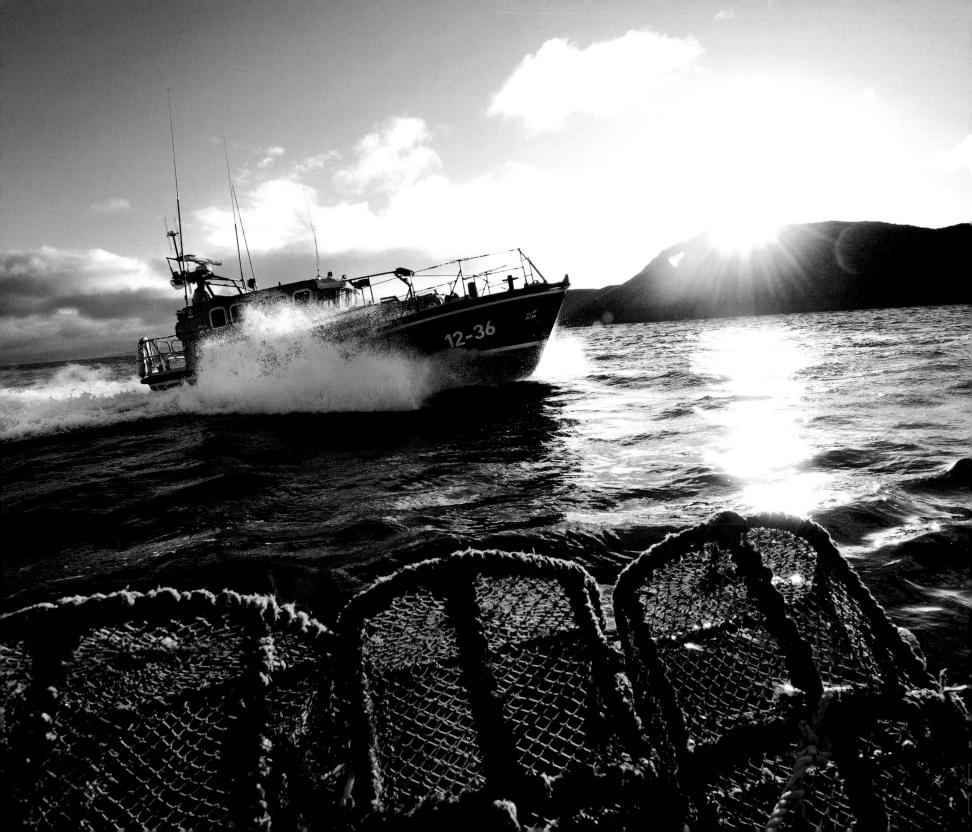

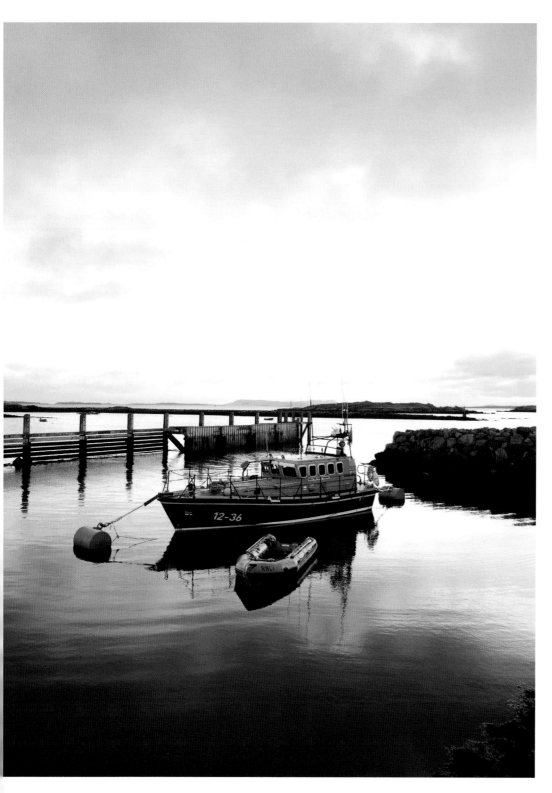

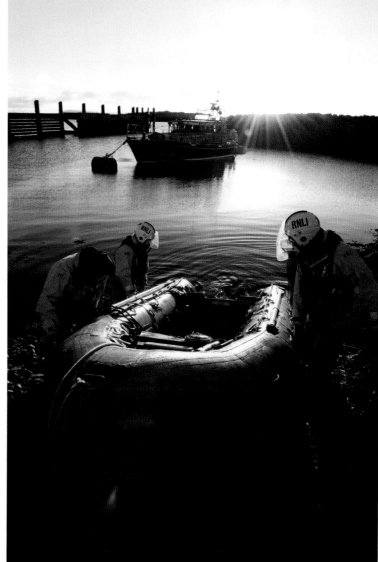

Leverburgh is one of the RNLI's new stations. It opened only on trial in May 2012, but by the end of the year they had already launched on shouts eleven times. The new station fills a gap in the coastal cover here, with Stornoway to the north and Portree and Barra to the south. The growth of offshore fish farms and renewable energy projects, and increasing leisure craft, has prompted the call for the new boat here, driven by the local community who really pushed for it to happen. It is the first new all-weather lifeboat station in Scotland for 22 years.

Opposite page: In the Sound of Harris, the Leverburgh lifeboat *The Royal Thames* is out on exercise.

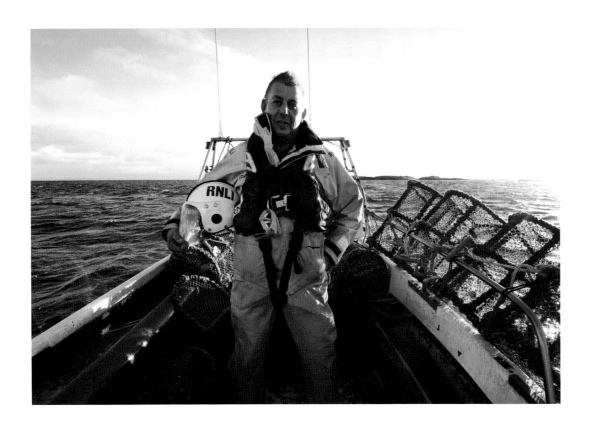

Leverburgh coxswain Mike
Green is a fisherman, whilst
crewman Kenny Macleod is a
crofter on Harris.

The new Leverburgh crew refuelling on tea and bacon butties after an evening exercise.

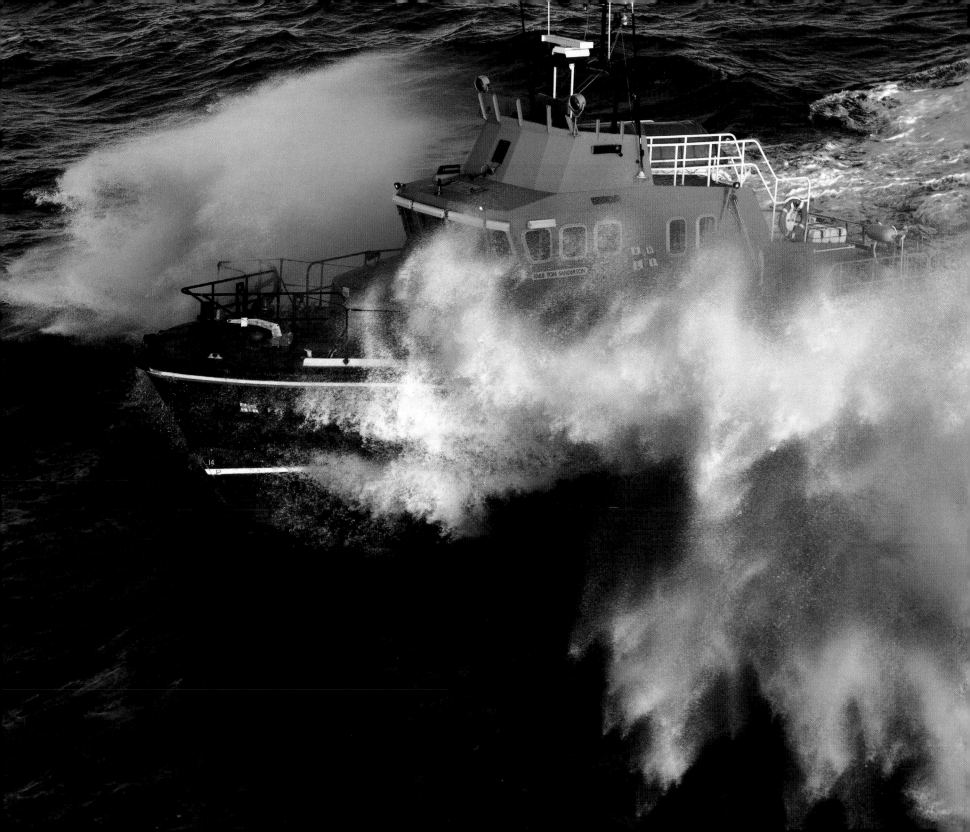

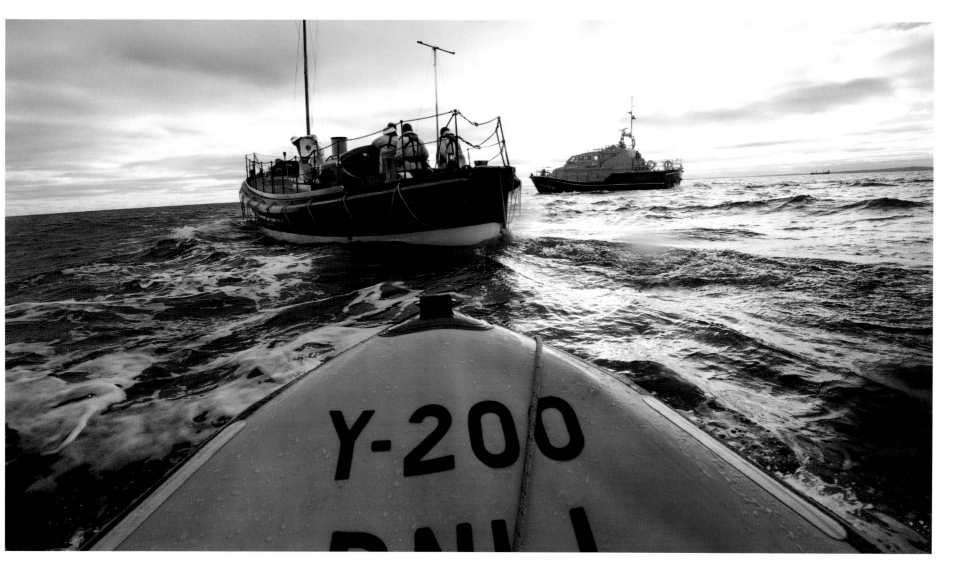

Opposite: Stornoway Severn class *Tom Sanderson* takes on fierce conditions in the north Atlantic beyond the Isle of Lewis.

Generations of Longhope lifeboatmen have guarded the waters of Pentland Firth since 1874, the scene both of heroism and tragedy. On the night of 17 March 1969, the Longhope Watson motor lifeboat *TGB* launched to go to the help of the Liberian steamship *Irene*. At the lifeboat's helm was coxswain Dan Kirkpatrick, one of the most decorated of all Scottish lifeboatmen, being awarded the Silver Medal for gallantry three times. The previous year he had launched in the dead of night to rescue fifteen men from a stricken trawler *Ross Puma*, though he hadn't yet had the time to go and collect his medal. He would never have that chance, for the lifeboat capsized in the maelstrom that night with the loss of all eight crew. The lifeboatmen who gave their lives alongside coxswain Dan Kirkpatrick were second

coxswain James Johnston, bowman Ray Kirkpatrick, mechanic Robert Johnston, assistant mechanic James Swanson, and crewmembers John Kirkpatrick, Robert Johnston and Eric McFadyen.

In the aftermath of the tragedy in such a small community, thoughts turned in particular to the bereaved families. Margaret Kirkpatrick and Maggie Johnston had both lost a husband and two sons. The current coxswain at Longhope, Kevin Kirkpatrick, is the grandson of Dan, and he also lost his uncle and father in the 1969 disaster. The crew will never forget the selfless dedication of those men who went before them and they honour their memory by serving on the boat with an equal determination. In the local cemetery is a fine memorial with a bronze statue in the form of a lifeboatman gazing out to sea, placed at the head of the graves of the eight men. At its base, a bronze plaque, which reads: 'Greater love hath no man than this, that he lay down his life for his fellow men.'

As the crew prepare to head out to sea on the Aith Severn class *Charles Lidbury*, they leave footprints in the snow. Aith is the most northerly lifeboat station in the British Isles, fifteen miles north-west of Lerwick, capital of the Shetland Islands. Moored alongside a jetty in Aith Voe, the lifeboat occupies a prominent position right in the heart of the community and faces some truly wild weather in its operations.

It wasn't until the 1930s that the first lifeboat station was established in Shetland, though for some time the RNLI had been looking into the possibilities of doing so. With shipping in the area increasing, and with communication technologies also improving, it was settled that a station would be opened at Lerwick on the east coast but by a strange, tragic twist of fate, there was a shipwreck and this resulted in the forming of a second station here.

On the night of 28 March 1930, an Aberdeen trawler *Ben Doran* ran aground on the Ve Skerries, tiny rocky islands to the west of Aith. Their plight was not seen until the next day, when another trawler spotted the stranded vessel, but in heavy seas and a full gale, her crew could do little to help, save hurry back to port to report the emergency. Several motor-boats put to sea, but they too were unable to get close to the wreck. The nearest lifeboat at that time was at Stromness, almost 120 miles away. Her crew eventually reached the *Ben Doran*, only to find that the trawler had already broken up and her crew of nine had all perished.

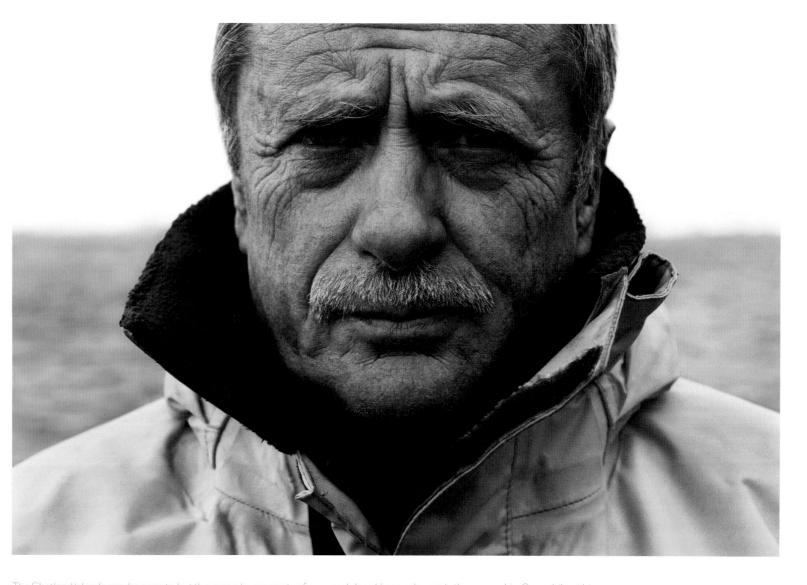

The Shetland Islands may be remote, but they see a huge variety of seagoing commercial traffic. Mariners in these waters face some of the toughest sea conditions as may be experienced anywhere. Having had an Arun class lifeboat, the *Soldian*, for almost twenty years, Lerwick was one of the earliest stations to be allocated the Severn class, the largest in the fleet and the most powerful RNLI lifeboat ever built.

The most recent time the RNLI's Gold Medal for bravery was awarded was for a rescue off the Shetland coast on 19 November 1997. Celebrated coxswain Hewitt Clark, already the holder of a Silver and three Bronze Medals, drove the Severn class *Michael*

and Jane Vernon alongside the cargo ship *Green Lily*, within yards of the granite cliffs in a near hurricane, to pull five of her crew to safety. The decision to launch had been made after it appeared all hope had gone. The Coastguard Sea King rescue helicopter managed to lift the remaining ten crew off the vessel but tragically in doing so, the winch-man, William Deacon was lost. In the violent winter storm, reaching force eleven, 50 ft seas broke over the lifeboat however they eventually made it home to safety. It was a service that well sums up the story of the RNLI — with teamwork, commitment, and an immense amount of courage, they achieved the extraordinary.

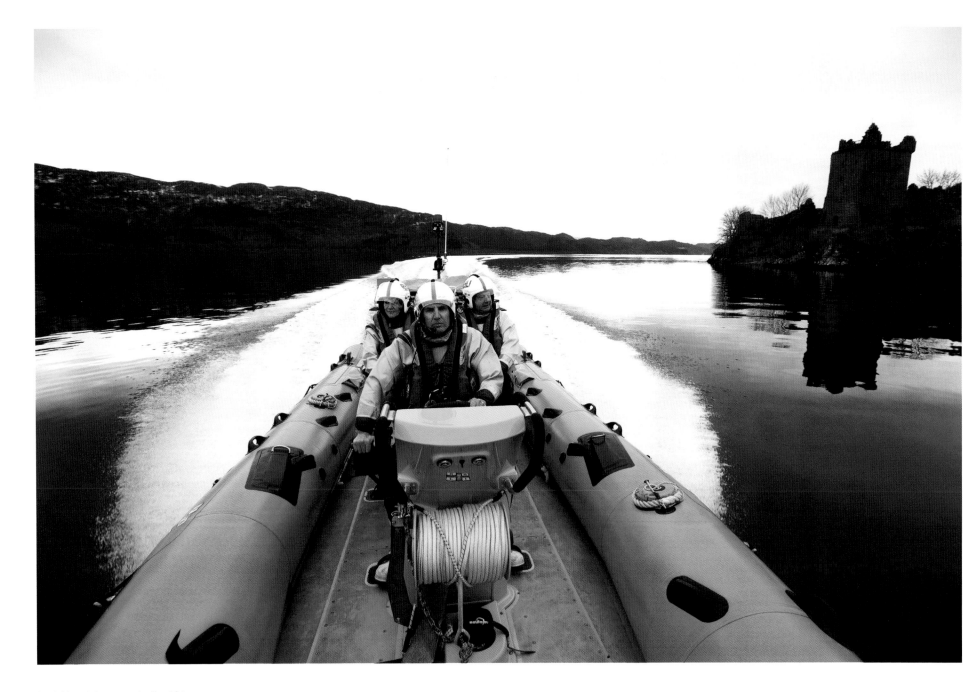

Loch Ness is home to the first lifeboat on
the inshore waters of Scotland. The station
operates an Atlantic 75, the *Thelma Glossop*.

Established in 1858, Fraserburgh was Scotland's first lifeboat station and in its illustrious history has encountered more than its fair share of disaster. The first motor lifeboat, the *Lady Rothes*, was stationed here in 1915, bought by a local man to commemorate the saving of his daughter from the *Titanic*. But disaster struck in 1919 when it capsized in a ferocious north-easterly gale, killing the town's decorated coxswain Andrew Noble and a crewman. Noble had taken over as coxswain in 1887, and served throughout the transition from oar and sail power to motorised lifeboats. He had been at the helm of a pulling boat in 1909 when, twice the same year, he had earned the Silver Medal for bravery. In rescuing the crew of a herring boat, Noble's rudder yoke had been destroyed and he brought his men to safety at full stretch over the side of his lifeboat, working the rudder with his bare hands.

In 1953 the town was thrown into mourning once again, when in February six crew lost their lives after the lifeboat capsized within sight of the shore, trying to help fishing boats to safety at the harbour entrance. And a further tragedy struck on 21 January 1970, when the Watson-class *Duchess of Kent* lifeboat capsized while trying to help the Danish fishing vessel *Opal* 40 miles out into the North Sea. The lifeboat had pitch-poled, bow over stern, tossed by a gigantic wave. Five of her six-man crew were drowned. The bodies of four of the crew were found trapped inside the hull of the lifeboat when she was righted three hours later by a Russian cargo boat. Sole survivor John Jackson Buchan, who had been thrown clear in the capsize, hauled himself onto her upturned hull, until he was rescued by another boat that had been standing by.

The tragedy left five widows and fifteen youngsters without their fathers. The dead were coxswain John Stephen, the town's assistant harbourmaster; Fred Kirkness, the lifeboat's engineer; William Hadden, a Customs and Excise officer; fishworker James Buchan and toolworker James Buchan, who was reputed to have jumped on to the lifeboat as it passed the pierhead. He had just finished a night shift at the local factory and was walking round the harbour to clear his head before he went home when he heard the maroons go off. He started running and jumped on as it went past the harbour walls. His family never knew where he was as he never came home from work. Survivor Jackson Buchan died in 1999. He was a well-known taxi driver in the town, but never spoke of the tragedy.

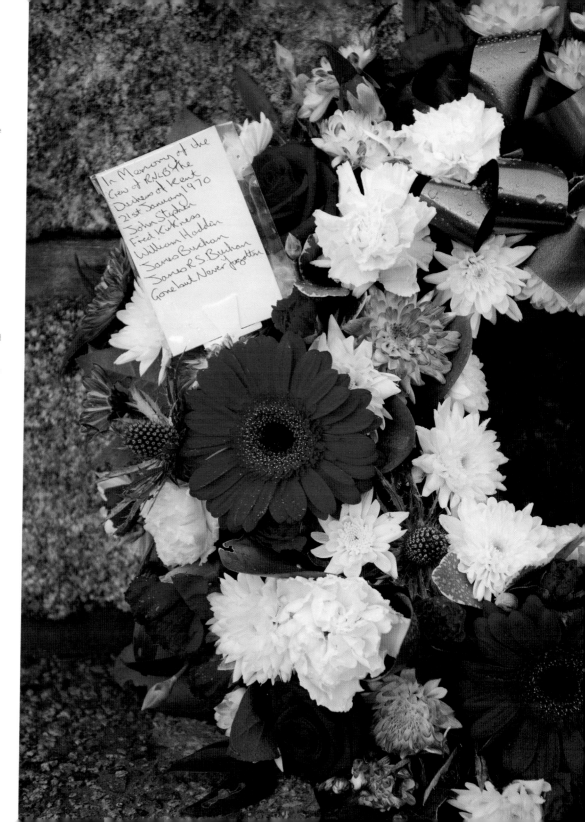

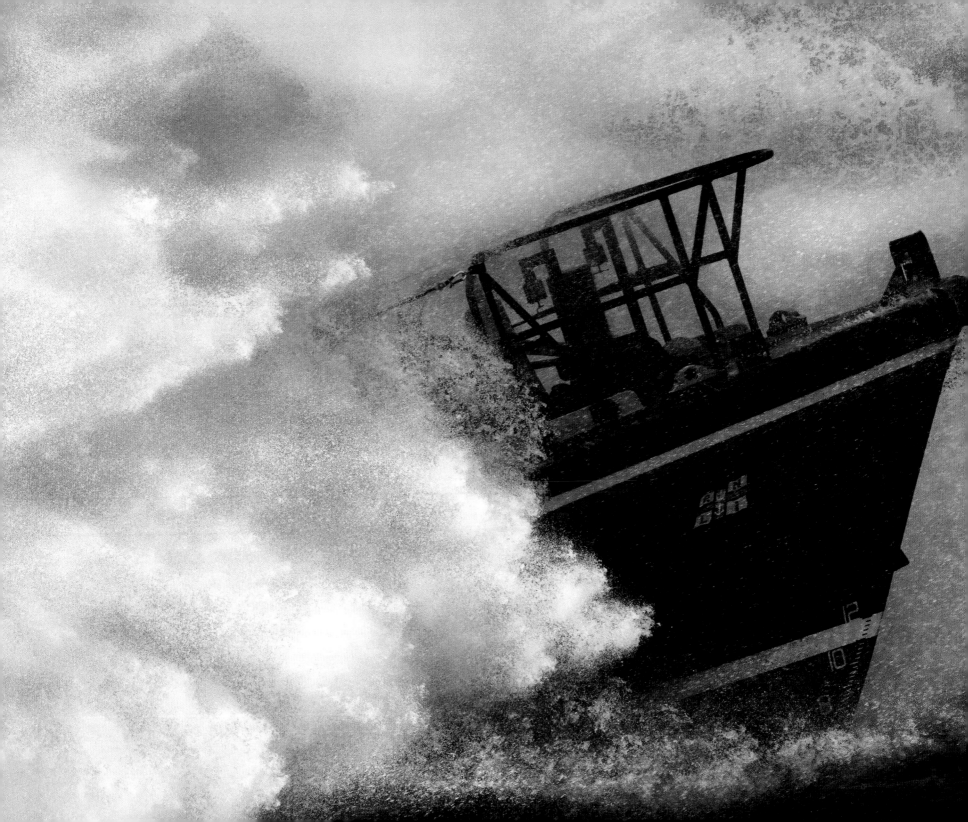

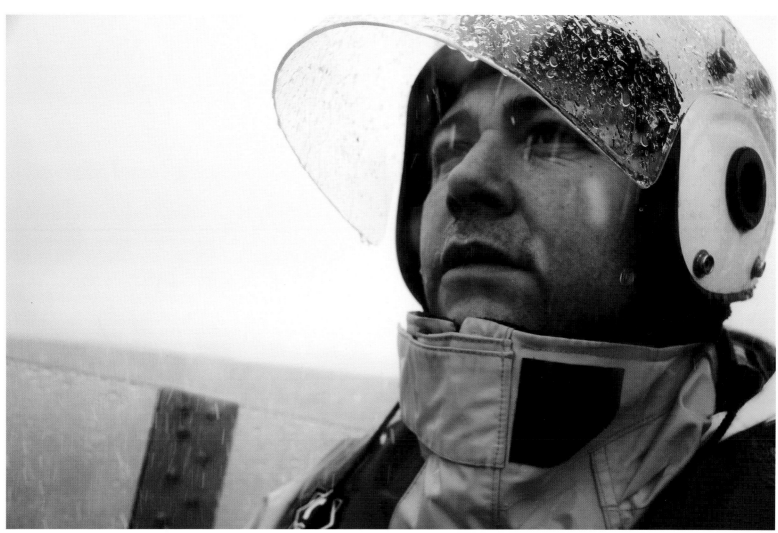

Dunbar got its first RNLI lifeboat in 1865. Named the *Wallace* — gifted to the town by a wealthy lady descended from the legendary William Wallace — she had ten oars and was equipped with sails. Much has changed since then, though the commitment and efforts of the crews here remains much the same.

Coxswain Gary Fairbairn was awarded the Bronze Medal for Gallantry after he rescued a husband and wife from their Swedish yacht *Ouhm* during a severe gale-force storm. The Dunbar lifeboat *John Neville Taylor* was twice knocked onto its side in the terrible conditions, but he managed to drag the pair aboard. At one stage, the lifeboat was hit on her starboard side by a huge breaking wave, and her portside wheelhouse windows were completely underwater. 'I take my hat off to my crew though, they were amazingly brave that day', Gary recalls. 'In all my 30 years of being on the seas I've never encountered conditions like that.' Gary certainly has the lifeboat spirit in his blood — his great-grandfather Walter Fairbairn was awarded a Silver Medal in 1905 after he helped save the lives of six men from a stricken steamship in a northerly gale.

Left: The Dunbar Trent class *John Neville Taylor* is barely discernible as she cuts through a wild North Sea swell. The previous Trent lifeboat, stationed here for more than a decade, was wrecked after her moorings snapped during severe storms over the Easter weekend of 2008. She had launched 206 times and rescued 171 people.

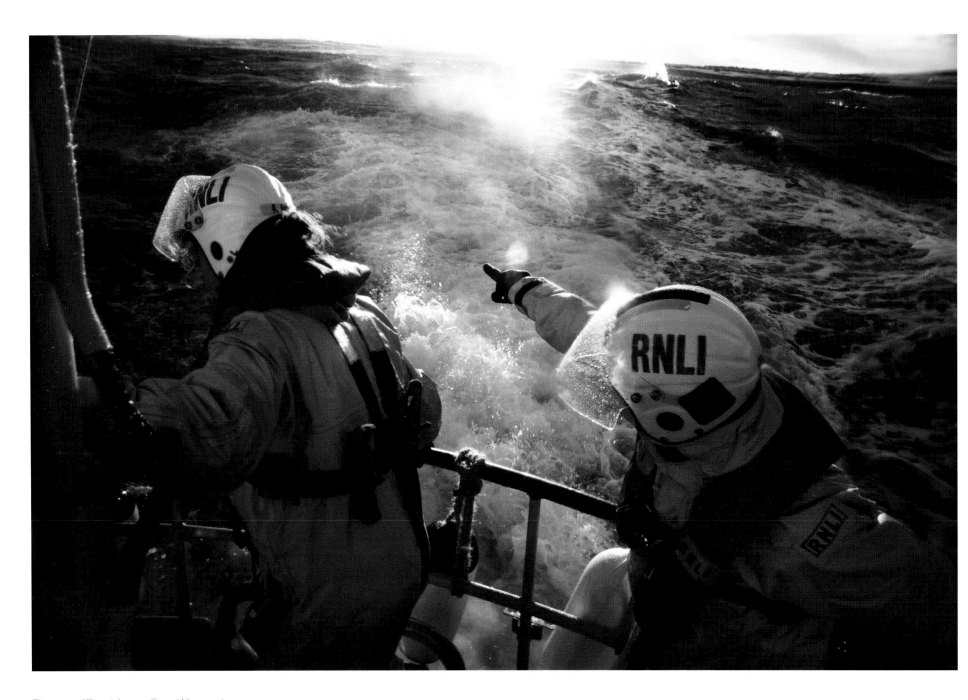

The crew of Berwick-upon-Tweed Mersey class
lifeboat *Joy and Charles Beeby* perform a
search and recovery exercise in heavy seas.

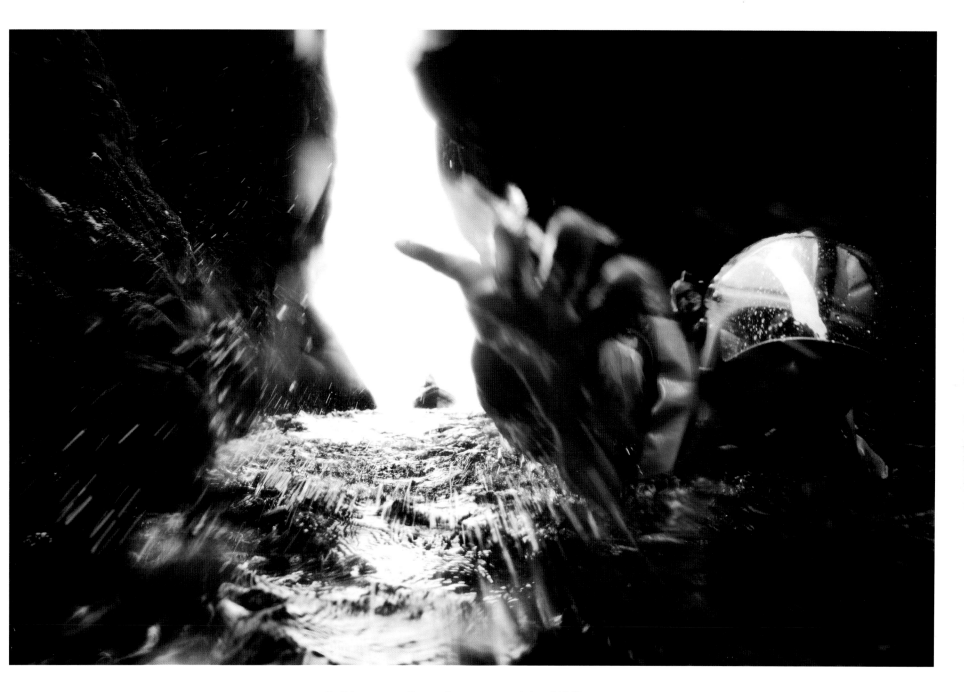

St Abbs crewman Darren Crowe was awarded the RNLI Bronze Medal in 2011. He swam through rough seas to rescue a fisherman who had fallen off the rocks and was trapped by rising waters in a cave. Darren is modest about his achievements: 'We are all volunteers, we're not in it for medals. What we did was just part of our job.' The survivor, Simon Haston, reflects: 'If the RNLI had not been there I would have died that day.'

SEAHOUSES TO TORBAY

CHAPTER TWO
SEAHOUSES TO TORBAY

By the end of the eighteenth century Britain was the centre of a rapidly expanding commercial world, a world whose future was afloat, and it was from these islands that shipping routes encircled the globe. The approaches to London, Liverpool, Manchester, Cardiff, Dublin and many other ports were thick with masts and sails, each vessel the source of much economic prosperity but also a potential victim of the tides and winds on which they depended for their trade.

In foul weather, the North Sea is notoriously one of the most hostile places for shipping to be found anywhere in the world. For centuries there has been an almost constant stream of vessels plying up and down the east coast of Britain, with their various cargoes – and it has been estimated that, in the last 500 years, in excess of 50,000 ships have been lost here.

In 1789 a Newcastle ship, the *Adventurer*, was wrecked near the mouth of the Tyne. From the shore people could see its crew dropping from the rigging into the raging sea, but no boat could put out to help them. The disaster induced a group of gentlemen to offer a prize of two guineas for the best design of what would in fact be a lifeboat. The winning design, after some slight modification, was entrusted to South Shields boat-builder Henry Greathead. His boat, aptly named the *Original*, was the first in the world to be designed and constructed purely as a lifeboat. She was launched in 1790 and remained in active service at South Shields for over 40 years. Greathead would build more than 30 lifeboats, paid for by private charity, and manned and administered locally. It was not for another 30 years after he had begun to build lifeboats that any attempt was made to create the national service we now know today.

On 4 December 1849 there was another disaster at the mouth of the Tyne. *Provident*, one of the two lifeboats kept at South Shields, was capsized soon after reaching the wrecked brig *Betsy*. She had a double crew of 24 men, mostly local fishermen, yet all but four of them were drowned. The tragedy was felt across the country, especially among seafarers, and it rallied the cause of the Institution. A new design competition was launched and after a huge number of entries and much debate, the prize was awarded to James Beeching, whose 36ft, twelve-oared, self-righting design was considered closest to the ideal for a lifeboat. His design formed the basis of the fleet for the next 50 years.

The tremendous improvement in the range, power, efficiency and strength of lifeboats since Greathead built the *Original* has been part of a continuous process. Indeed, the history of RNLI innovation in lifeboat design may be sketched as a series of outstanding milestones, which begins with the adoption of the self-righting lifeboat for general use, following the staging of a design competition, in 1851; the completion of the first steam-driven lifeboat in 1890; the fitting of the first petrol engine in a lifeboat in 1904; the first use of radio telephony in a lifeboat in 1929; the installation of a diesel engine in 1932; the fitting of twin-screw engines in the smallest class of lifeboat in 1936; the design and introduction of the Oakley self-righter in 1958 and the appearance of inshore lifeboats in 1963. Though costs have risen sharply, so too has the effectiveness and reliability of the service. Innovation continues in the form of the next generation of all-weather lifeboat: the Shannon class.

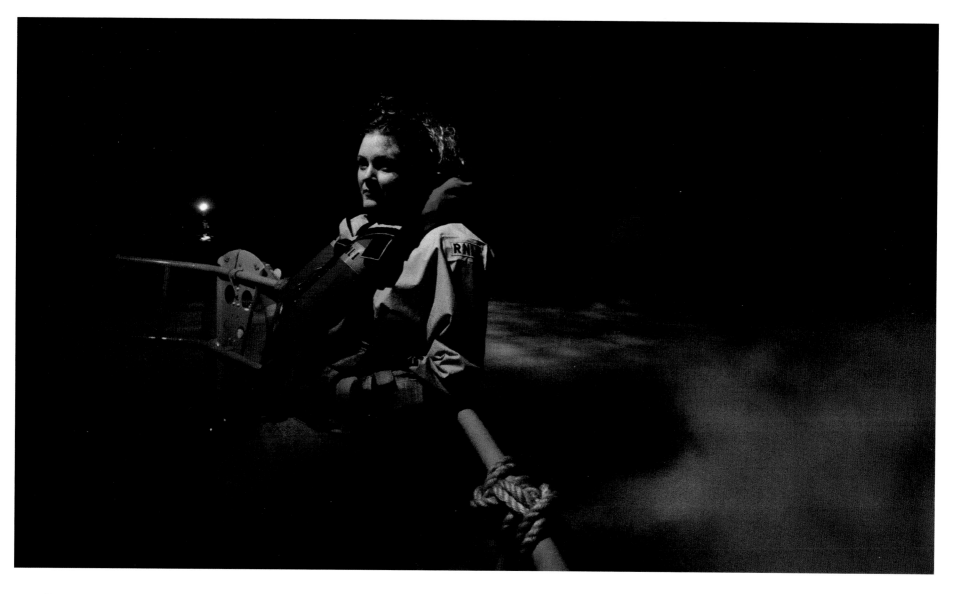

Previous page: On 6 September 1838, the paddle-steamer *Forfarshire* ran aground off the Northumberland coast. The Longstone lighthouse keeper and his 22-year-old daughter, Grace Darling, put out to sea in a small open boat, or coble, and saved nine survivors clinging to the rock. Though it was a terrible tragedy — the steamer broke in half after hitting the rocks of the Farne Islands, and most of the passengers were lost — Grace's doughty actions inspired the public and focused attention on saving lives at sea. She was awarded the RNLI's Silver Medal, the first female medallist.

A fearless girl who became a reluctant celebrity, she sadly died of tuberculosis only four years later. She was rightly regarded as a heroine for her actions and provides a reminder into the modern day that the work of rescue at sea is the responsibility of everybody, not just one organisation. Over 160 years later, the lifeboat *Grace Darling* operates at nearby Seahouses lifeboat station and a nearby RNLI museum tells Grace's story.

Teacher Kerensa Airey is a crew member on the Seahouses Mersey class *Grace Darling*. The light from the Longstone can be seen beyond her, piercing the dark night.

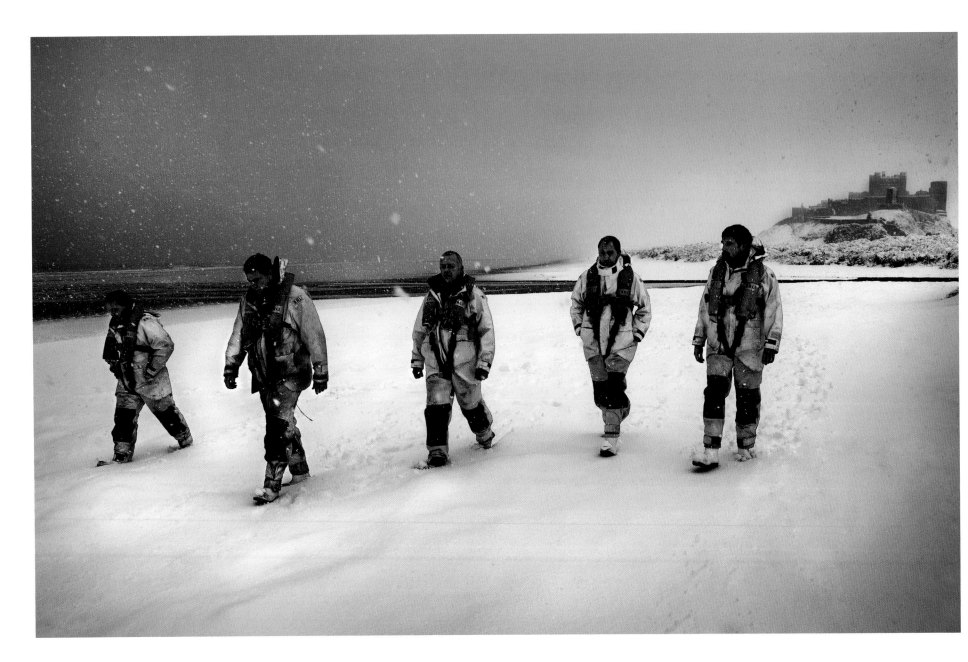

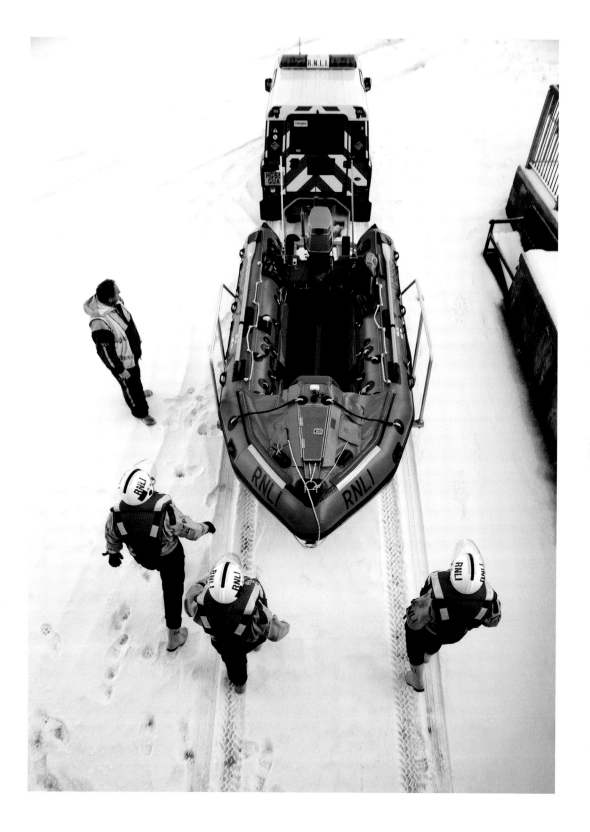

Left: The crew returning through the snow near Bamburgh Castle in Northumberland after a search exercise on the beach. One of the first lifeboat stations in Britain was established in the late eighteenth century at Bamburgh from the proceeds of a charitable trust set up after the death of the Bishop of Durham, to render help in case of shipwreck. A lookout system was established at the castle with its view over the treacherous Farne Islands, whereby horsemen were sent out on patrol when the weather turned bad to keep an eye to the sea for ships in trouble.

In 1786 the trust asked a London inventor, a coachbuilder by the name of Lionel Lukin, to develop his ideas of making an unsinkable boat using cork and watertight buoyancy chambers and to test it using one of their small local boats, a coble. His 'unimmergible' boat proved successful, giving volunteer rescuers confidence enough to take on heavy surf and high winds, and there was a rescue boat to Lukin's design at Bamburgh for many years after this.

Right: The Seahouses D class inshore lifeboat *Peter Downes* being towed through the snow along the harbour just before launching. The lifeboat was named in memory of a Sutton Coldfield man who died following a diving accident in the English Channel in 2002. Mr Downes' wife Carolyn felt something positive should come out of her husband's death and she was instrumental in raising the money for the new boat.

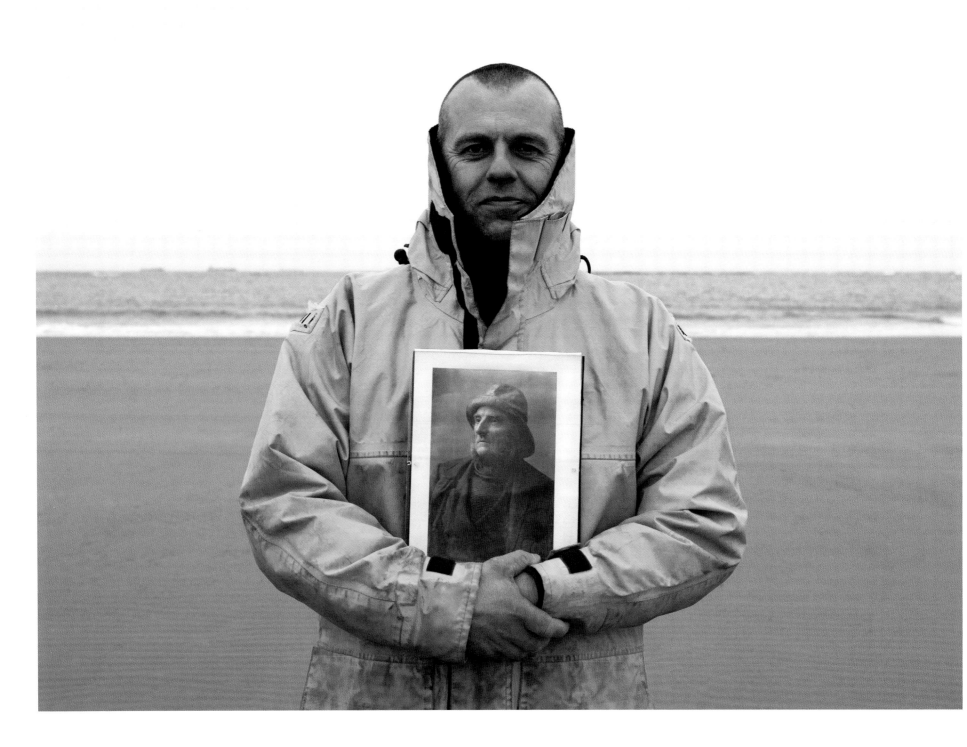

Top right: A little rain never stops RNLI fundraisers from shaking their buckets with a smile on their faces. Here, on the Parade at Oadby on the outskirts of Leicester, volunteers Derrick Young, Sheila Harrison, Sarah Bailey, John Harrison, and Chris Young are all set for another wet afternoon's effort, like generations before them. Though it is about as far from the coast as you can get in England, the Leicester Branch has done some fantastic work providing the RNLI with funds for some 14 lifeboats over the years. Redcar's Atlantic 85 *Leicester Challenge III* is the latest to be supported by the kindness and generosity shown by the public.

Left: At Redcar, we meet Mike Picknett, the senior helmsman who has been a volunteer here for almost 30 years. He was recently awarded the British Empire Medal for his services to the lifeboat. Dave Cammish, Lifeboat Operations Manager at Redcar tells us: 'Everyone at the boathouse is delighted for Mike. He's a good example of what makes the RNLI tick. It's all about commitment, dedication and, when it's called for, courage.' He holds a photograph of Thomas Hood Picknett, his great-great-great uncle, and the coxswain of the first *Zetland* lifeboat.

Right: The oldest surviving lifeboat in the world, the *Zetland*, can be seen today at Redcar in North Yorkshire. She was built in 1802 to Henry Greathead's design and served the town for over 70 years, launching for the final time in 1880. She saved more than 500 lives.

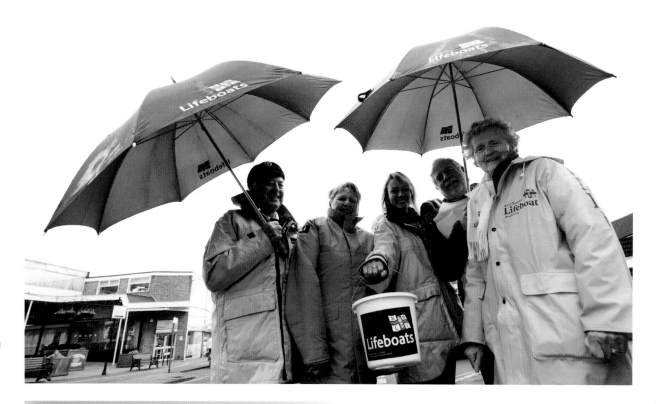

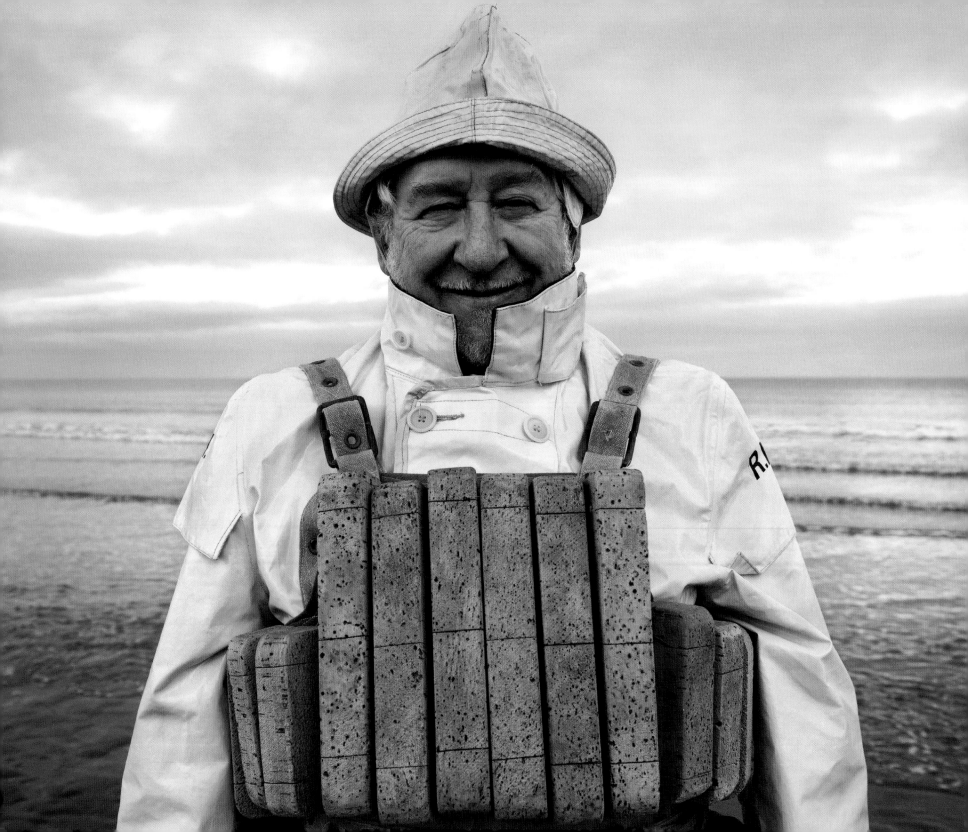

In the early years the chances of survival for any man thrown overboard were never good, especially as most could not swim. The first buoyant cork lifejackets were gradually introduced from 1854, though they were particularly uncomfortable to wear, especially for a man rowing hard on an oar. On 9 February 1861, when Whitby's lifeboat capsized on duty, just one crewmember survived. Henry Freeman was the only man wearing the new experimental lifejacket. It was his first day volunteering in the lifeboat.

A storm had been building and when dawn broke the lifeboat was launched. By early afternoon, five crews had been saved from fishing boats caught in the gale and the lifeboatmen were exhausted by their battle with the raging seas. Two schooners were then seen being driven onto the shore north of the piers. One of them succeeded in crossing the harbour bar to safety, but the other, the *Merchant*, began to drift toward the beach. The lifeboat crew put to sea again, pulling hard on their oars through the breakers but they capsized just 50 yards from shore. Twelve lifeboatmen drowned within sight of their distraught relatives, who were among the hundreds who watched helplessly from the beach. The greatest tragedy of all was that the men had lowered their lifebelts, because they had rowed so much that day their arms were ripped raw with chafing.

Though devastated by the disaster, Freeman went on to honour his lost friends by spending more than four decades in the service. As coxswain for 22 years he saved countless lives. A bronze sculpture of Freeman is now proudly displayed on the wall of Whitby's lifeboat station, which opened in 2007. He wears his trusty cork lifejacket and the Silver Medal for gallantry he was awarded after the tragedy. Overlooking the harbour, his weather-beaten face stares out past the piers, to the North Sea, the cause of so much heartbreak and heroism over the centuries.

Whitby crews were involved in one of the most outstanding lifeboat rescues of the First World War, on 30 October 1914. The hospital ship *Rohilla*, on her way to Dunkirk to evacuate wounded soldiers, ran into a reef and broke in half in a fierce gale. Six lifeboats, including two from Whitby and others from as far afield as Tynemouth and Scarborough, rescued 85 people in an endeavour that lasted almost three days in the most severe conditions.

Left: Former coxswain at Whitby Pete Thomson restored the *William Riley* lifeboat, which was on service here until 1931.

Below: RNLI lifeguards begin their day's work at the beach in Scarborough by marking out a safe swim zone with their distinctive red and yellow flags.

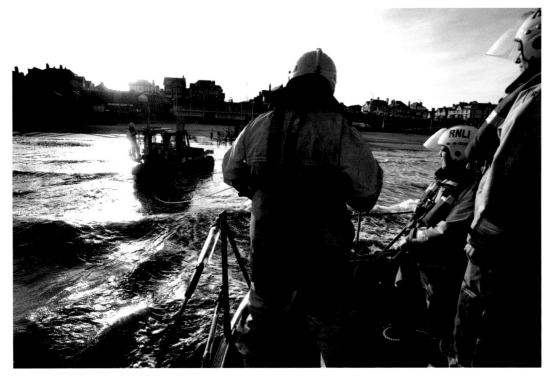

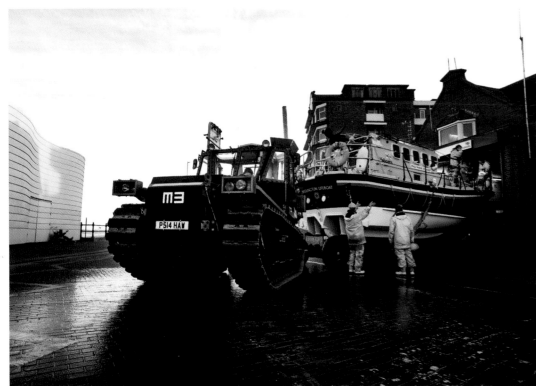

At Bridlington, the Mersey class *Marine Engineer* is quickly launched from the beach. In recovery, it's a slower process needing patience and accuracy from the wide-ranging shore crew. It's a snug fit in this boathouse.

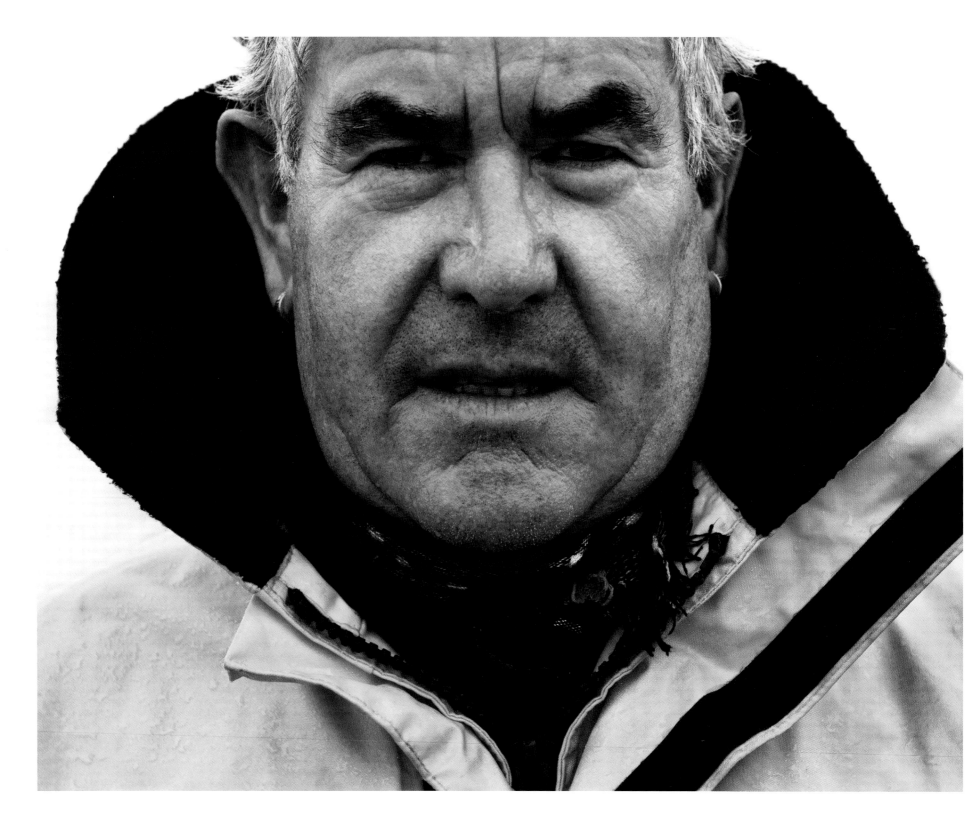

A lifeboat station sits at the end of Spurn Head, a curving peninsula of gravel and sand formed by the endless movement of sea and river. For many years this has been the home of the only full-time coastal lifeboat crew. Alongside the deep-water channel of the Humber Estuary, with quick access to the North Sea beyond, it is a well-chosen spot, though remote. But when the weather turns wild it is a tough place indeed.

Brian Bevan was only 28 when he was given the post as new Superintendent Coxswain here in 1975, which also made him the youngest coxswain in the country at the time, and it was not long before he was making even more impressive records at sea. In 1979 he became the first man to be awarded RNLI Bronze, Silver and Gold Medals for Gallantry in a single year — in fact, all within less than two months. He had at his command a new Arun class, the *City of Bradford IV*. Capable of 18 knots and with a watertight wheelhouse and new electronics, she was the most advanced lifeboat yet built. Though traditionalists might have doubted a large boat built from fibreglass, rather than mahogany as in the days of old, she would soon prove her mettle.

On New Year's Eve in 1978, Bevan launched in a strong gale to the aid of the *Diana V*, a Dutch coaster 28 miles away, and after three very difficult approaches managed to take off six people, including a young girl. It earned him a Silver Medal. On 15 February, the Romanian freighter *Savinesti* suffered from engine failure, 37 miles from Spurn Point. The Wells lifeboat launched in freezing temperatures and huge seas and stood by, before the *City of Bradford IV* took over. Coxswain Bevan escorted the ship to safety after fifteen hours at sea, earning a Bronze for his efforts.

But, it was the heroics of the previous night, Valentine's Day no less, that secured his place among the legends of the RNLI. *The City of Bradford IV* was nearly lost at sea when she had to be taken alongside the sinking motor vessel *Revi* 35 times in a north-easterly snowstorm to rescue four men. As the lifeboat was about to be crushed fatally, Bevan managed to pull her clear by a matter of inches. The skipper of *Revi* was hauled to safety minutes before the ship rolled over and sank. For their gallantry, the Humber crew were all awarded RNLI Bronze Medals too.

Right: The current Superintendant Coxswain at Humber is Dave 'Spanish' Steenvoorden. He came here over twenty years ago as a crew member and he took charge in 2004. He used to work as an offshore fisherman, now he has his hands full in the daily running of the station. There is little time off here, even at Christmas, when the weather is often at its worst.

Following page: A few months later, down the coast in Skegness, we join Mersey class *Lincolnshire Poacher* as she is recovered after a successful exercise. The crew are onboard until the carriage arrives to pull them up the beach to the boathouse.

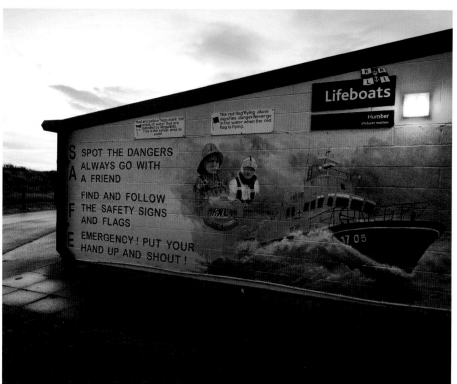

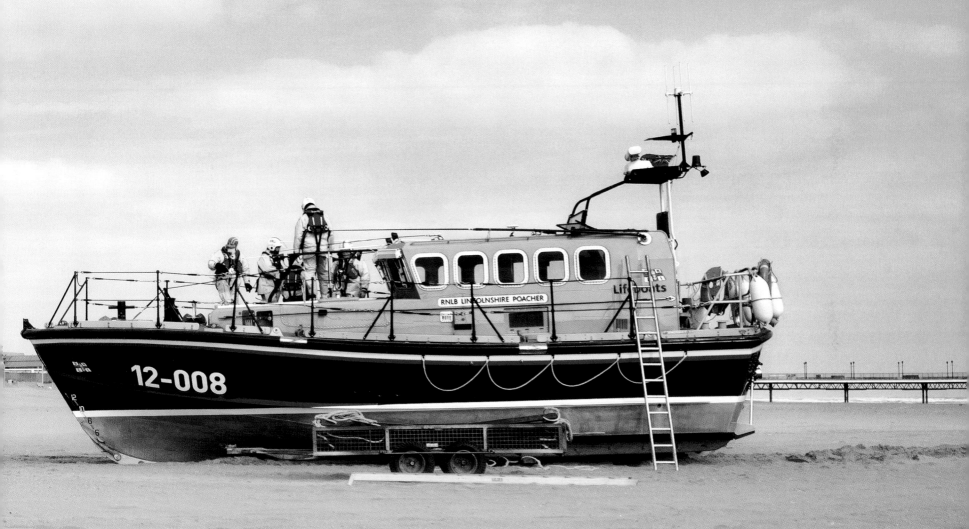

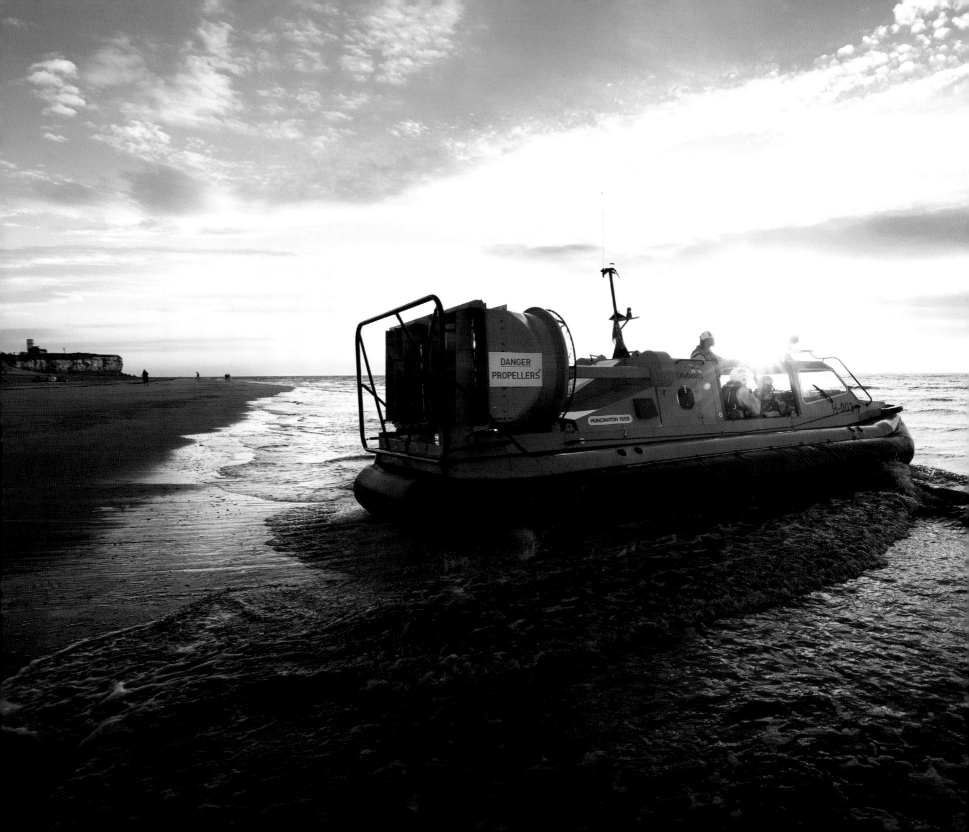

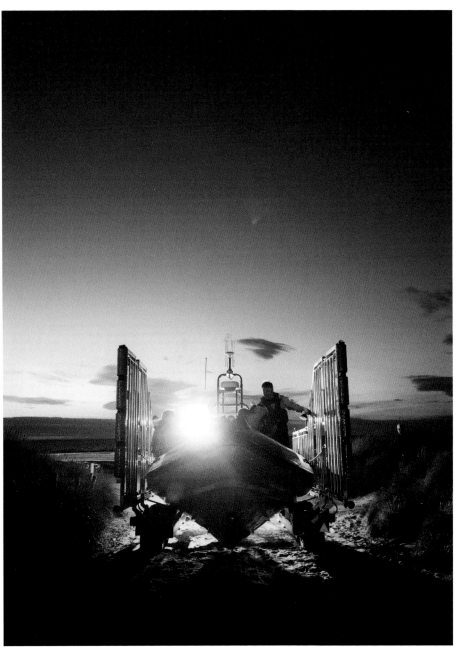

The dangerous sands of the Wash and the strong tidal streams in this bight make the waters off Hunstanton in north Norfolk particularly challenging. The first RNLI lifeboat established here, financed by subscriptions from the Licensed Victuallers Society in 1867, was a self-righting pulling boat drawn by horse and carriage.

Today the dangers are met by the hovercraft *The Hunstanton Flyer*, one of only four in the country, and a new Atlantic 85 *Spirit of West Norfolk*. With a top speed of around 35 knots, the £130,000 inshore boat is packed full of the latest technology. She came on station in 2011 and her cost was met by generous local donations.

In the summer, this coast can be glorious. Yet, during the winter fierce northeasterly gales push the waters of the North Sea onto the north Norfolk coast, making a perilous lee shore for shipping. Known as the 'Devil's Throat', this coastline was littered with shipwrecks for centuries. The first lifeboat came to Wells in 1830 — one of the Greathead designs, paid for by the people of the town — and in 1869 the RNLI took over operations here. As is so often the case, the lifeboat has seen both success and bitter tragedy. On 29 October 1880 the *Eliza Adams* capsized when returning to shore and eleven out of her crew of thirteen were drowned. The disaster affected the whole community, leaving ten widows and 27 children fatherless, but they vowed to continue to man a boat.

Former Wells coxswain David Cox is rightly something of a local legend. He has been volunteering with the lifeboat here for almost 50 years. He joined as a launcher at eighteen and retired as coxswain. In 1979 he was awarded the RNLI Silver Medal in recognition of his determination and seamanship when his Oakley class lifeboat, the *Ernest Tom Neathercoat*, stood by the Romanian cargo vessel *Savinesti*, with 28 people on board, which had broken down and lost both her anchors. In a north-easterly hurricane and heavy snow, she was drifting 37 miles southeast of Spurn Point and was in grave danger of running aground on the Race Bank. Eventually, the Humber lifeboat arrived on the scene and was able to escort the casualty into the shelter of the River Humber.

When David brought his boat back into Wells, she had been at sea for over eleven hours in sub-zero temperatures and for the whole return journey snow had blown furiously into his open cockpit. The return of service report said it all: 'Wind — Force Eleven, Violent Storm, Visibility — Poor to Nil, Continuous Snow, Blizzard, Sea State — Phenomenal'. David chuckles when reminded of this. 'Yes, it was a pretty rough day alright. One of the worst in my life, I suppose, but we just had to have a go. I had a nice hot bath when I got home, that's for sure.'

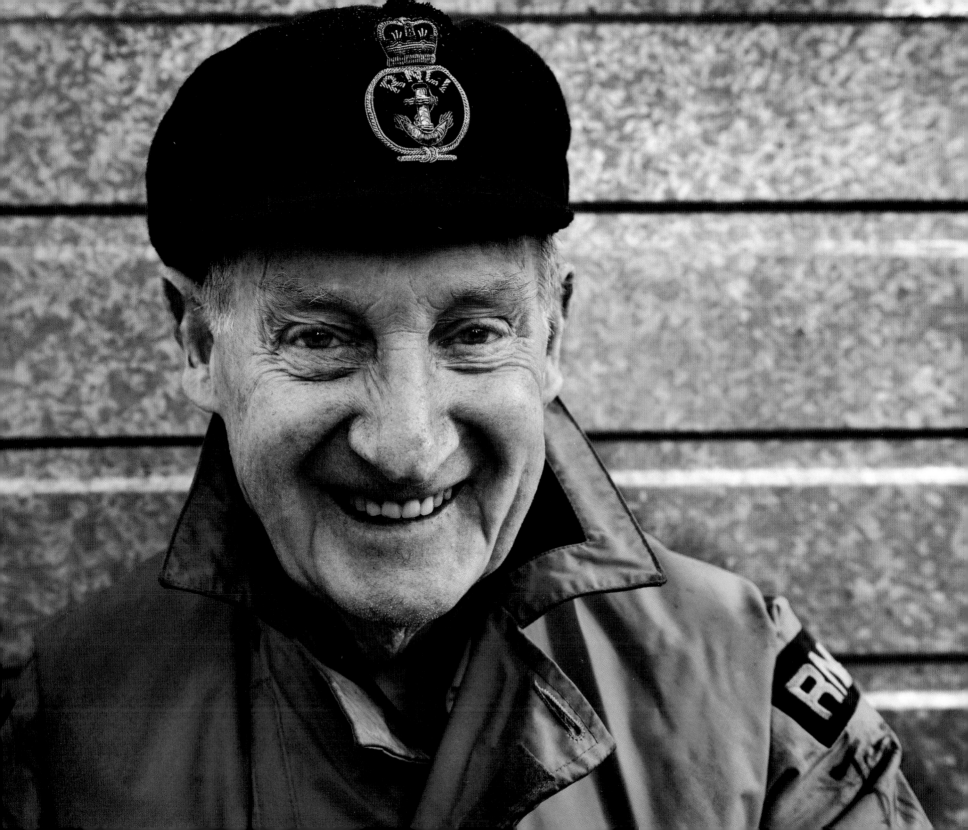

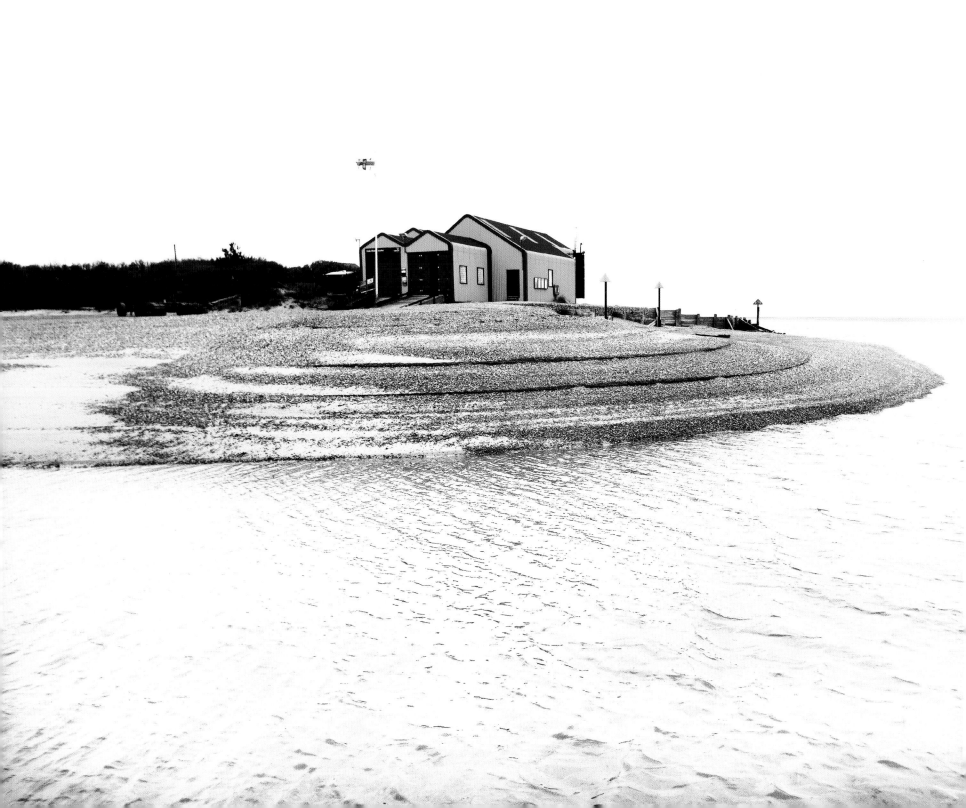

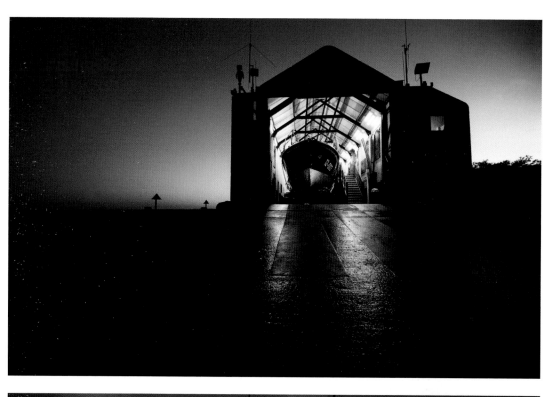

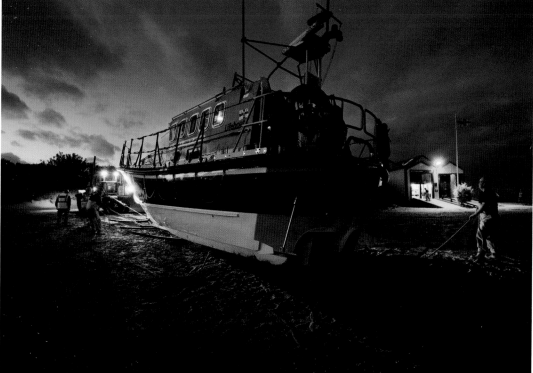

The little lifeboat station has stood at the eastern end of Wells beach since 1895. When the new Shannon class comes here in 2015, they will have the opportunity to rebuild a new facility.

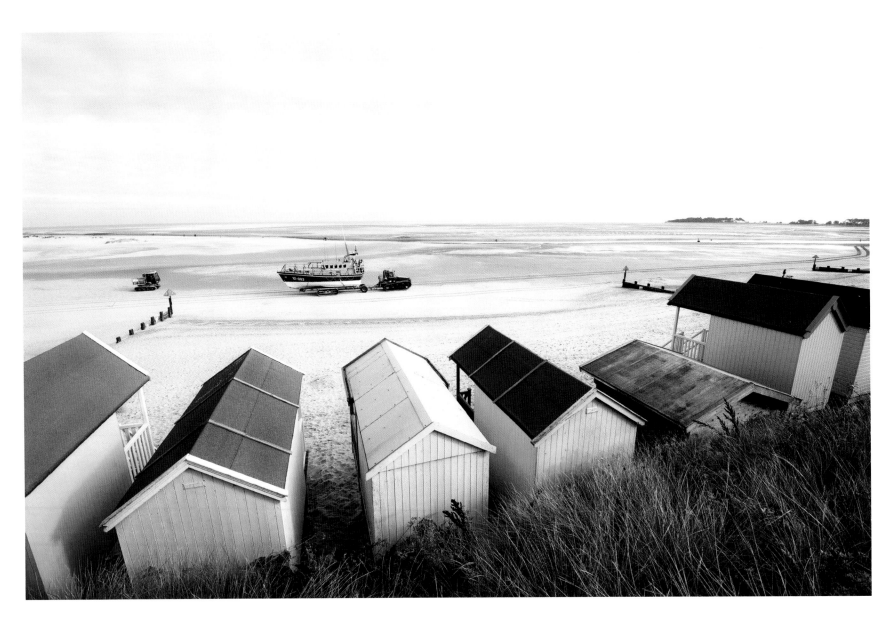

Above: Until tractors that could take lifeboats into the sea were developed, horses helped to launch many lifeboats, and the last occasion was in 1936 at Wells. Today, the Mersey class *Doris M Mann of Ampthill* is brought to the water's edge by a high-powered Talus MB-H launching tractor. The 'Crawler' boasts a Caterpillar 3208 V8 diesel engine. It has, in the event of mechanical failure, the ability to be 'battened down' and abandoned on the seabed without any sea water getting in.

Opposite: If the tide is out, the Talus tractor will tow the Wells lifeboat and its crew to a suitable launch site, either out past the beach huts or across the channel in front of the boathouse to launch from the sands near East Hills. This can mean a trip of up to two miles before the boat can launch, one of the longest beach launches of any lifeboat station, and can add twenty minutes or more to the launch time. At high tide it's a different story. The lifeboat is simply pushed down the boathouse ramp straight into the harbour channel. It can be on its way within six minutes of the shout going up.

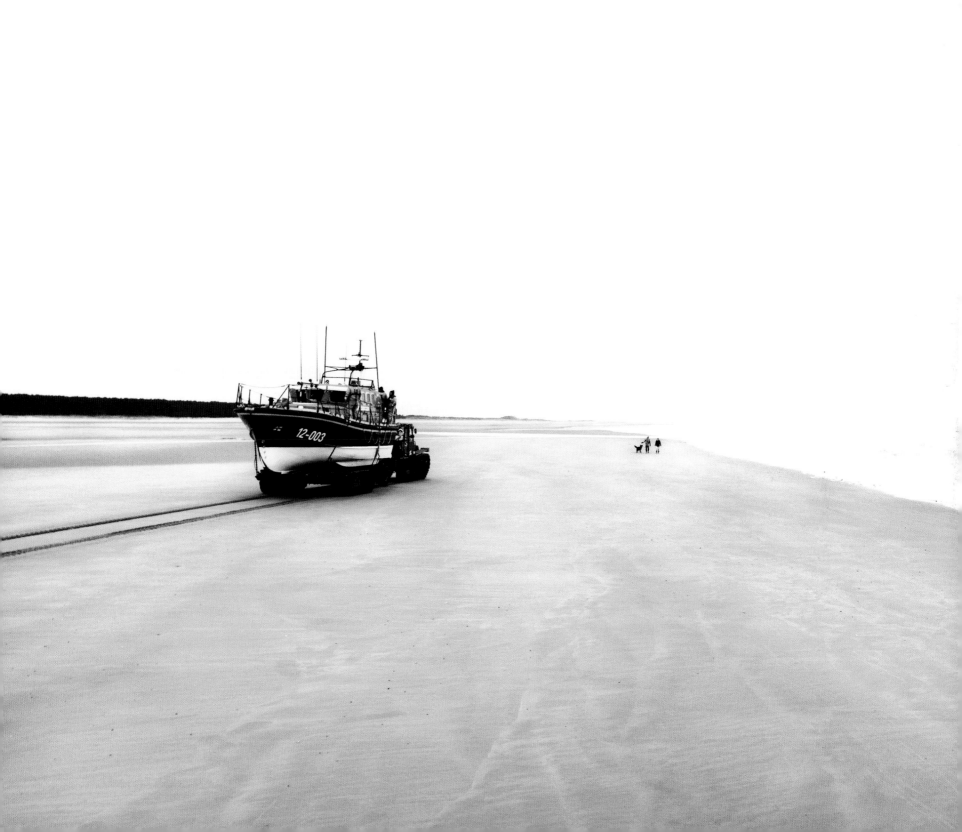

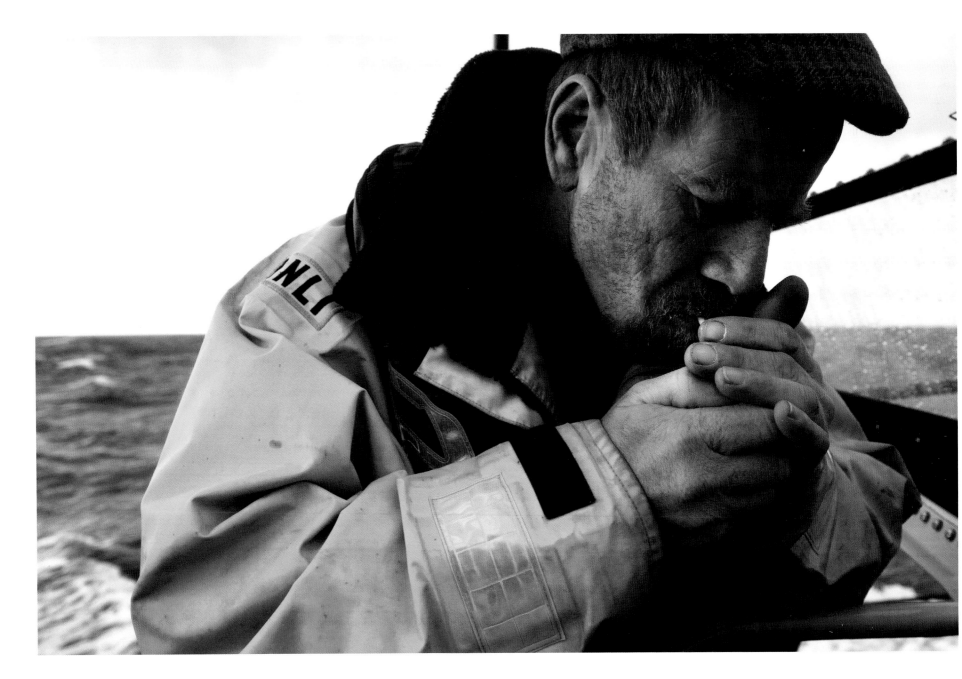

Second coxswain Nicky King lights a well-deserved cigarette. .
Inside the Wells boat, crewmen Jim Heasman and Fred Whitaker
share a joke, as we head out on exercise.

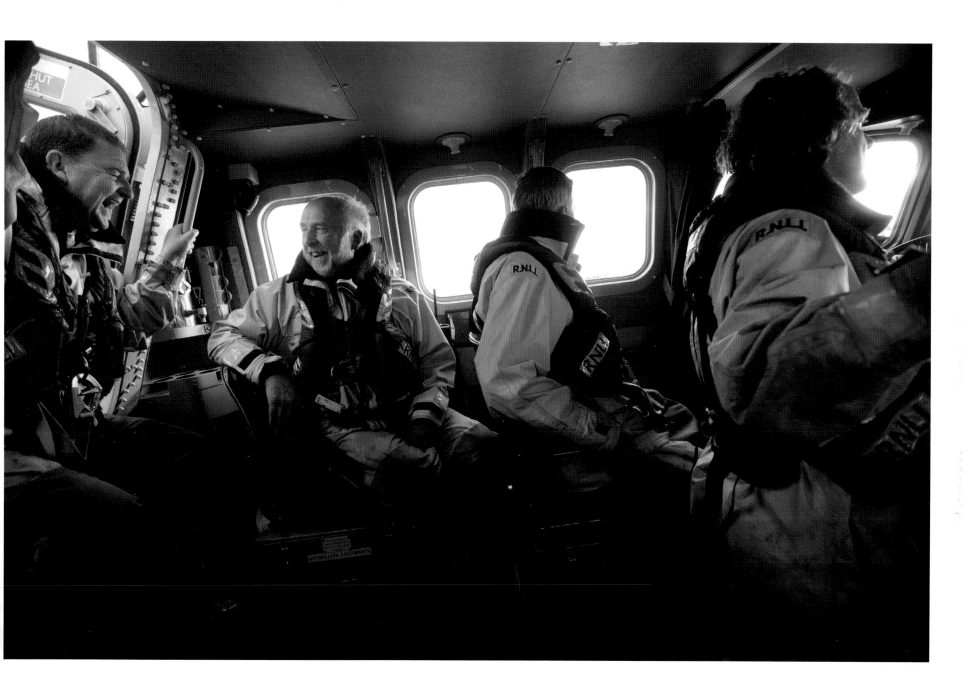

Not far from the beach in Caister there's a small pub named in honour of some legendary lifeboatmen. For over 130 years a lifeboat was operated here by the RNLI, before the Great Yarmouth and Gorleston station got a new, faster Waveney class lifeboat. During the Great Storm of 1901 the Caister number 2 lifeboat capsized with the loss of nine of her crew. The former second coxswain, James Haylett, then aged 78, had two sons, a son-in-law and two grandsons in the boat. When he saw the lifeboat capsize, he dashed into the surf and after very great effort he nonetheless managed to rescue two members of the crew. At the inquest that followed, some questions were put to him and it was suggested that the lifeboat might have been returning to her station after abandoning her mission. To this suggestion, Haylett replied in words that almost overnight became famous for their eloquent simplicity: 'Caister men never turn back.'

The RNLI lifeguard command unit at Gorleston beach near Great Yarmouth.

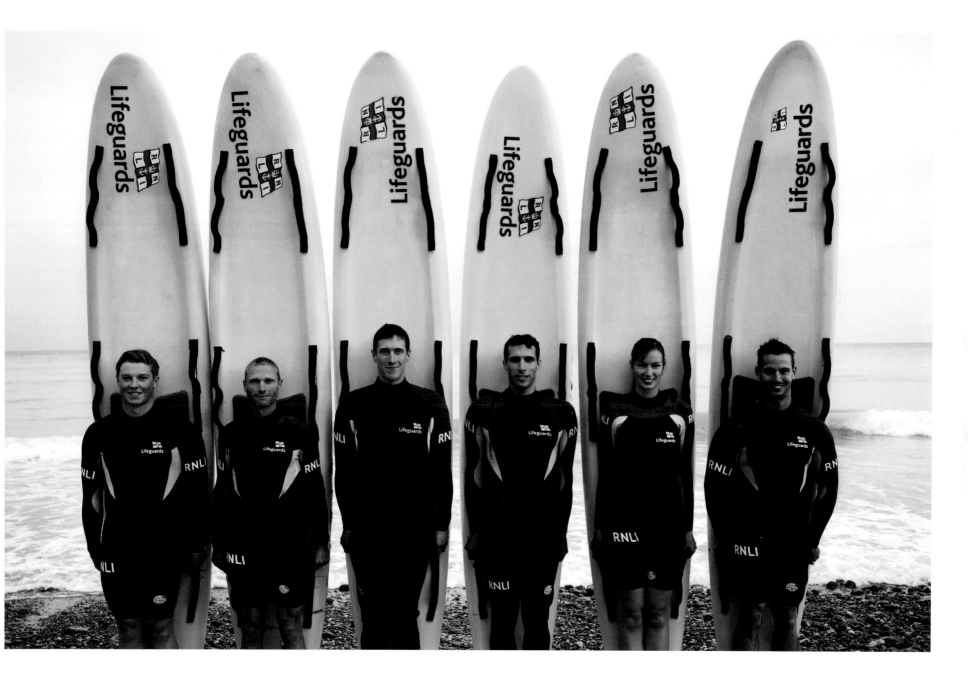

Today RNLI lifeboat volunteers or search and rescue helicopter crews can respond within minutes, and often save lives close to the shore. But sometimes, at the beach, seconds count. For the best chance of survival you need trained people on the shore who can see dangers as they develop — someone who can prevent accidents before they happen and respond instantly if they occur. Ninety-five percent of a good lifeguard's work is preventative. We'll never know how many lives have already been saved by their vigilance.

Above: Beaches along the North Norfolk coast are now patrolled by RNLI lifeguard teams. In the pouring rain, we join them at Cromer as they train with their surf rescue boards in the slate-grey sea. From left to right are: James Buckland, Francis Glazebrook, Vince Pank, Sam Kendrick, Dani Holford and Luis Alonso Davis.

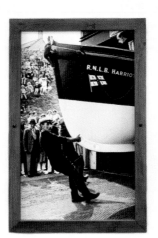

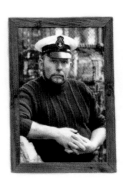

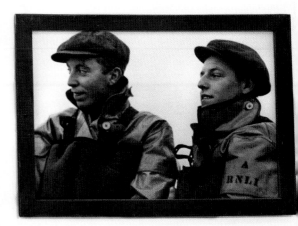

boat. During his 53 years of service he launched a total of 387 times, helping save some 873 lives. Blogg was, in the words of his contemporaries, 'one of the bravest men who ever lived.' Perhaps surprisingly, he never learnt to swim.

Blogg's career spanned the technological changes that swept through the RNLI. His first Gold Medal was earned aboard Cromer's pulling lifeboat during the First World War in 1917, rescuing survivors from the Swedish steamer *Fernebo*, which had been blown to pieces by a German mine. His ageing crew had already been rowing in mountainous seas for several hours, rescuing sixteen men from the Greek ship *Pyrin*. It was not until midnight, under the light of searchlights from the cliff-top, that Blogg's boat was able to plough through the breakers to reach the second vessel and take off its crew. His second Gold was for saving fifteen men from the Dutch tanker *Georgia*, an epic rescue that took more than twenty hours at sea, and his third came in the motor lifeboat in 1941 as he went to the aid of a Second World War convoy aground in a gale on Haisborough Sands. In turbulent seas Blogg and his crew rescued 88 men.

Despite public fame, Blogg remained a modest man who neither smoked nor drank. He had a quiet kindness that endeared him to everyone he met and, most important of all, he inspired confidence in his crew: 'quick and resolute in decision, unerring in judgement, fearless before danger.' Blogg lived in Cromer all his life, working as a crab fisherman and letting out deckchairs and beach huts, with his faithful dog Monte at his side. He stood down in 1947, at the age of 71, eleven years past the usual retirement age. The following year, the new Cromer lifeboat was named the *Henry Blogg* in his honour and his nephew, Henry 'Shrimp' Davies, took over as its coxswain. Blogg said it was the happiest day of his life.

Today the coxswain of the Cromer boat is John Davies, a lobster and crab fisherman, the best skipper in town. The eighth generation of his family to serve, he has been volunteering with the lifeboat for over 30 years. The legendary Blogg and Shrimp were his great uncles and he took over as coxswain from his father Richard.

On the seafront at Cromer is an RNLI museum that tells of the town's most famous son. Renowned for his deeds at sea, Henry George Blogg is the RNLI's most decorated lifeboatman. He was coxswain at the Norfolk station for almost 40 years and was awarded three Gold and four Silver Medals for Gallantry. Blogg joined the Cromer lifeboat crew in 1894 at the age of 18, having gained invaluable time at sea on his stepfather's crab

Just up the road from the sea front, John's wife Claire runs their popular fish shop. The hard-won Cromer crab is among the best in the country. On the wall hangs a painting of her father-in-law Richard William Davies, former coxswain of the Cromer lifeboat. Richard was an inspirational man and was at the helm for 23 years. He was awarded a Bronze Medal for saving the crew of the yacht *Happy Bear* in 1993 and he also earned three vellum certificates of thanks for his efforts. The third was for a rescue done without his boat in 1999 — just weeks before his retirement — when he dashed down to the beach after his pager went off and, knowing there was not time to wait for the boat, stripped off, ran into the cold sea and kept a struggling swimmer afloat 150m off shore until the inshore crew plucked them to safety.

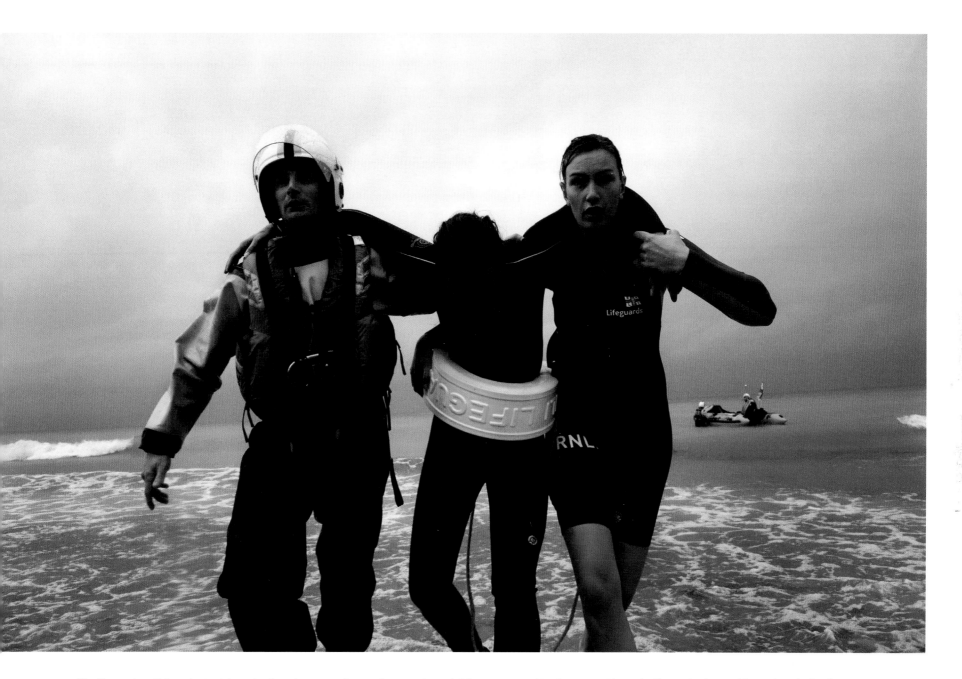

The Tamar class lifeboat *Lester* is launched into deep water from a slipway at the end of the Cromer pier. The 'old' boathouse is now home to the inshore lifeboat *George and Muriel*, launched directly across the sands of the east beach. RNLI lifeboat crews often work in combined rescues with nearby lifeguard units providing a ring of safety from beach to open sea. Here, Cromer crewman Jason King and lifeguard Dani Holford assist a swimmer to shore.

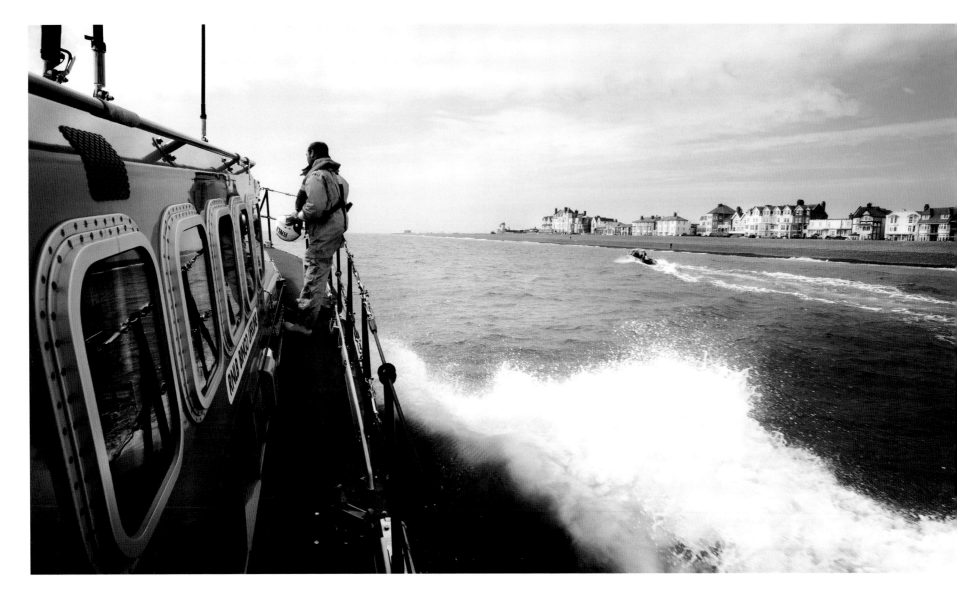

The tranquillity of Aldeburgh in summer is a far cry from this part of the coast in winter, when the crew are called out in wild weather. They often put to sea to offer assistance to boats passing the Aldeburgh Napes, dangerous shoals some four miles offshore, which have claimed many vessels over the years. There has been a lifeboat at Aldeburgh without a break since 1851, and before that along the coast at Sizewell.

On 7 December 1899 the lifeboat capsized when struck by a mighty sea on her broadside. At first it was reported that all were saved, but when the roll-call of the crew of eighteen was called six were missing. They had drowned, trapped beneath the upturned boat. The nation was shocked, yet in the outpouring of grief came new resolve. The City of Winchester collected the money for a replacement boat. Despite this tragedy, a new crew was quickly formed and before the end of the month another lifeboat was ready to put to sea.

At Aldeburgh, the relief fleet Mersey class *Bingo Lifeline* readies herself for a first launch down the shingle beach. As she is washed down after another successful exercise, and the helmets are stowed ready for the next launch, 'George' and some of the other crew dogs patiently wait to go home.

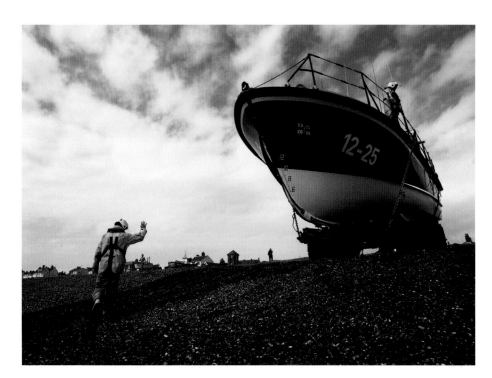

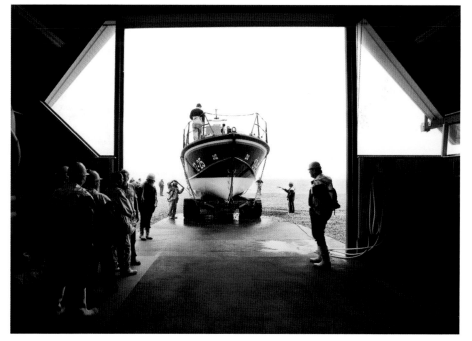

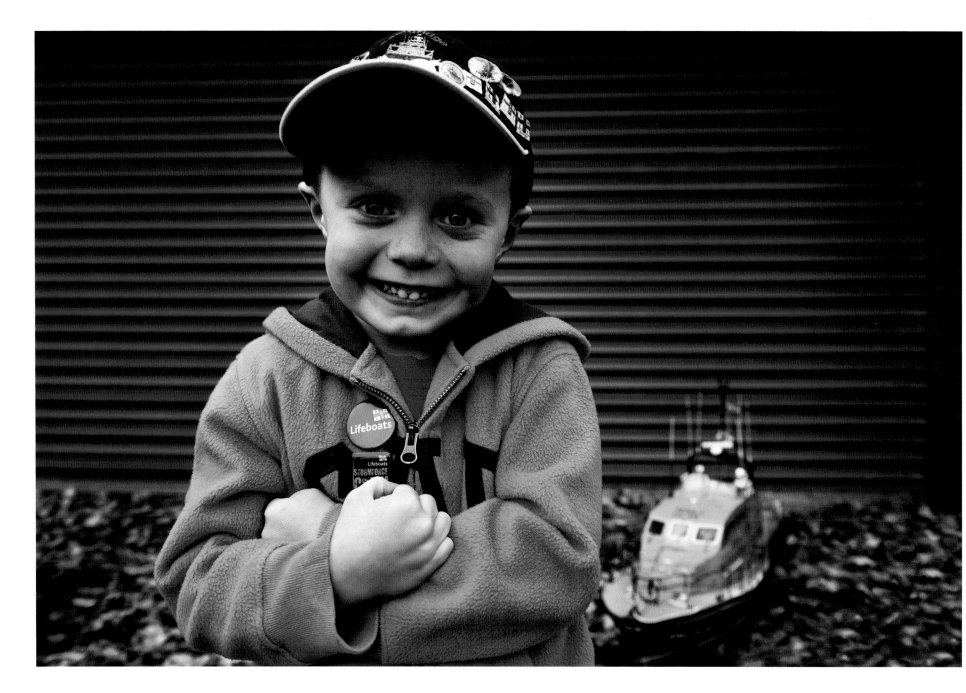

Kyle, aged six, just loves lifeboats. His grandfather David Boyden has been making models for many years. Whenever they have the chance, they head to Fairlands Valley Park in Stevenage to launch them amongst the ducks, imagining rescues as they go.

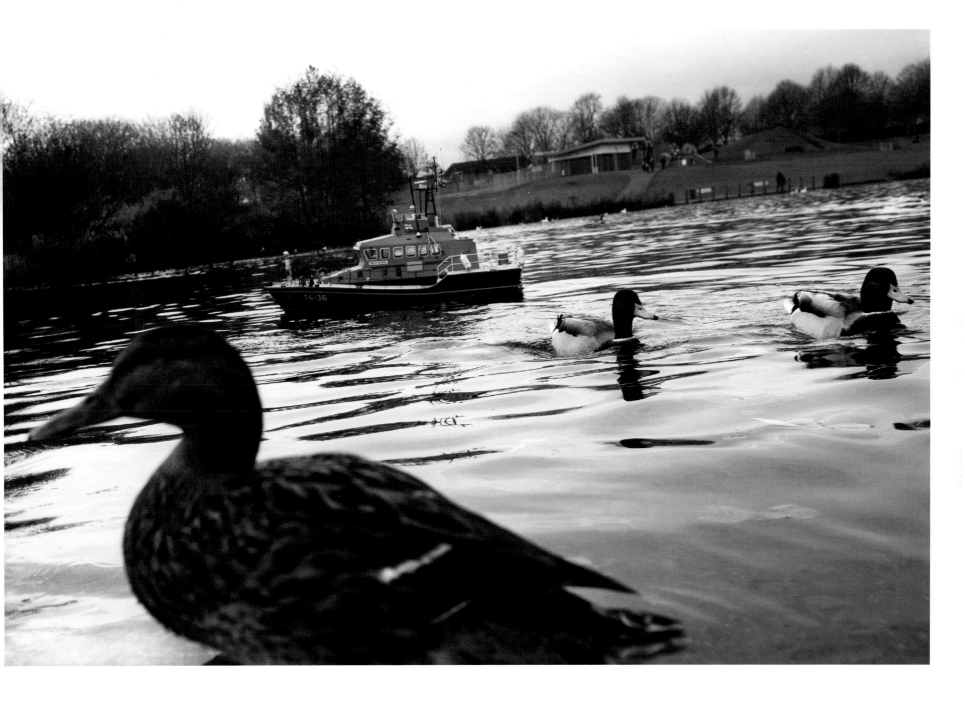

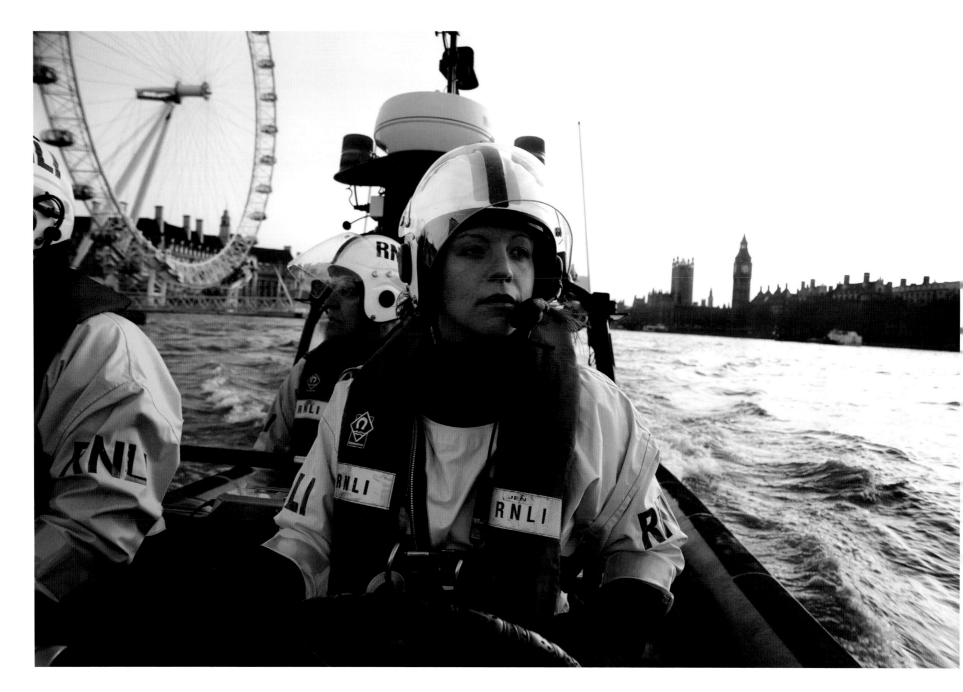

In 2002 four lifeboat stations were established along the River Thames. Tower lifeboat station is now the busiest of all the RNLI stations, with 499 launches last year alone.

In 2012 the RNLI played its part in celebrating the extraordinary commitment of its Patron, Her Majesty The Queen. Under Her Majesty's patronage, the RNLI has saved over 60,000 lives. It was fitting that the RNLI was centrally involved in the Jubilee Celebrations, and not just providing safety cover along the river: a new lifeboat joined the Thames Diamond Jubilee Pageant. The Tamar class *Diamond Jubilee* then took up service at Eastbourne. Crewman Gary Pittaway waves to the crowds while Jen Rotchell surveys the river below Westminster.

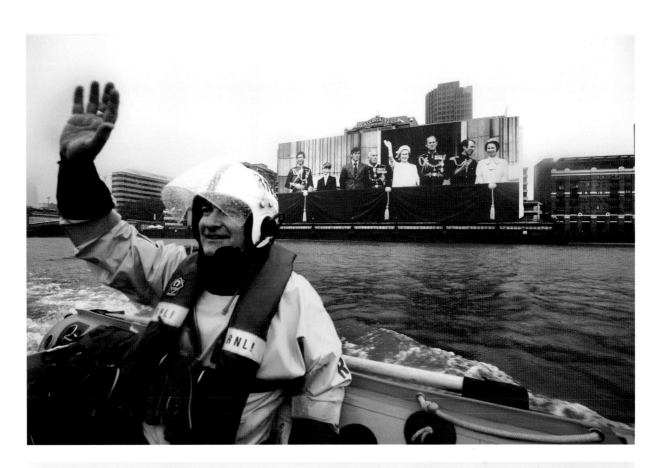

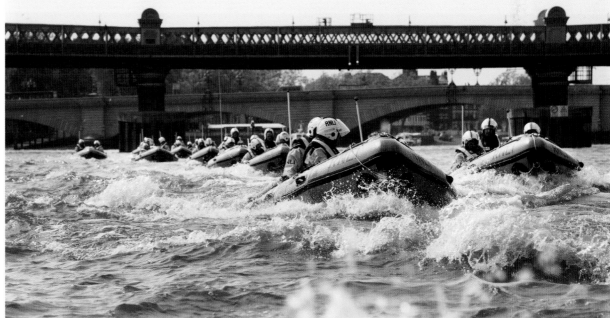

Southend-on-Sea is the only station to operate three inshore lifeboats and a rescue hovercraft. It is also one of the busiest, averaging over 100 shouts each year. Working alongside its flank stations, Sheerness and Gravesend, the crew at Southend provide coverage for the ever-increasing amount of river usage in the Thames estuary. The Atlantic 75 *Vic and Billie Whiffen* is launched into deep water by a davit at the pierhead. The pier is over a mile long, so when a shout goes up the crew can catch a converted milkfloat or race there on bicycles.

Opposite: At Whitstable today the lifeboat is an Atlantic 75, the *Oxford Town and Gown*, so named because she was funded by the Oxford Lifeboat Appeal. In 2012 they launched the boat 54 times to emergencies, ranging from disabled dinghies and drifting fishing boats, to missing kayakers and kite-surfers in trouble. Out in the estuary, the new wind farms and the second-world-war Maunsell sea forts are dynamic local landmarks.

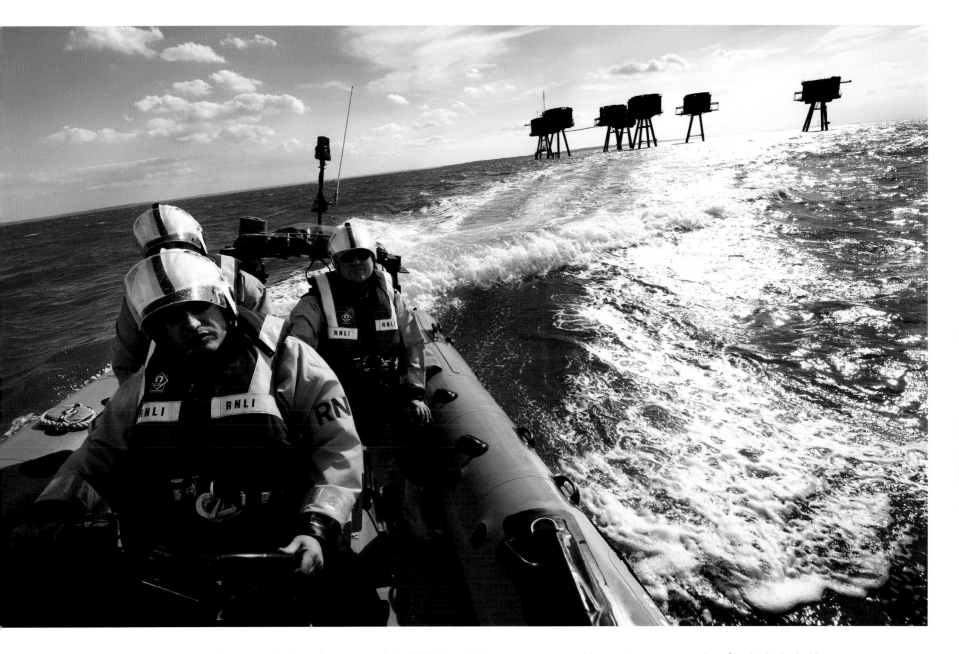

With the growing popularity of recreational sailing and water sports in the 1950s, the charity was beginning to find that the fleet of wooden lifeboats was not always appropriate for dealing with a dinghy sailor or holidaymaker in trouble. It could still take up to 30 minutes to get the smallest lifeboat, the 35ft carriage-launched Liverpool class, to sea. With just a 9-knot maximum speed, there was a real risk that these lifeboats would arrive too late for a swimmer swept out to sea by a rip current or the crew of a small sailing boat in trouble. In 1963 the RNLI decided to trial ten 16ft inflatable rescue boats close to popular summertime resorts to provide a modern response to these fast-developing incidents.

With rubber boats bouncing along at 20 knots, the image of the RNLI was instantly transformed, and these lifeboats quickly proved themselves an essential complement of the all-weather fleet. Soon after, a rigid hulled version of an inflatable rescue boat was designed and found to offer good sea-keeping for such a small, fast boat. The RNLI took on its first 21ft, 29-knot inshore lifeboat, the Atlantic 21, in 1972 and these versatile boats have been busy ever since.

A lifeboat station depends upon the teamwork of a wide range of volunteers: the shore crew, of course, but also the Lifeboat Operations Manager, a number of Deputy Launching Authorities, a treasurer, fundraisers, a medical adviser, and other supporting roles. David 'Larry' Lamberton MBE, now retired, gave much of his life to the Whitstable RNLI as a helmsman, deputy launching authority and operations manager. He joined the crew in 1963 and during his time at sea saved 204 lives. We meet him at home for a brew, with his wife

Diane, who has been supporting the lifeboat as a fundraiser for almost 50 years too. 'It's been a wonderful time', David tells us, 'ever since the coxswain put his hand on my shoulder and asked me to join him. Helping other people is, of course, a real reward but it's also the friendships that you make. It's a brotherhood being on the crew and it has given me the best times of my life.'

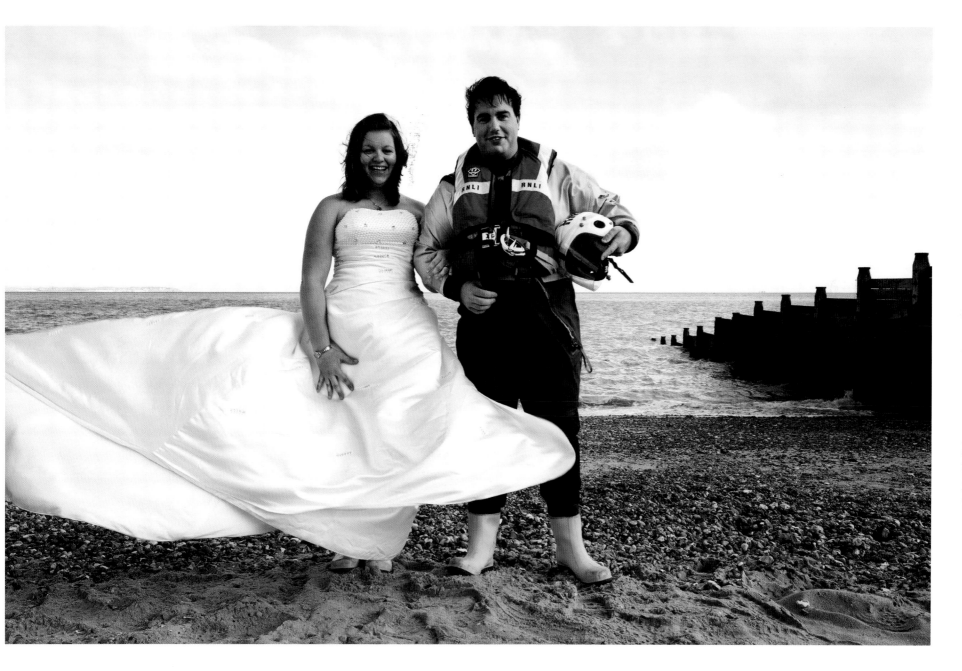

John Skinner, Whitstable crewman, used to work in the Royal Fleet Auxiliary but has now settled here working as a technician in the offshore wind farms. He recently married Kayleigh and they met at the RNLI College in Poole whilst on a training course. She had been a member of the crew at Barmouth in Wales.

Whitstable crewman Robin Nicholls is a furniture maker; whilst his team-mate on a number of rescues, Dan Monk, is the manager of the local supermarket.

In Margate, the Lifeboat pub offers a warm welcome and we raise a glass or two to heroes past. The Margate lifeboat, then the *Lord Southborough*, was one of three lifeboats manned by RNLI crews that sailed for Dunkirk. The Margate boat, commanded by Edward Parker, transferred over 600 men from the beaches to larger vessels offshore before returning to the Kent coast loaded with soldiers.

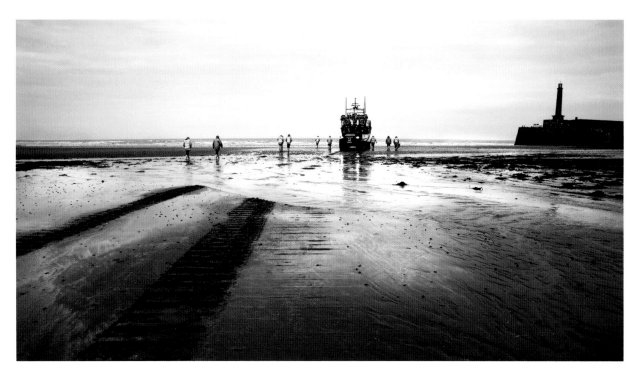

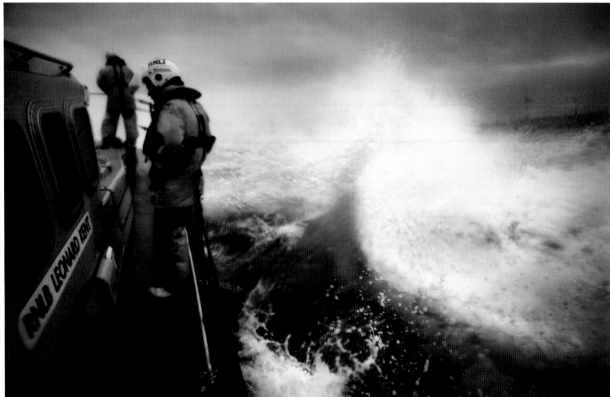

The Mersey class *Leonard Kent* enters choppy seas as we head out on exercise after launching across the beach at low tide. The following month, at the Thanet wind farm, the crew train in kinder conditions.

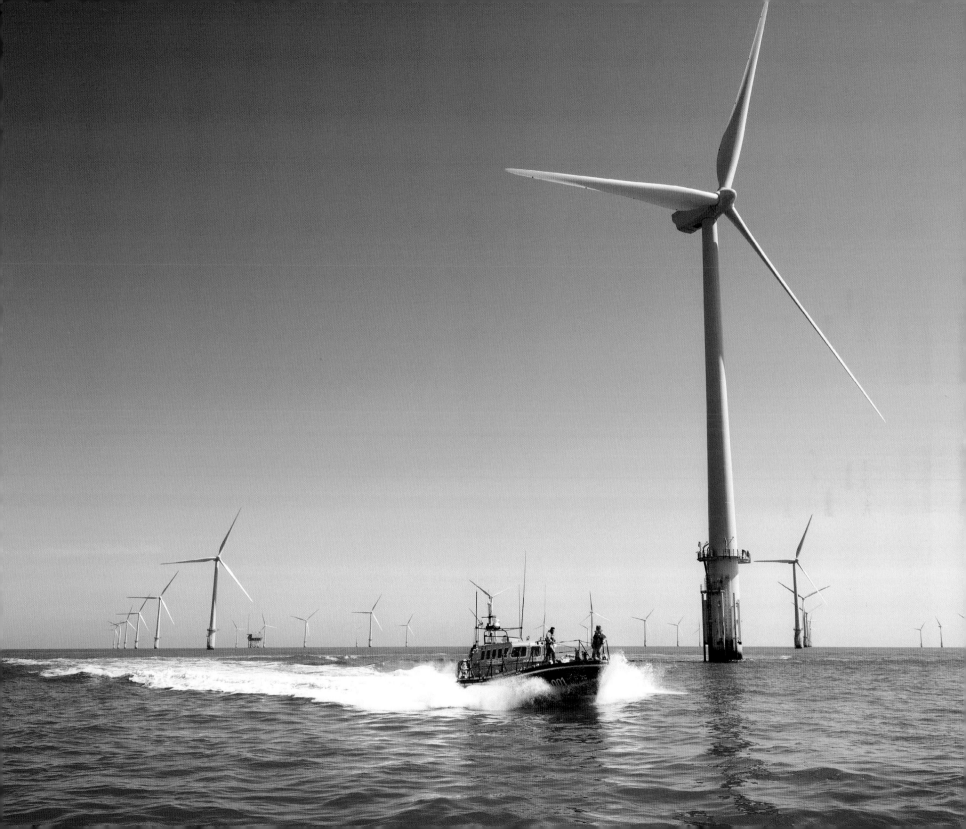

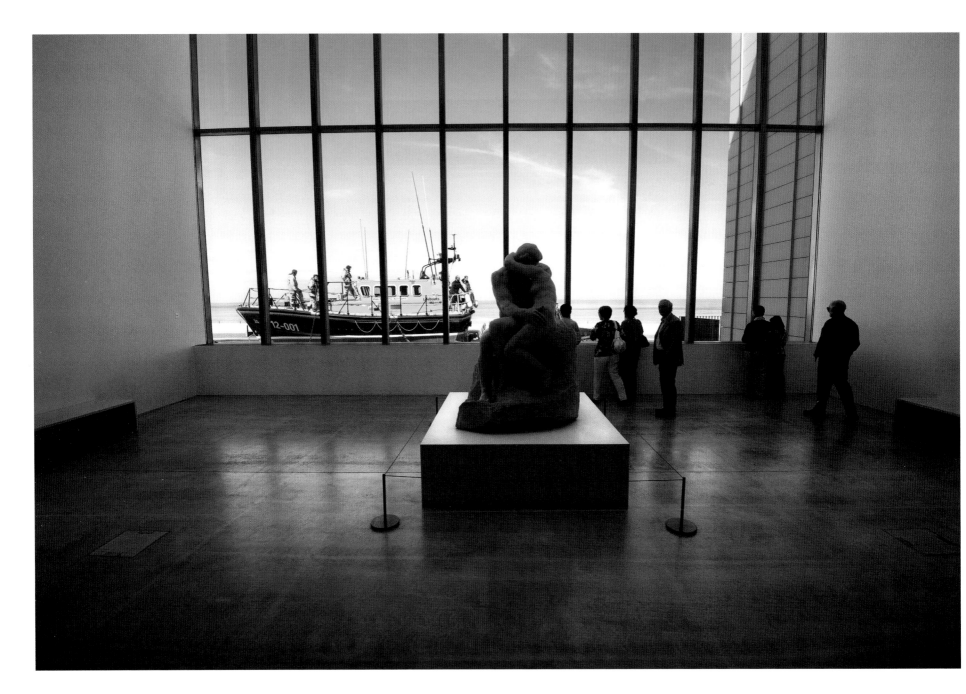

The relief fleet Mersey class *Peggy and Alex Caird* is on station at Margate whilst her boat is away for routine maintenance. For a brief moment as she trundles past the windows, visitors to the new Turner Contemporary gallery seem as interested in the lifeboat as in the artwork.

As the lifeboat returns from a shout, families gather in the crew room.

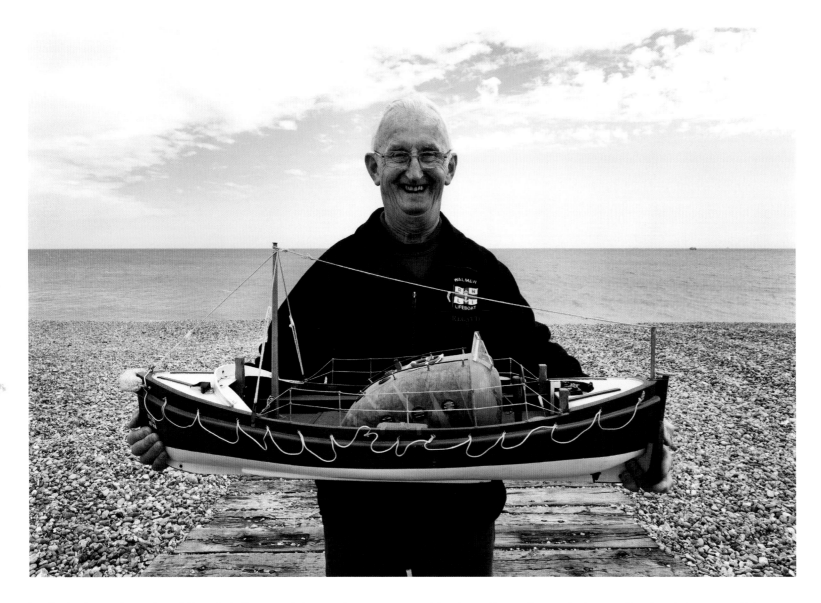

Les Coe has been volunteering at Walmer for half a century. In happy retirement, he now looks after the boathouse. It was built in 1871 and from the shore at low tide you might just make out the masts of wrecks on the infamous Goodwin Sands. Les proudly shows us one of their models, this time it's an old Liverpool class. He first joined as shore crew in 1955 and soon moved up into the boat itself. 'In them days', he tells us, 'it was just something that chaps really wanted to do. Well, a certain type of chap, I mean, I just really wanted to be part of it and worked my way up. It's been a long time, but I've enjoyed every minute of it.' Les was awarded the 'Thanks of the Institution inscribed on Vellum' in 1970 after helping to rescue two men cut off by the tide in a cave. Today his son Andy is a helmsman here and, in time, Les hopes that his granddaughter might also join up. 'This station has been like a home to me. They'll have to carry me out of here when my time comes!'

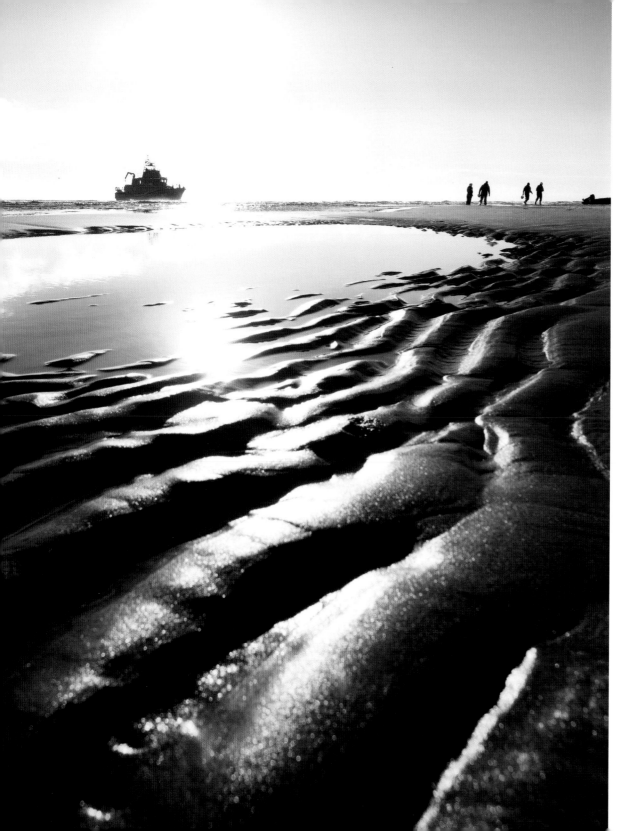

The spirit of the RNLI expresses itself best in the tireless work of volunteer crews in truly horrible conditions. That spirit can be seen in the valiant efforts of the Ramsgate lifeboat in 1881, going to the sailing ship *Indian Chief*. Caught on the Long Sand off the north Kent coast, she was literally disintegrating, battered relentlessly by the storm. As the violent waters overcame their ship, the sailors had lashed themselves high in the rigging, this bleak refuge their only hope of survival.

Lifeboats from Aldeburgh, Clacton, and Harwich had also been alerted to their plight, but it was only the Ramsgate boat that had been able to make it to the wreck, led by coxswain Charles Fish. He wrote later that he'd never encountered such a cold wind: 'It was more like a flaying machine than a natural gale of wind. The feel of it in the face was like being gnawed by a dog. I only wonder it didn't freeze the tears it fetched out of our eyes.'

After surviving a night on the water in mountainous seas, his lifeboat crew eventually rescued eleven men. Fish was awarded a Gold Medal for his actions, and his crew all received the Silver Medal. William Lloyd, the mate of *Indian Chief*, summed up the efforts of the lifeboat beautifully: 'When I looked at the lifeboat's crew and thought of our situation a short while since, and how, to rescue us, these big-hearted men had offered their own lives, I was unmanned. I could not thank them. I could not trust myself to speak ... what do you think of such a service? How can such devoted heroism be written of so that every man who reads shall know how great and beautiful it is? Our own suffering came to us as part of our calling as seamen. But theirs was courted and endured for the sake of fellow-men they'd never seen.' Crews from Ramsgate and Dover now regularly exercise in the difficult shallows of the Goodwin Sands.

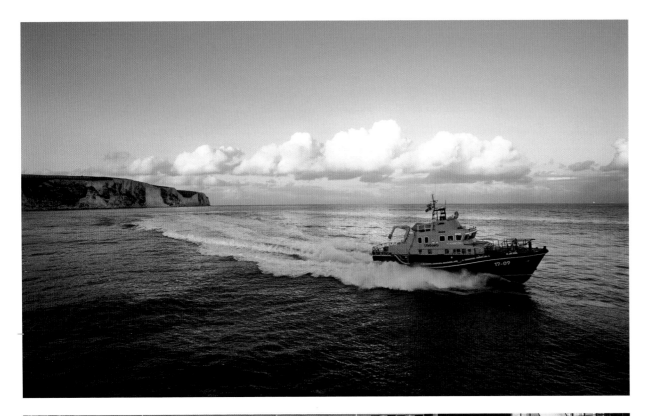

Dover Severn class *City of London II* covers waters beneath the white cliffs and far out into the busy English Channel. With its cross-channel ferries and cruise ships, Dover Port is a frenetic place in which to operate.

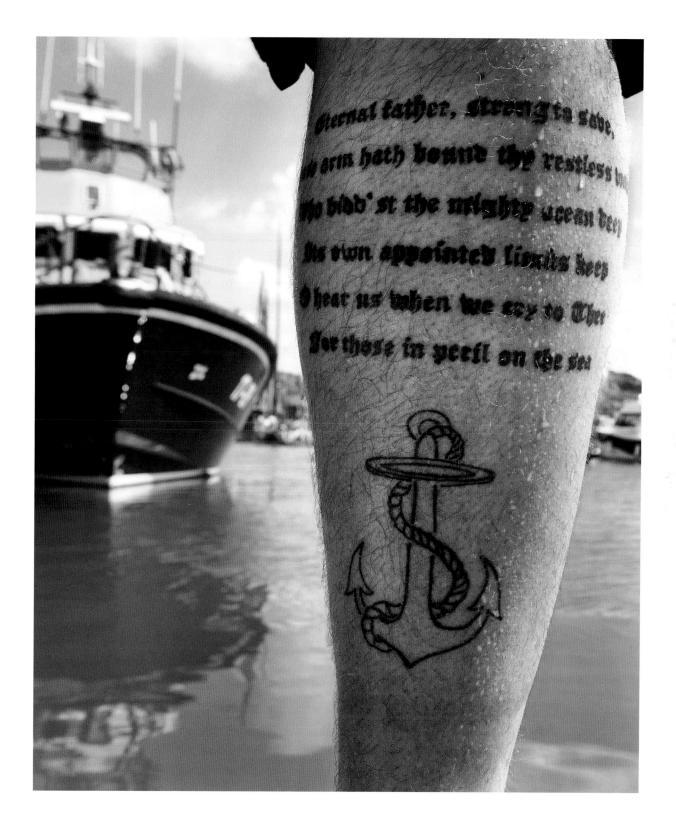

The words of 'Eternal Father, Strong to Save'
are an appropriate tattoo for Dover crewman
Jack Gimber.

Dungeness crewman Garry Clark rescued seven people from the training yacht *Liquid Vortex* early in the morning of 3 January 2012. In winds that reached storm force eleven, Garry leapt onto the yacht, set up several tows, took care of casualties and worked with the skipper to eventually guide the yacht into harbour. He was later awarded the Silver Medal for his immense courage that day. 'There were moments when you knew that it could be a day when it all went wrong, without a doubt' he says, 'but it's great it turned out the way it did. It was a huge honour for me, but really it was an award for everyone who supports us here.'

Opposite: There has been a lifeboat stationed on the windswept shingle of Dungeness since 1826, guarding the Channel from Folkestone to Rye Bay. Mersey class *Pride and Spirit* looks immaculate in the early morning sunshine.

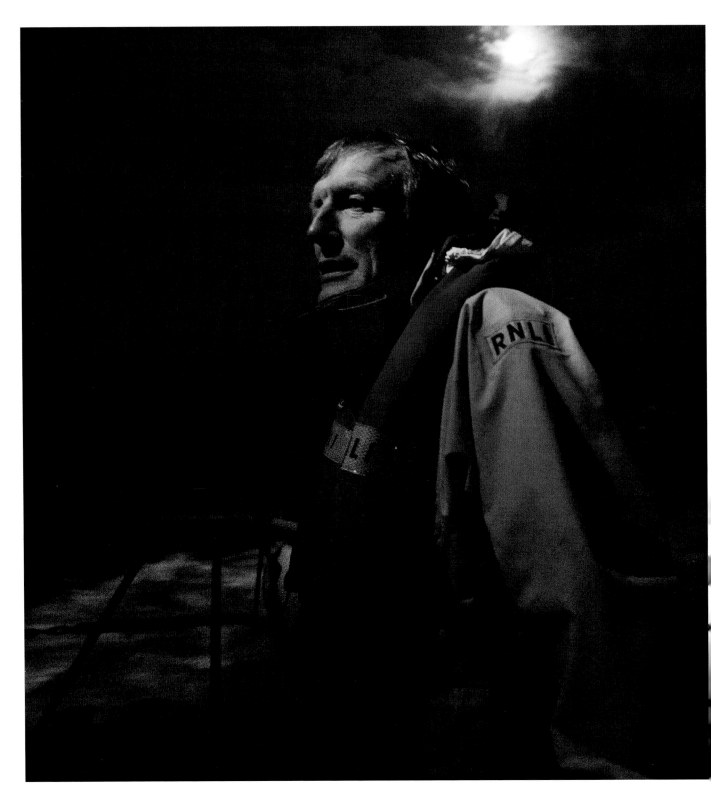

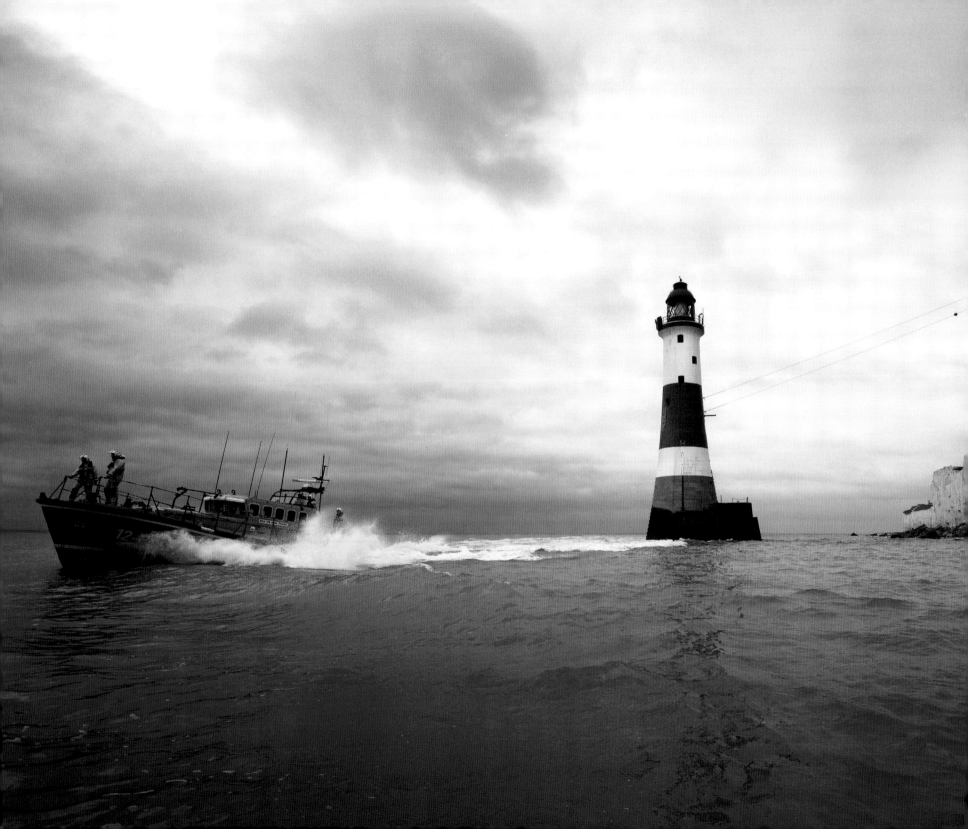

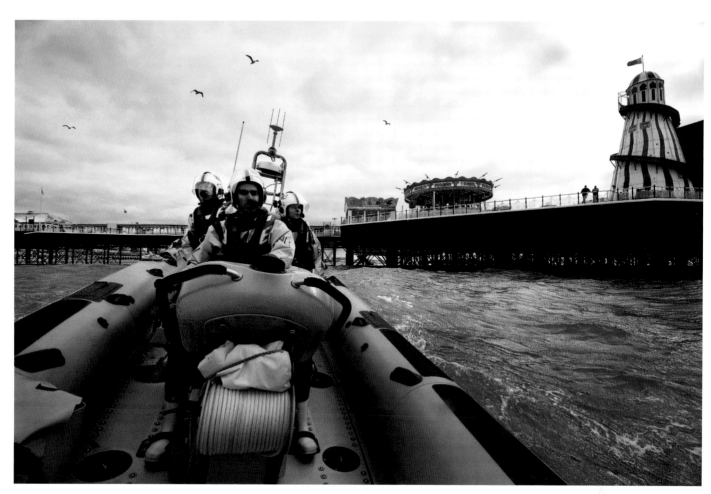

Eastbourne's old Mersey *The Royal Thames* was frequently called out to search for casualties in the waters off Beachy Head. Eastbourne now has a new Tamar class lifeboat, the *Diamond Jubilee*.

The RNLI first stationed a lifeboat in Brighton in 1825, during its very first year of operation, as the popular resort was rapidly growing and people wanted to be by the seaside like never before. The first boathouse, of sorts, was a cave in the cliffs near the old Chain Pier.

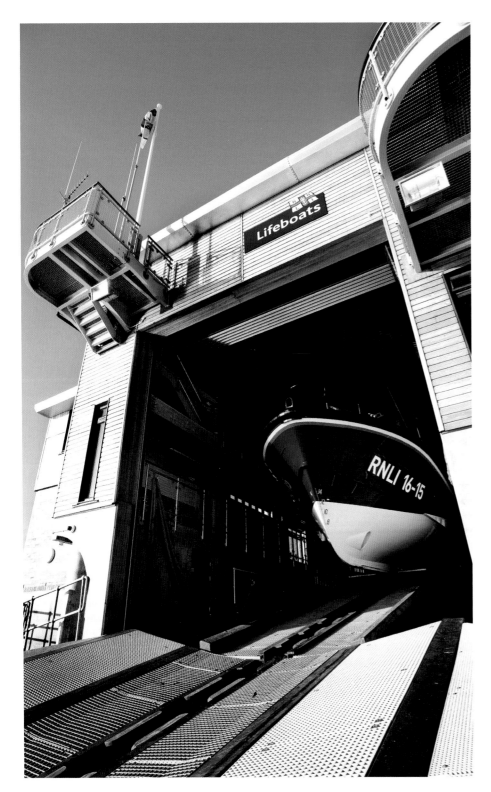

At Shoreham Harbour, the smart new boathouse is home to a state-of-the-art new Tamar class lifeboat. The new boathouse and slipway opened in October 2010 following a three-year community appeal to raise £1 million towards the new build as the old boathouse was crumbling away and the kit room frequently flooded. The station's new £2.7 million Tamar lifeboat — named the *Enid Collett*, after the donor whose generous legacy funded it — arrived in Shoreham on 10 December that year. She had her first shout just two days later.

The Tamar also has a Y class inflatable boat, which is stored in a hidden compartment underneath the aft deck. At the press of a button, the transom folds down and the boat is ready to go. There is also provision for a PWC — a personal water craft, a jet ski — to be fitted here if preferred and, like the Y class, it could be deployed and recovered whilst still at sea.

The first Littlehampton lifeboat came on service in 1884 and she was called the *Undaunted*, and many other boats served with distinction here over the years. In Christmas 1966 the BBC's children's television show 'Blue Peter' launched a lifeboat appeal and after an overwhelming response enough money was raised for four new high-speed rubber inshore rescue boats. *Blue Peter I* was allocated to Littlehampton, with the others going to Beaumaris, North Berwick and St Agnes in Cornwall. Blue Peter has now funded a total of 28 lifeboats across seven stations over the years — a remarkable contribution to the RNLI's efforts. Today, there are two lifeboats at Littlehampton, a small D class *Spirit of Jupiter* and a modern Atlantic 75, also named *Blue Peter I* seen here on exercise with Coastguard helicopter Rescue 104.

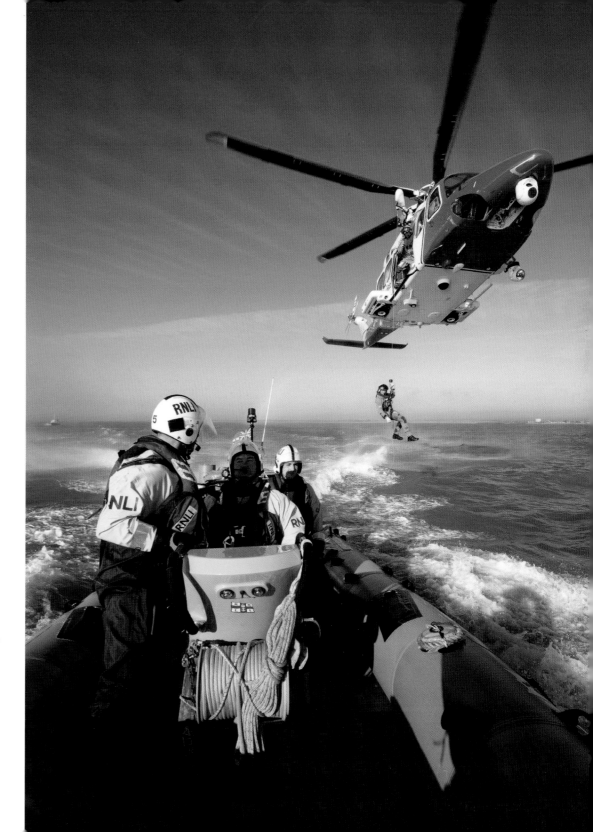

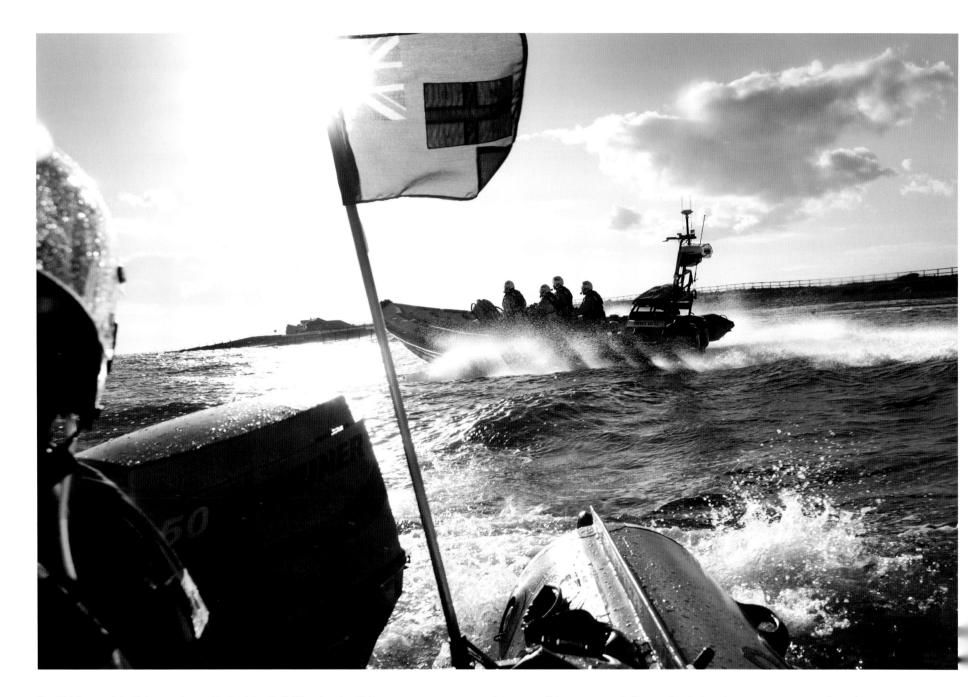

The RNLI opened the lifeboat station on Hayling Island in 1865 and rowing lifeboats were the mainstay here for almost 60 years. For a time the station was closed, as flank stations at Bembridge and Selsey got new motor lifeboats, but with the increase in recreational sailing it was time to put a lifeboat to sea again. Two modern inshore boats are now operated here, the Atlantic 85 and the smaller D class and they provide reassurance and a valuable service for mariners in the Solent's eastern approaches. In 2012 they launched almost 80 times.

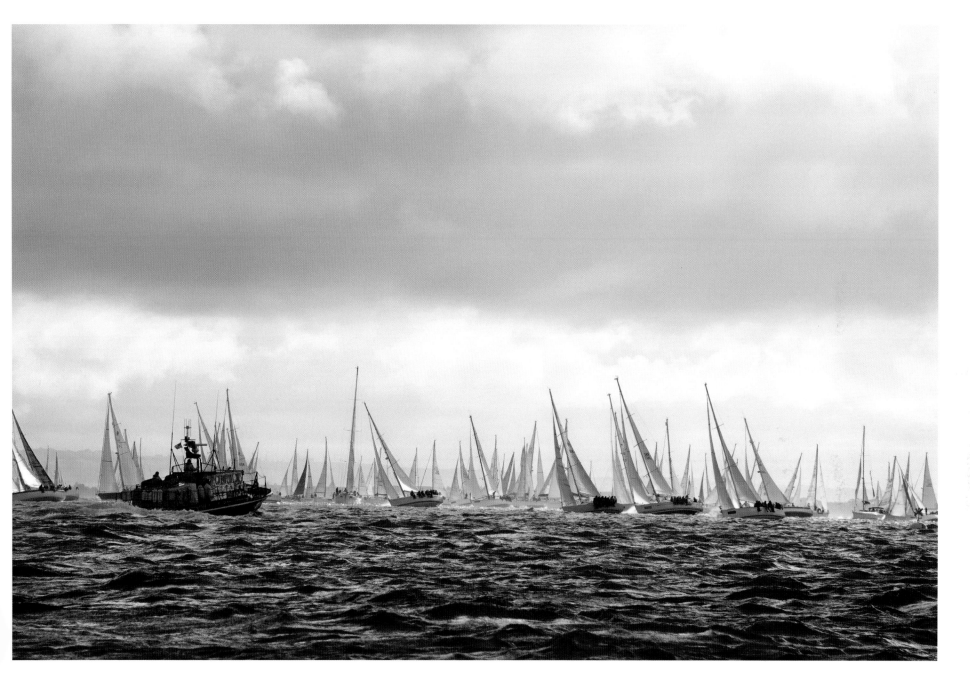

Calshot's Tyne class *Alexander Coutanche* keeps watch during a frenetic day's sailing for the Round the Island Race. Formerly at St Helier in Jersey, this lifeboat served the waters of the Solent for the last time in 2012. Calshot now operate an Atlantic 85 and a D class inshore lifeboat.

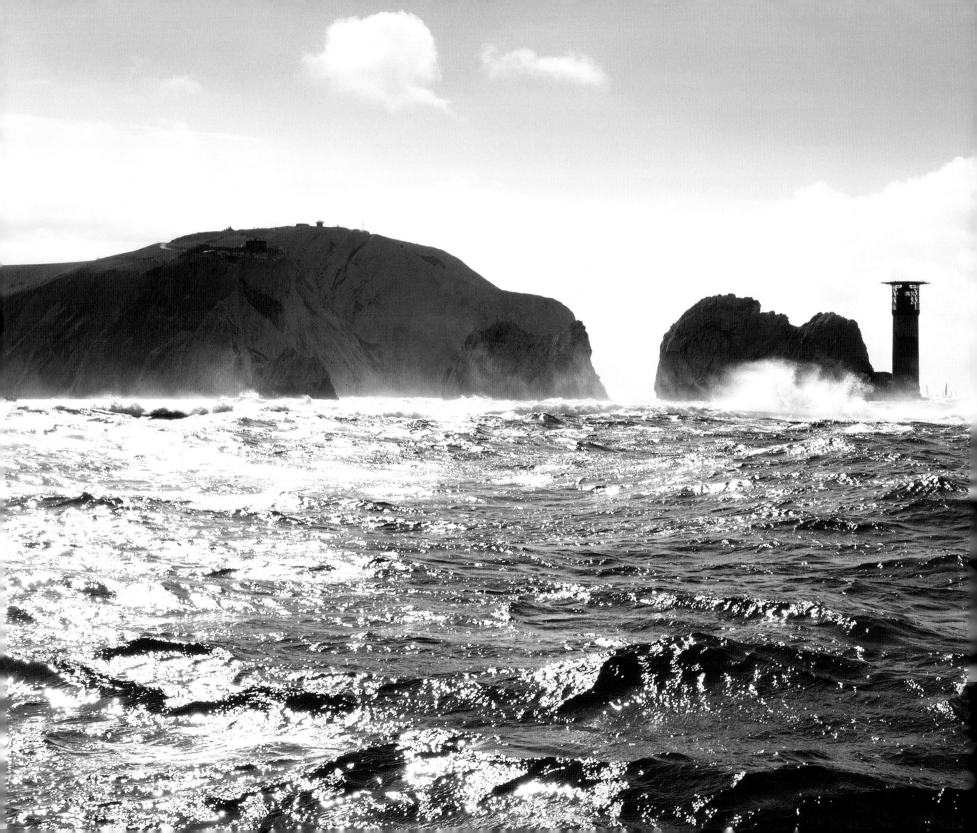

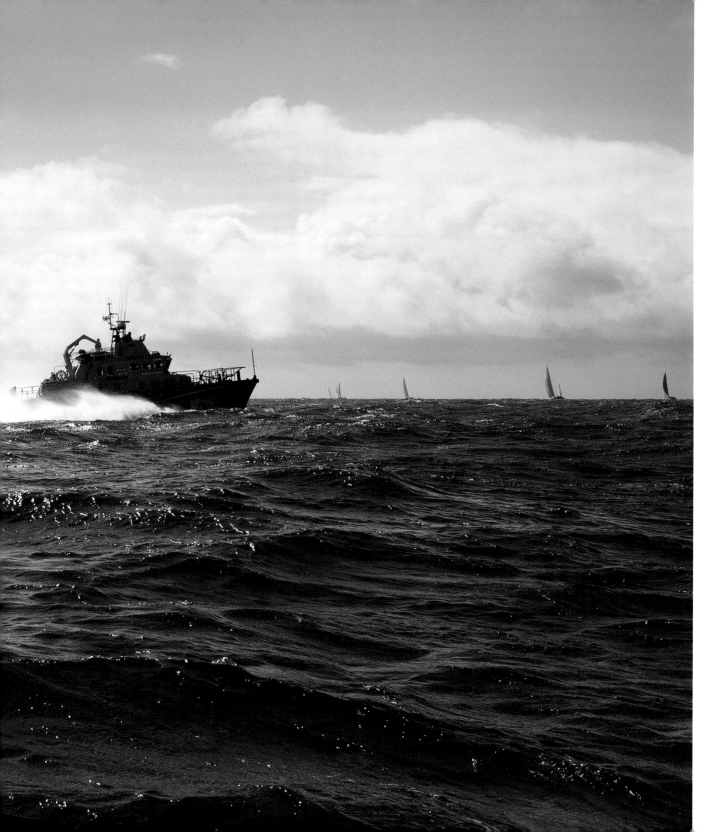

The chalk stacks of the Needles rise from the sea at the western end of the Isle of Wight, with its distinctive lighthouse built here in 1859. Before it became fully automated in 1994, the keepers would serve one month on, one month off, operating a 24-hour watch. These waters are now protected by the Yarmouth Severn class *Eric and Susan Hiscock (Wanderer)*.

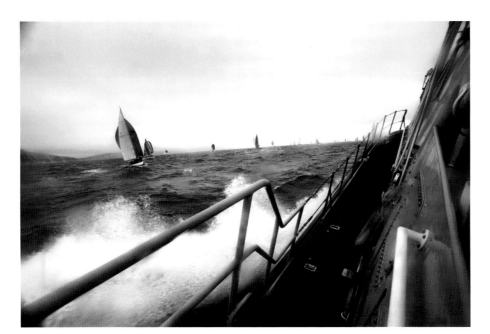

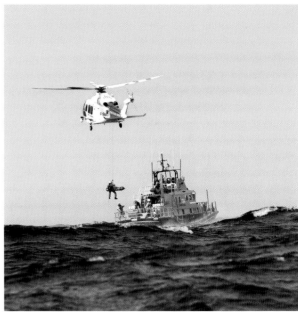

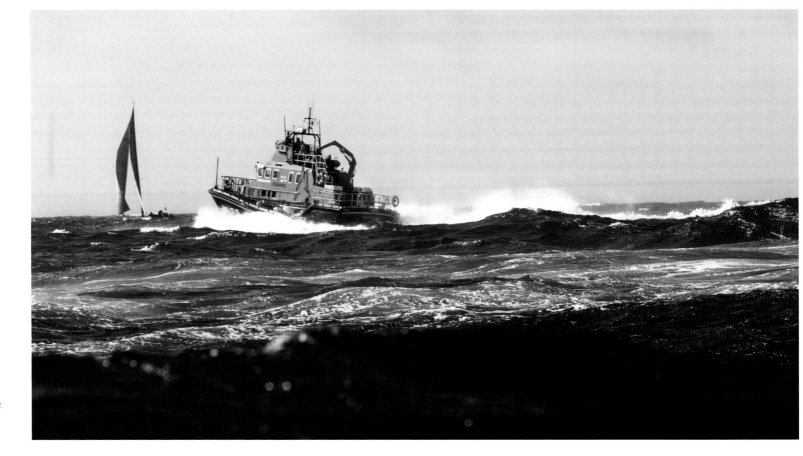

It's a busy day at sea for the Yarmouth lifeboat, as racing yachts and pleasure boats of all kinds run into trouble. A casualty is winched off by Coastguard helicopter Rescue 104, an AgustaWestland 139 based at Lee on Solent.

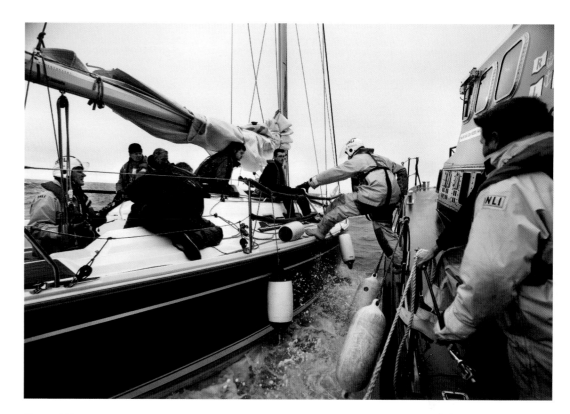

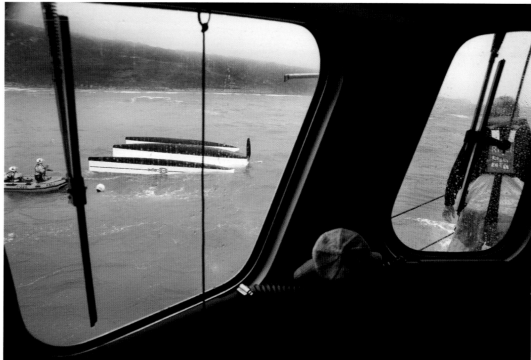

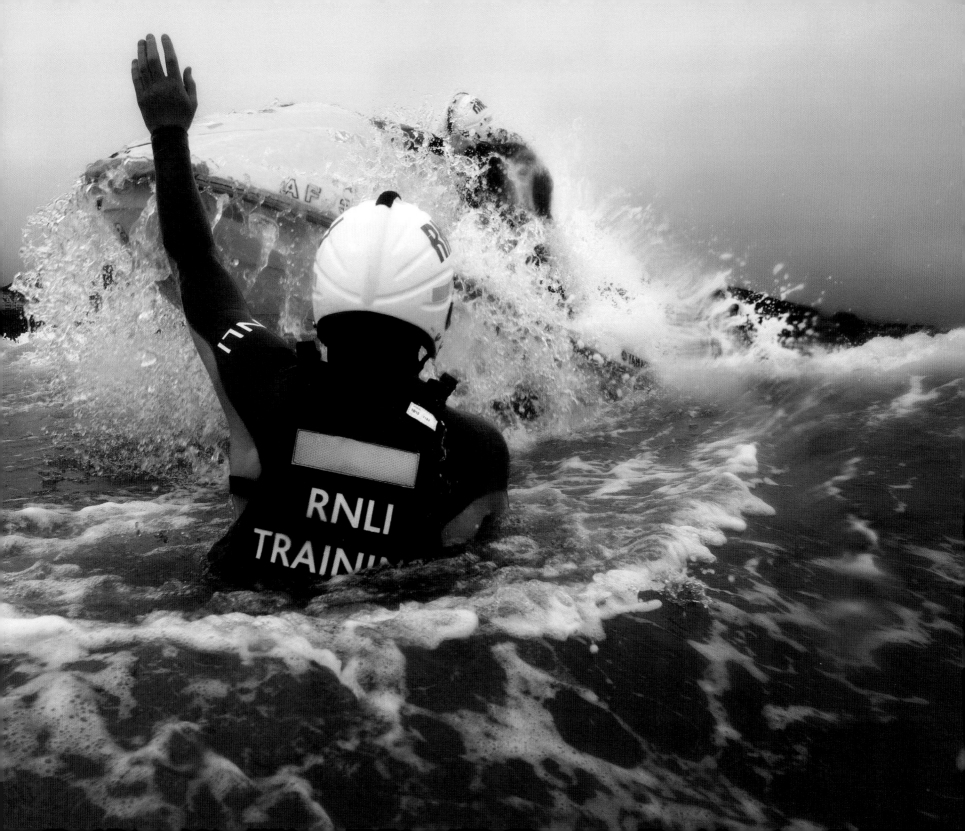

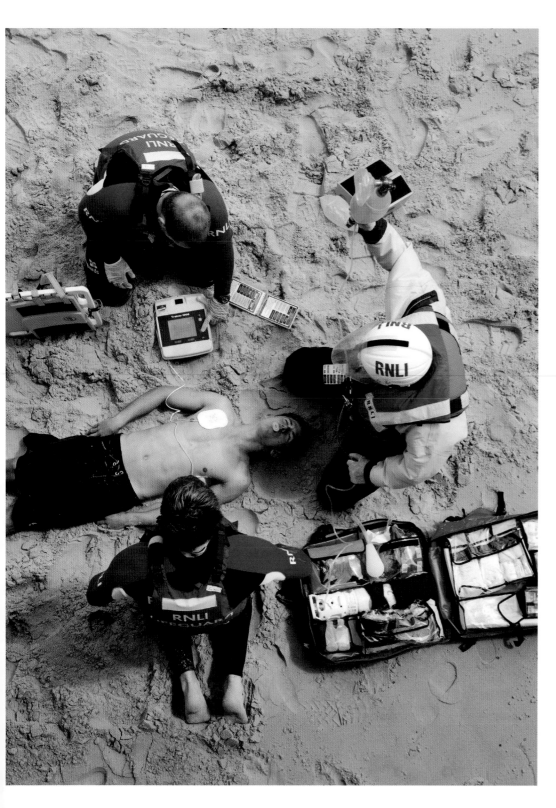

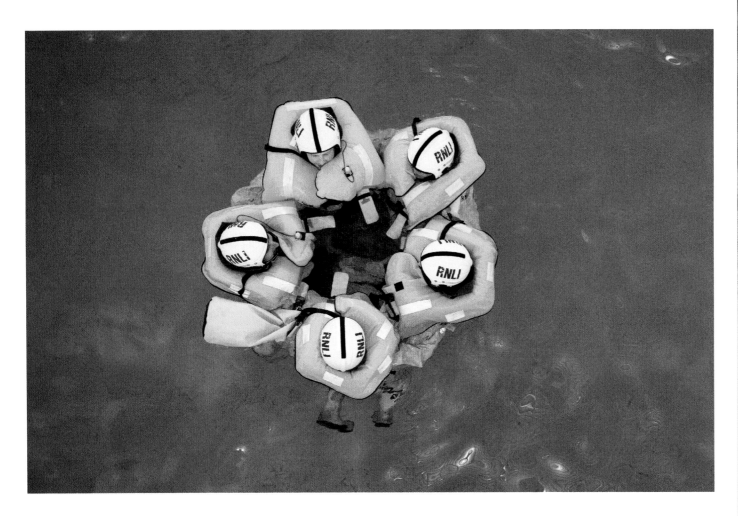

This and previous pages: All RNLI volunteers receive the very best in training and much of this is delivered at the charity's own residential facility in Poole. Here, both lifeguards and lifeboat crew undergo first aid courses, with highly realistic casualty scenarios going some way to preparing them for the real thing. The RNLI College also houses an indoor wave pool used for sea survival and inshore lifeboat capsize training. In this shot, new volunteer crew form a heat-conserving huddle. When back at their stations crew are constantly trained, with most boats going out on exercise at least once a week.

With fake blood running freely, Clinical Operations Manager Paul Savage and Casualty Care Trainer Chris Walker prepare for a 'moulage' training exercise with crewmembers from across the country. Back ashore in Swanage, they debrief after learning many new useful skills.

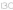

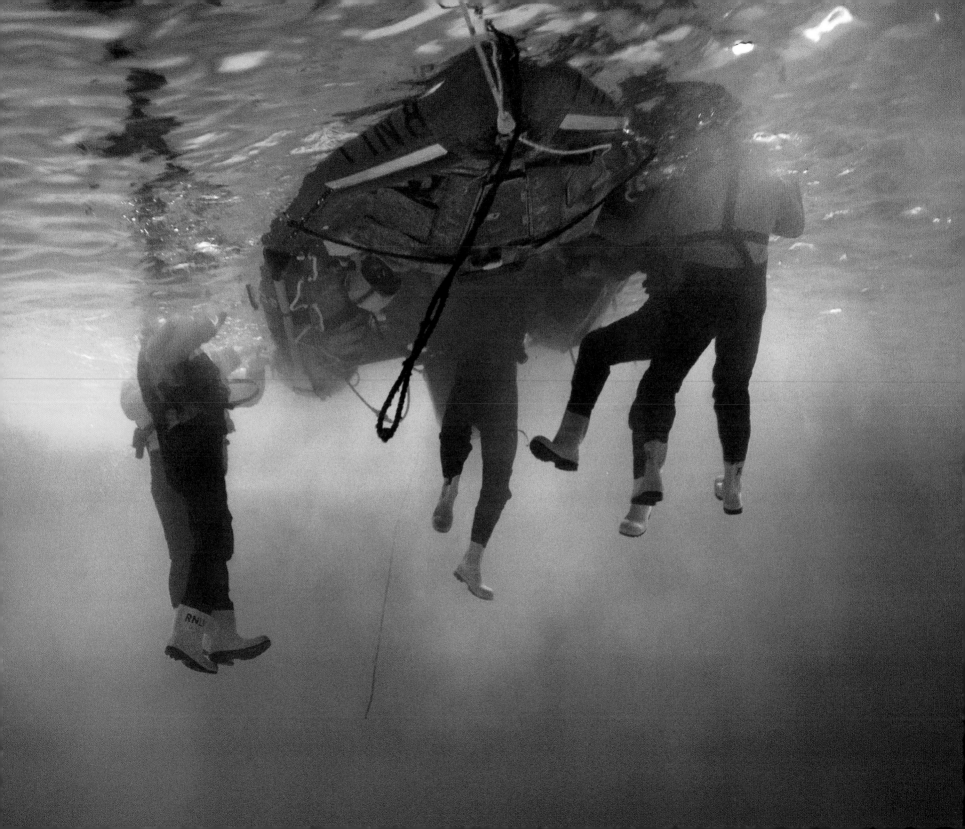

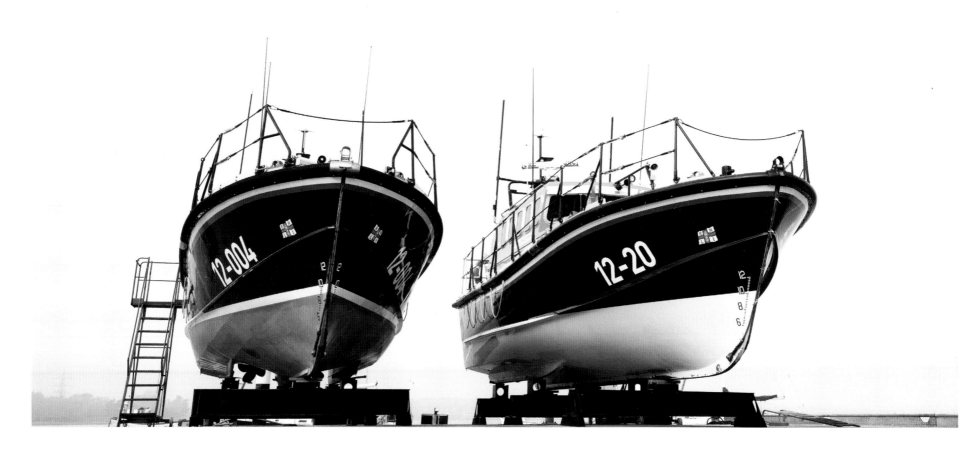

Plans have been approved to construct a new RNLI boatyard at Poole so that
all-weather lifeboats can be built and maintained in-house. The move is part of an
ongoing efficiency drive that aims to save millions of pounds each year, whilst also
ensuring control over quality and supply. The charity already designs and builds
the hulls and superstructures of all-weather lifeboats and builds all inshore lifeboats.
This is the next logical step towards a sustainable future. Here, Margate's Mersey
Leonard Kent, boat number 12-20, and the relief fleet *Royal Shipwright*, 12-004, are
in for repairs.

Irishman Peter Eyre, an RNLI Naval Architect, proudly shows us his hull model for the new Shannon class lifeboat. He played a major role in developing its high-bow design and, four years on, the lifeboat is now undergoing sea trials all round the coast of Britain and Ireland. 'I'm chuffed it was named after an Irish river and the strong connection the boat now has with Ireland', he says. 'I think the moment it first goes out on a service will be the high point of my career. My parents will be so proud. It's a great legacy to be a part of. I think it will sink in gradually. When the first life is saved. I think that's when it will really hit home.'

Above: Most drownings happen in the world's poorest countries, which have either very limited lifesaving services, or none at all. Despite the scale of the problem, it is barely recognised — a hidden epidemic. The RNLI is increasing its international work to try and reduce this staggering and needless loss of life. Idrissa Ndiaye, a volunteer lifeguard from Senegal, took part in the RNLI's 2012 Future Leaders in Lifesaving programme. This bespoke course is designed to equip candidates with essential skills to run effective coastal lifesaving services in their home countries.

Opposite: Bill Walton has been an RNLI volunteer for over thirteen years, advising the public on sea safety and the importance of lifejackets. This is a crucial aspect of the RNLI's work in education and prevention. 'Remember lads', he's quick to remind us, 'lifejackets are useless unless worn!'

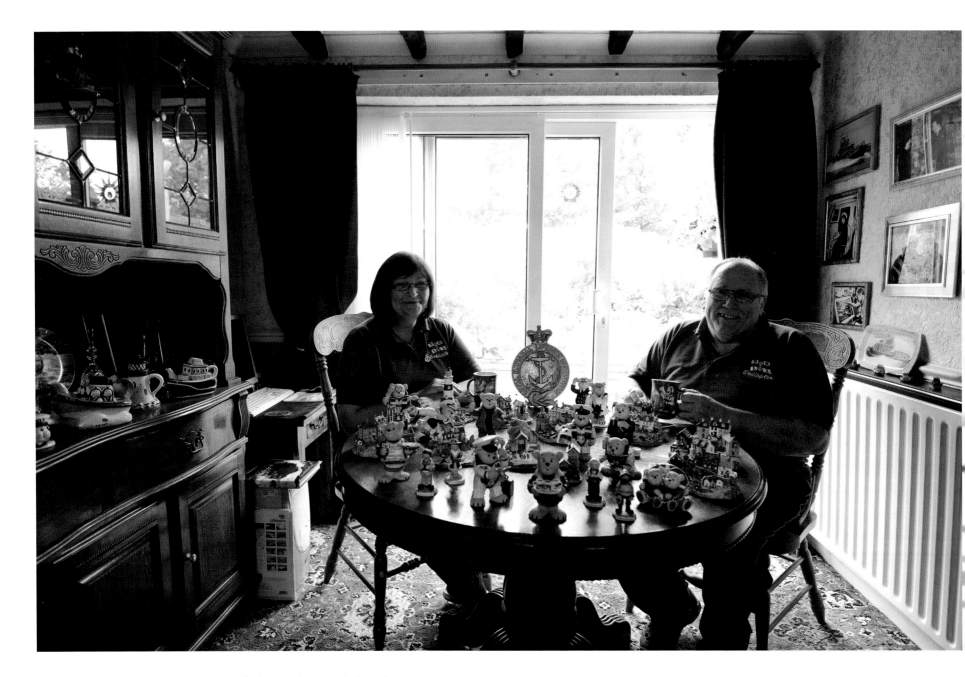

Over a nice cup of tea, at home in Birmingham, Erdington volunteers Jacky and Chris Clifford are happy to talk all things RNLI. Indeed, most of the planning for the Branch's next fundraising efforts happens round this table. Their collection of lifeboat teddies is certainly something to behold too.

Likewise, everything is shipshape in the Manchester kitchen of Ernest Barker, Treasurer of the North Trafford Branch of fundraisers.

Exmouth Mersey class *Margaret Jean* returns to the boathouse.

Exmouth first had one of the pioneering Greathead-designed lifeboats, which arrived in 1803, but little information details its service here. During a severe storm in 1814 the lifeboat-house was washed away and the lifeboat was removed from the town too. The RNLI re-established a station in 1858 and the lifeboat has been in action ever since. After a local appeal reached its target of raising £2 million a new boathouse was built in 2009.

On Christmas Day 1956, crewmember Will Carder was swept overboard by a 20ft wave as the *Maria Noble* lifeboat raced to the rescue of a Dutch vessel that was burning distress flares in the English Channel. Will was a popular member of the volunteer crew, running the local pub. Its sign now hangs in the boathouse.

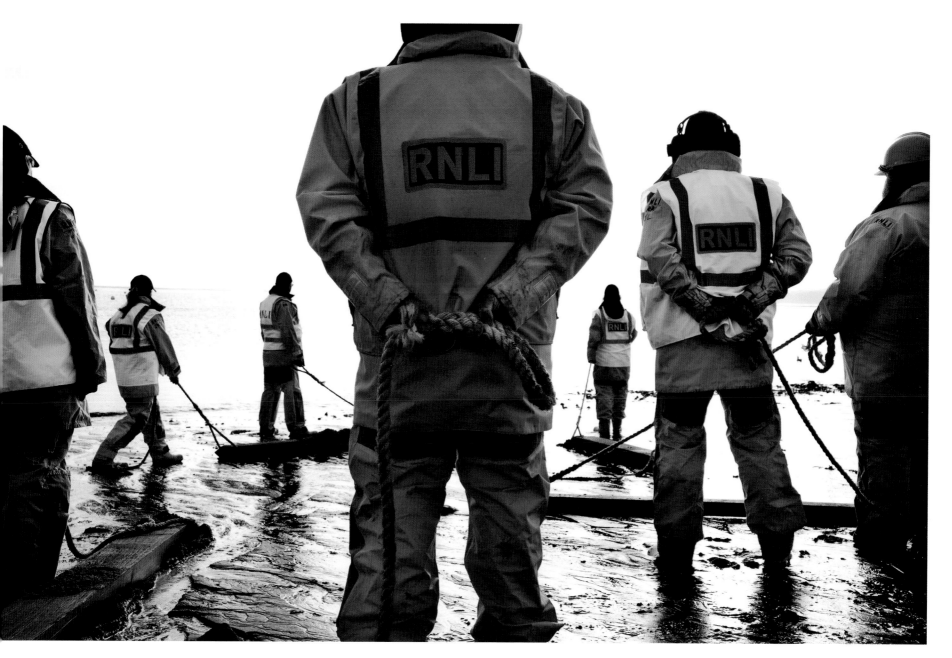

In Exmouth, with skids at the ready, the volunteer shore crew wait
for the lifeboat to return.

As is often the case, the RNLI volunteer spirit runs through a whole family. In Torbay, the Bowers are a good example of this. From left to right: Will is the lifeboat station's full-time mechanic; Keith, a former coxswain, was a Gold Medallist in 1976; his mother Marjorie Edwards helps run the Ladies Guild fundraisers; Colin, a former crewman, is now the Lifeboat Press Officer; and Ray Bower is also on the crew.

The RNLI flag was designed in 1884 and it has become well-known around Britain as a symbol of service at sea, flying from the lifeboats, but also appearing on all manner of souvenirs and gifts that help raise crucial funds for the charity. In Torbay, young Ben Fowler, son of the second coxswain, is happy to help spread the message.

Torbay crewmember Angie Morris, captain of the training tall-ship *Royalist*, is not bad in the kitchen either.

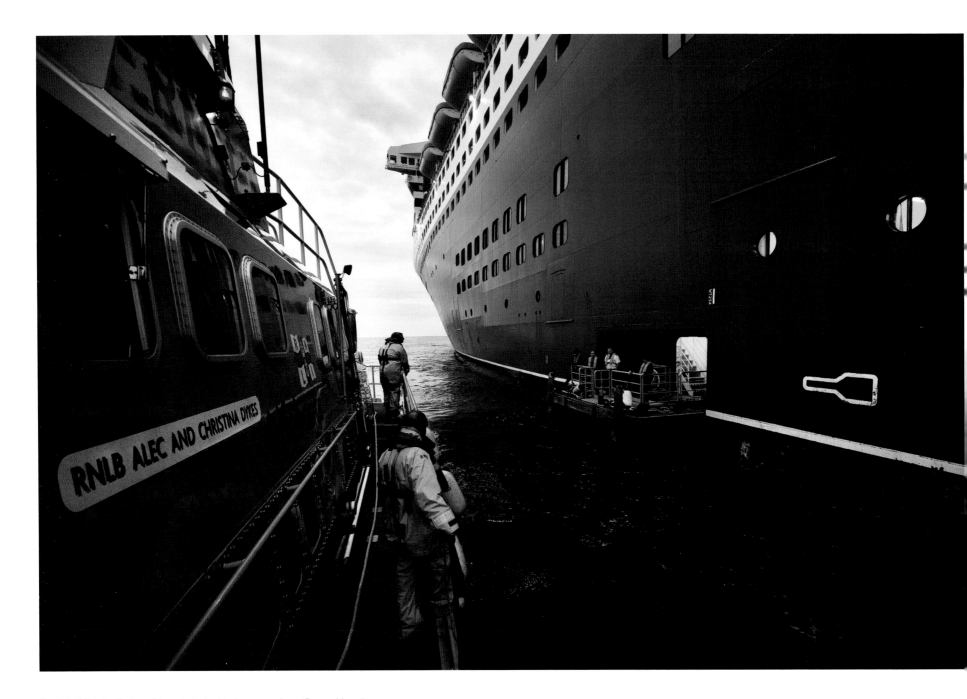

As night falls, the Torbay lifeboat is tasked to the ocean liner *Queen Mary II* to perform a medical evacuation.

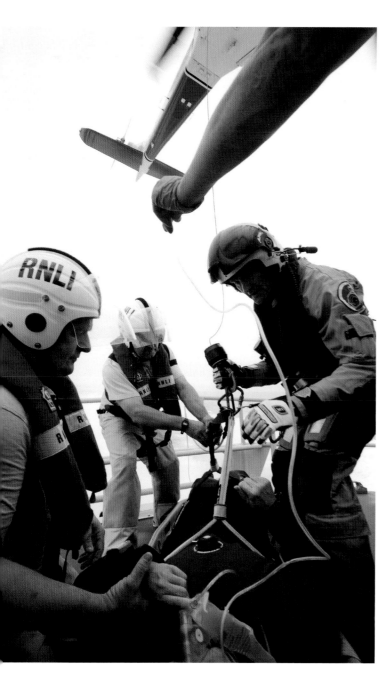

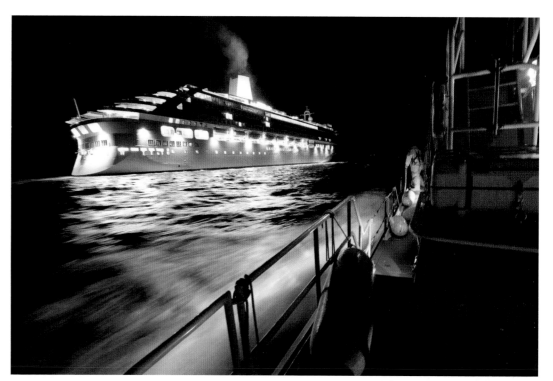

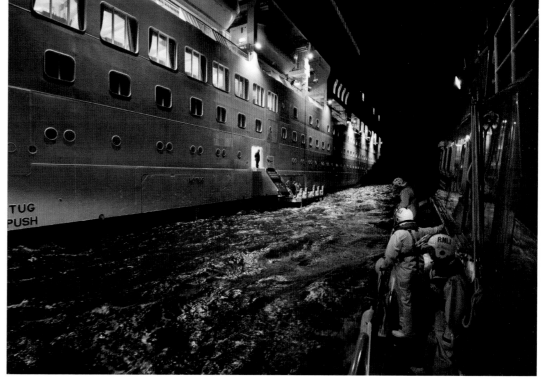

In the middle of Tor Bay off Brixham, Rescue 106 is on hand to transfer a casualty from the lifeboat. The diver is suffering from the bends and every second counts.

Another night, another urgent call, this time to the P&O cruise ship *Aurora*.

Since the first cork lifebelts in 1854, lifeboat crews have benefitted from the very latest designs. Here, members of the Torbay crew show this timeline of lifejacket innovation. From cork through to the Kapok in 1904, the Beaufort in 1970 and more recent all-weather and inshore jackets, newly designed by the RNLI and Crewsaver in 2011.

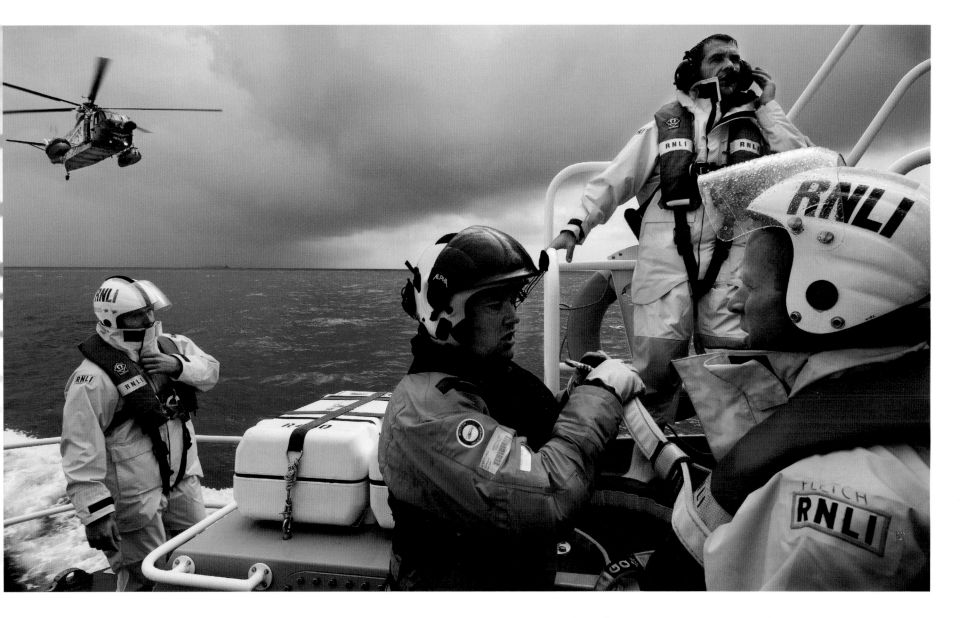

At Torbay, Silver-Medal winning coxswain Mark Criddle controls the scene as HM Coastguard helicopter Rescue 106 comes in to winch off crewman Gary Fletcher. Criddle was awarded a Silver Medal for his efforts during the *Ice Prince* rescue in 2008. This large cargo vessel, some 34 miles south east of Berry Head, was listing heavily as its cargo of wood had shifted in rough seas caused by a force nine strong gale. A helicopter crew were able to winch 12 casualties to safety. The crew of the Torbay lifeboat then spent 2 hours making more than 50 approaches to save the remaining eight crew members.

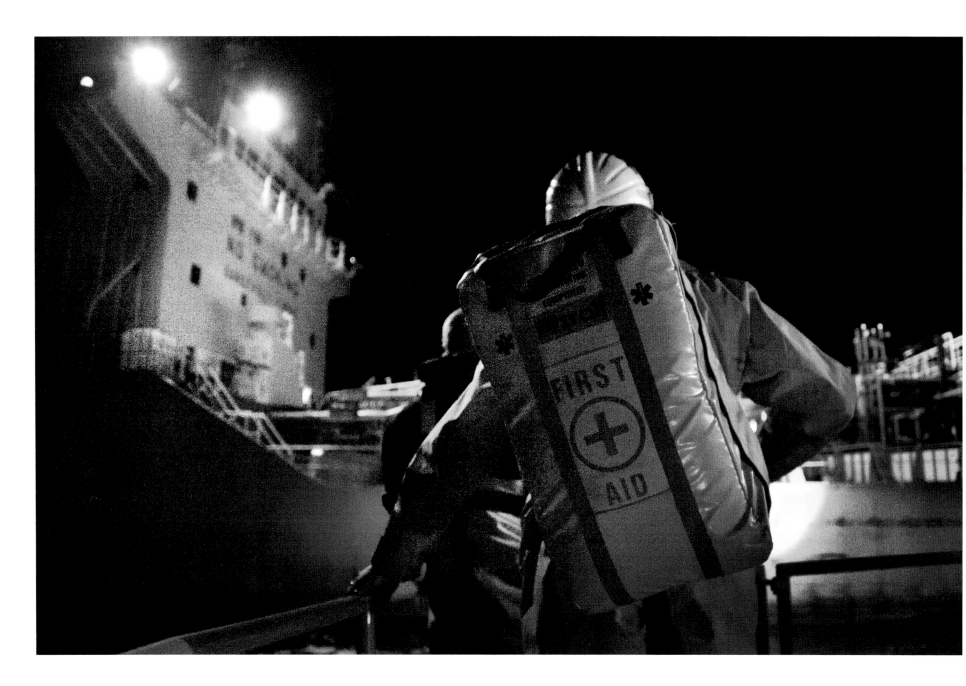

On the terrible night of 10 January 1866, a fleet of ships were caught out in Tor Bay when the wind moved suddenly to south-south-east blowing a hurricane. The fishing boats only had sails and many of them could not get back into harbour because the winds were against them. The beacon at the end of the breakwater was washed away and in the darkness the boats were at the mercy of the monstrous seas. Some of the wives brought everything they could carry, including furniture and bedding, to make a big bonfire on the quayside to guide their men home, but there was little hope. Over 40 ships were lost in that storm, and with them nearly 100 lives. When dawn finally came, wreckage could be seen stretching for nearly three miles up the coast.

Within the year, horrified by the depth of this tragedy, the RNLI established a lifeboat station in Brixham, promising the community it would never again have to witness such loss. Since then, the lifeboatmen of Torbay have been awarded 27 medals for bravery — one Gold, seven Silver and nineteen Bronze — and have saved many hundreds of lives in the process. As is happily seen elsewhere, from tragedy springs a remarkable spirit of service that endures through the generations.

Opposite: Many miles off Brixham in the middle of the night, the Torbay lifeboat comes alongside chemical tanker *ChemLeo* to give urgent medical care. Crewman paramedic Gary Fletcher prepares to jump aboard.

Left: The twin searchlights of the Torbay lifeboat pierce the dense fog. They are scanning the coastline, looking for a missing person who was later found safe and well.

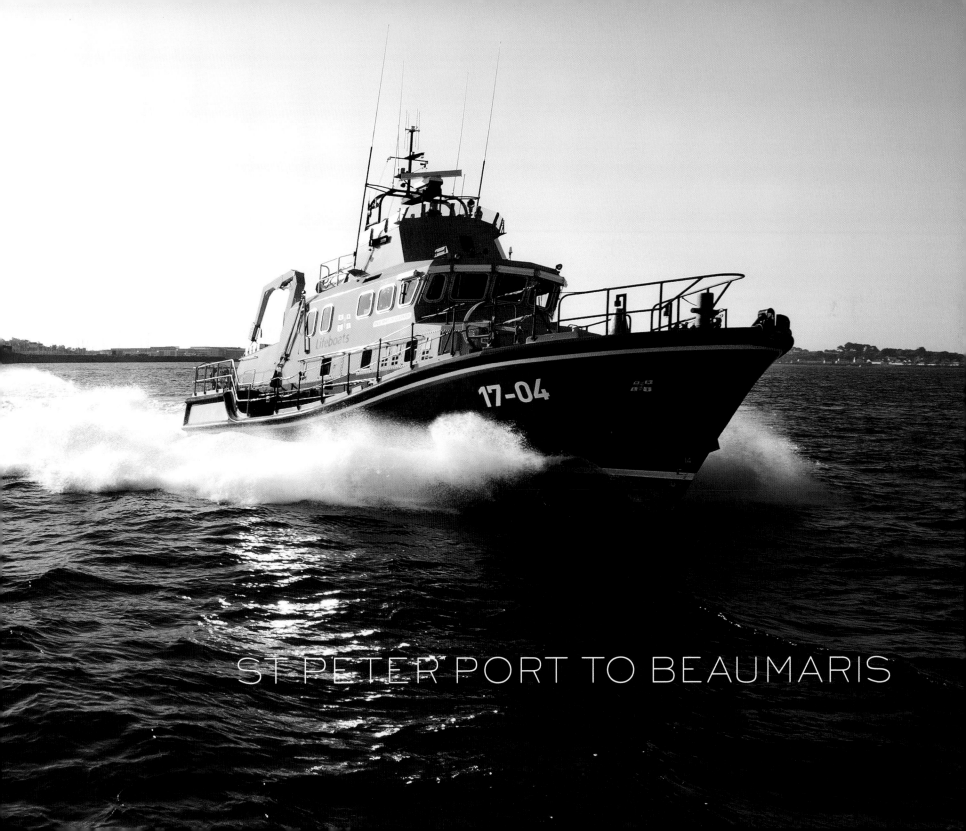

ST PETER PORT TO BEAUMARIS

CHAPTER THREE
ST PETER PORT TO BEAUMARIS

On 13 December 1981 the Ecuadorian cargo ship *Bonita*, loaded with fertiliser from Hamburg, hit heavy weather in the middle of the English Channel. They had 36 people on board, including wives and children. In Guernsey, the St Peter Port crew had just been summoned to move their Arun class lifeboat *Sir William Arnold* to a safer position in the harbour. Second Coxswain Peter Bougourd was sitting down to his Sunday lunch. 'This shouldn't take long', he said to his wife, as he got up from the table, expecting to be back before the food got cold. Other members of the crew were at home putting up their Christmas trees as the call came through.

Forty miles to the north, the *Bonita* was struggling in huge seas. A giant wave had caused the ship's cargo to shift and she was unable to right herself from a heavy starboard list. Having lost her engine power, the Captain sent a Mayday alert. The RNLI volunteers in Guernsey were already aboard the lifeboat when they heard they were needed and at 1.23pm they headed out to sea. A rescue helicopter had raced to the scene and despite the 100-knot winds had managed to take four people off the *Bonita* before its rotor blades began to ice up and its crew could not risk any more rescue attempts.

The *Sir William Arnold* reached *Bonita* at 4.30pm and the situation looked impossible. One moment the lifeboat would be on the crest of a wave level with *Bonita's* stern, the next she would be in a trough, below the propeller. In a series of approaches, a line was thrown to the ship, which people could then attach to themselves. They had to jump into the raging seas and be pulled aboard the lifeboat. After sixteen people had been rescued, coxswain Mike Scales drew away for a moment to give the crew a chance to gather themselves.

Less than ten minutes later they returned and pulled off the remaining casualties who could jump for their lives. A rescue helicopter was able to pick off another crewman who had broken both of his legs. Another injured motorman who had also broken his leg had been lashed to the hatch so as not to be swept away by the huge waves. With hypothermic, exhausted and injured people in need of urgent medical attention, Scales reluctantly decided to head to shore. A French tug later got the motorman to safety after he'd spent a harrowing night alone tied to his ship. The lifeboat finally reached shore at Brixham in Devon, which was the nearest port, at 11.13pm, after ten hours at sea. Of the 29 they had rescued, only one died from his injuries in hospital.

It was a brutal week in which Britain's coasts were ravaged by storms. Many RNLI boats were called out to sea: the Beaumaris lifeboat had rescued a fishing boat off Anglesey in a blizzard and off the Yorkshire coast the Humber lifeboat had come to the aid of another stricken cargo ship. And fatefully, in Cornwall, the crew of the Penlee lifeboat *Solomon Browne* put to sea on 19 December and never returned.

Coxswain Mike Scales was awarded the RNLI Gold Medal for Gallantry and his crew all received Bronze Medals. At the same ceremony, the wives and mothers of the Penlee crew received posthumous medals on behalf of their husbands and sons. The December storms of 1981 took a heavy toll. It was a week of courage and loss that will always be remembered by the RNLI.

Previous pages: St Peter Port Severn class *Spirit of Guernsey* races out of the harbour to exercise in the summer sunshine.

John Webster was a crewman during the *Bonita* rescue. 'There was real strength and depth on the boat that night. Peter Bougourd, John Bougourd and Peter Bisson all became coxswains after Mike Scales. That's four coxswains, present or future. A great team.'

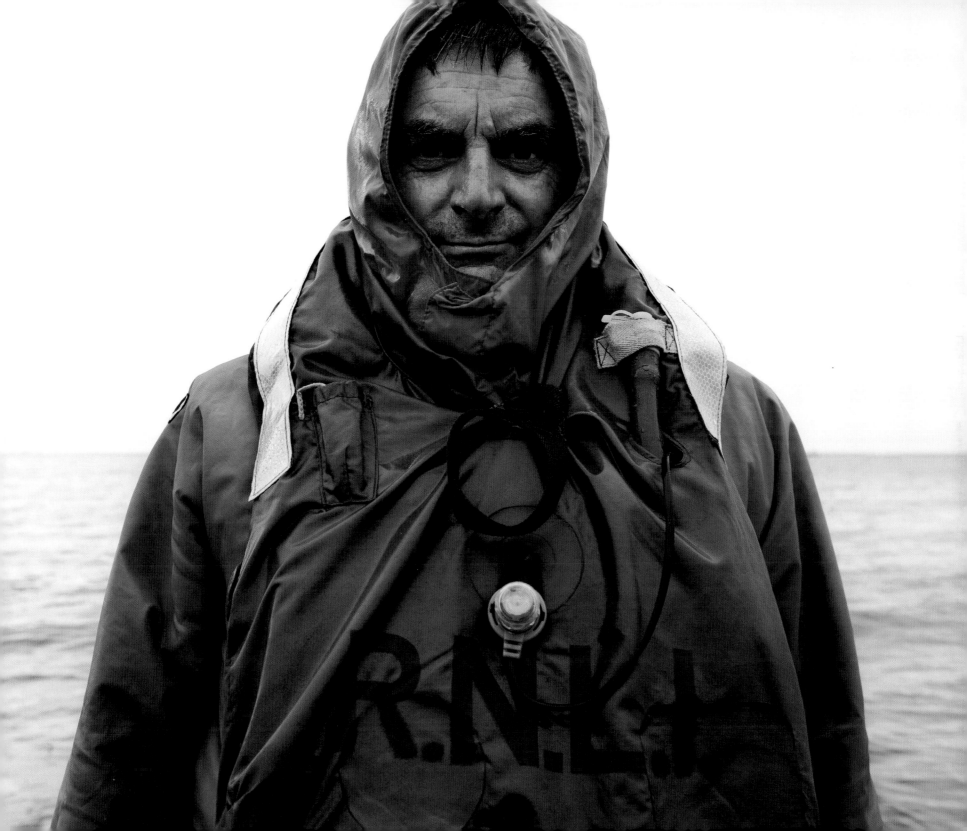

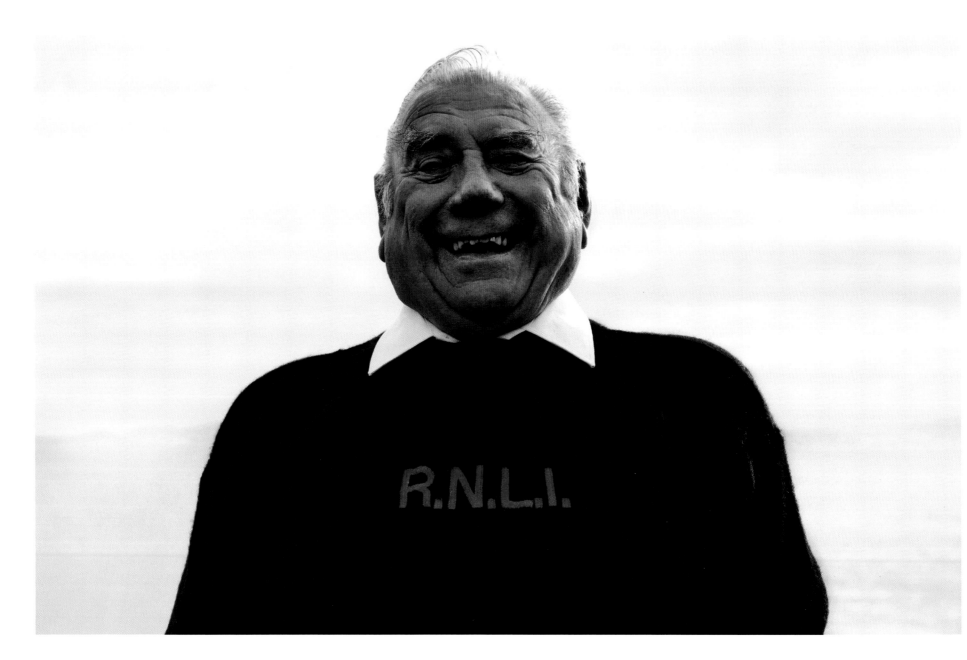

Peter Bougourd was second coxswain during the *Bonita* rescue and later became coxswain of the Guernsey boat. 'My wife said I wasn't worth a brass farthing in the garden for a fortnight after that rescue.' Peter wears the distinctive RNLI 'Guernsey' — the eponymous fisherman-style sweater still made here on the island by Guernsey Woollens and worn by crews all around the country. The wool is Midnight Blue 085 and RNLI is embroidered in Red cotton 1037, with 4,583 stitches in all.

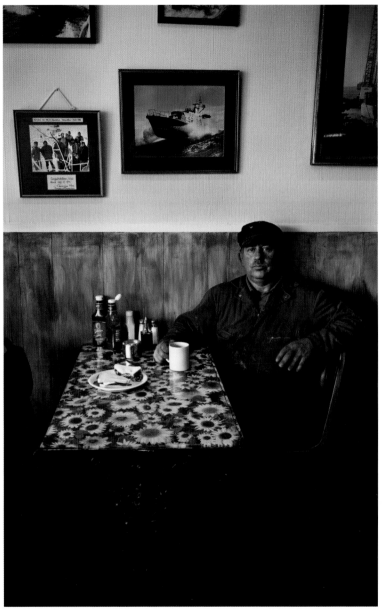

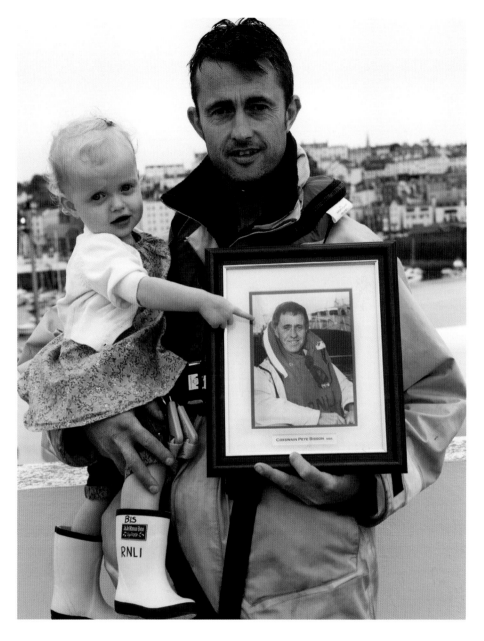

Richard Hamon, crewman during the *Bonita* epic, takes breakfast in a café at St Peter Port's harbour just around the corner from the lifeboat shed. The photographs on the wall show Richard and the crew arriving back in Guernsey after the rescue and their lifeboat at the time, the Arun class *Sir William Arnold*.

Today the lifeboat mechanic in Guernsey is Carl Bisson pictured with his daughter Luisa. His late father Peter was one of the volunteers that stormy Sunday night back in 1981. 'I joined the crew because my dad was on it', says Carl. 'When I was a nipper I used to come down to the station with the old man and then I joined properly when I was 21. My dad was the coxswain by then. He spoke a bit about the rescue, but was always a modest man. I was only seven at the time, but I remember the day they went. The weather was so bad we lost all the TV reception. As I got older I realised what they did, what they had achieved that day. And I'm proud of him.'

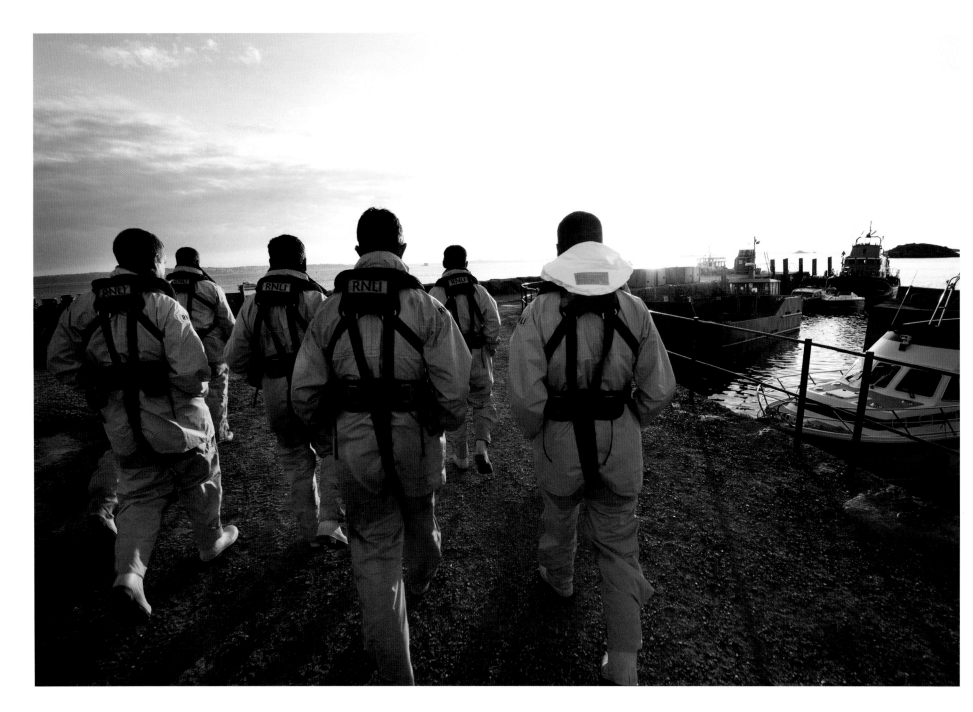

After a moment ashore in Herm, a small island to
the east, the Guernsey crew rejoin their boat.

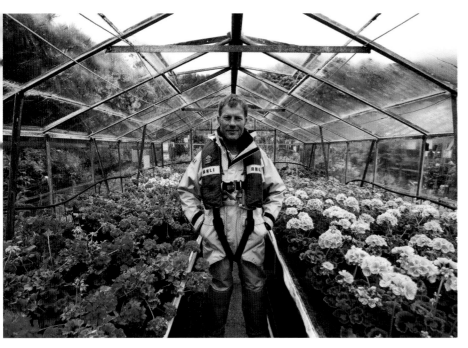

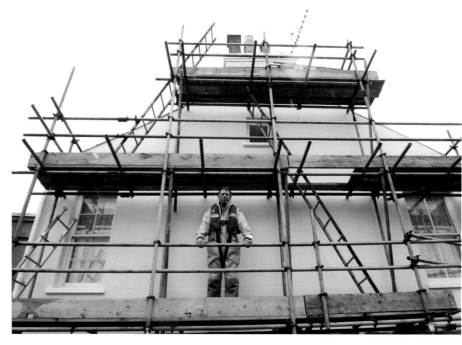

Lifeboat crew from the Channel Islands have day jobs as varied as anywhere in the country. In Alderney, mechanic Billy Watt is a crane-driver working on the breakwater; Jack Bingham gets his hands dirty in the local garden centre and crewman Dean Geran is a scaffolder. In Jersey, St Catherine helmsman Jamie Copsey works at the award-winning Durrell Wildlife Conservation Trust, though he's not yet had to rescue one of their Chilean flamingos.

As the St Catherine's lifeboat made one final search up Jersey's west coast, the beam of their spotlight picked up a fishing marker buoy about a mile offshore. In the waves they could just make out a strange shape, then a faint noise was heard. There was a little boy in the water.

An inbound aircraft had sighted an upturned boat floating out to sea in St Ouen's Bay earlier that day, the afternoon of 10 May 1997. Within 20 minutes the St Catherine inshore lifeboat had been launched. Three hours after a search had begun, the lifeboat crew finally heard the boy's cries for help in the dark. He'd been on a fishing trip with his father that afternoon, when their small open boat capsized and strong currents swept it away from their grasp. They managed to swim to a nearby buoy and, as night fell, his father then decided to try and swim for the shore to get help. He lashed his son to the marker buoy using a cord on his lifejacket. He turned for a moment to reassure him, then swam off and disappeared from sight. In time, the boy could no longer hear his father's voice. He called to him but there was no reply, only the sound of the waves, and soon there was nothing but darkness.

When they found him, the ten-year old had been in the water for five hours. It was a miracle that he had survived. He was transferred into the St Helier lifeboat and safely taken to the local hospital. At dawn the lifeboat resumed its search for his father. He had drowned trying to get help, making the ultimate sacrifice — saving the life of his son.

Opposite page: Nigel Sweeny, current Lifeboat Operations Manager at St Catherine, was the helmsman of the lifeboat who found the boy that night. It is something he will never forget.

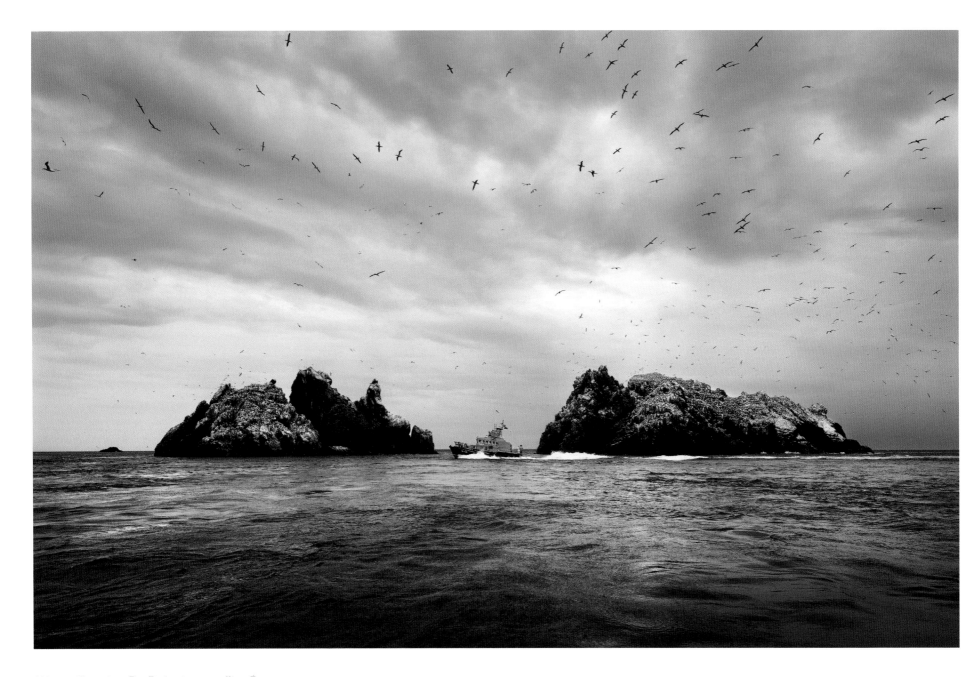

Alderney Trent class *Roy Barker I* motors off Les Étacs gannet
colony in unusually kind conditions. The waters here are known
to be particularly difficult, with severe winter swells and fierce
running tides.

In Alderney, Lifeboat Operations Manager David McAllister is a successful fishmonger. There's always a collecting box not far away.

Dave Turner, guardian of the lighthouse at La Corbière, is a talented model maker
whose lifeboats have pride of place at the St Helier station. His studio shed in his
lighthouse-keeper's cottage is a model-maker's delight.

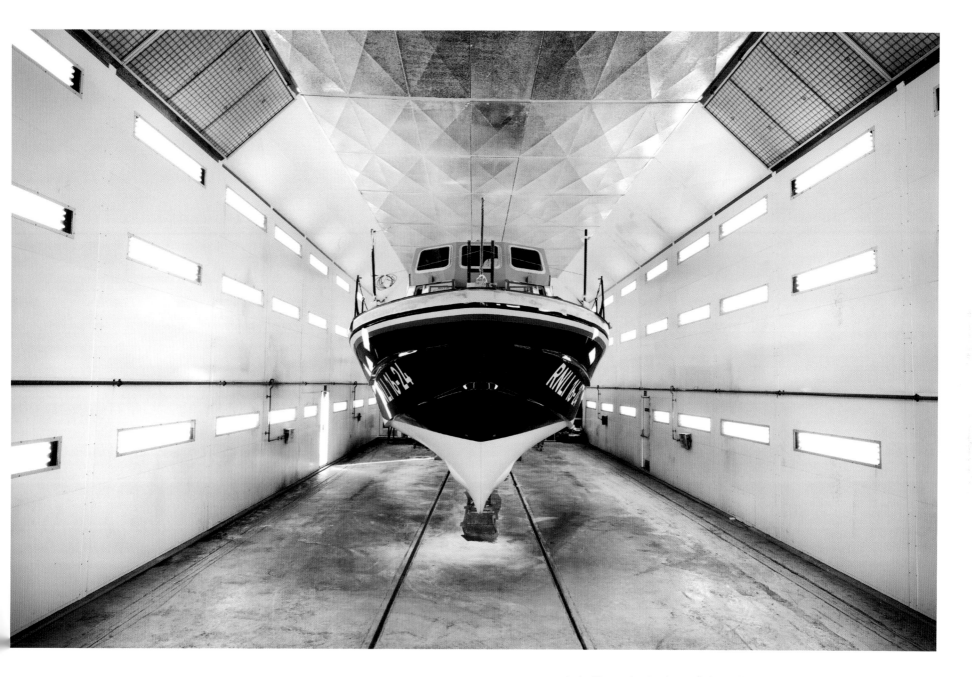

In the Plymouth paint shop at Babcock Marine, Porthdinllaen's new Tamar class lifeboat *John D Spicer* gets its first coat of paint in RNLI colours. In the early years of the RNLI, lifeboat hulls were painted in pale blue, later changed to the dark Royal Blue seen on today's lifeboats. To be precise, today's modern blue is Pantone 281 and the distinctive red and yellow trim uses Pantone 032 and 109. And RNLI orange, known around the world, is Pantone 021.

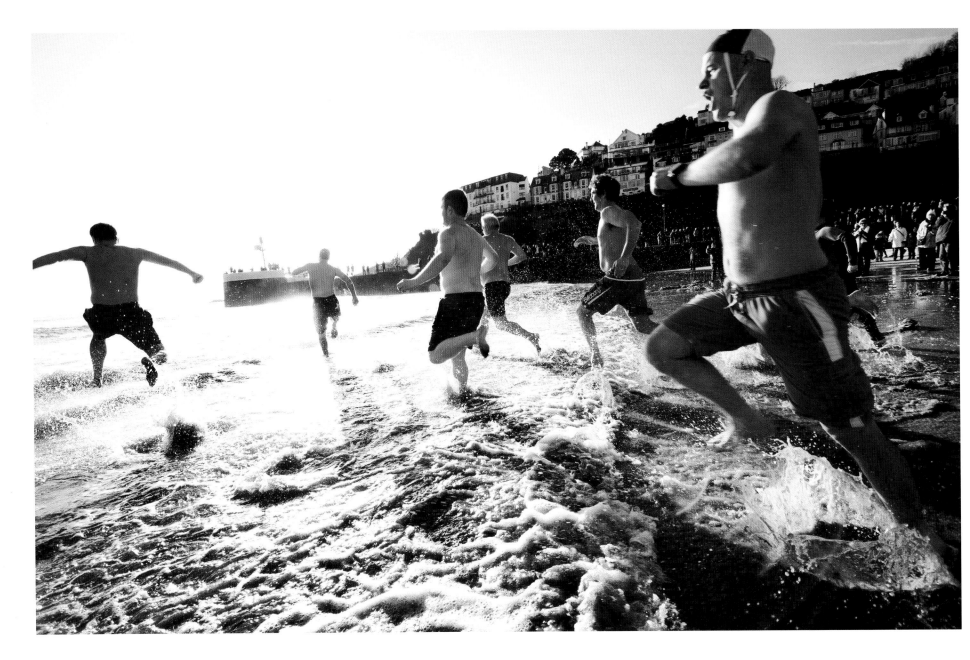

At Looe, the crew brave the cold for a New Year's Day swim.

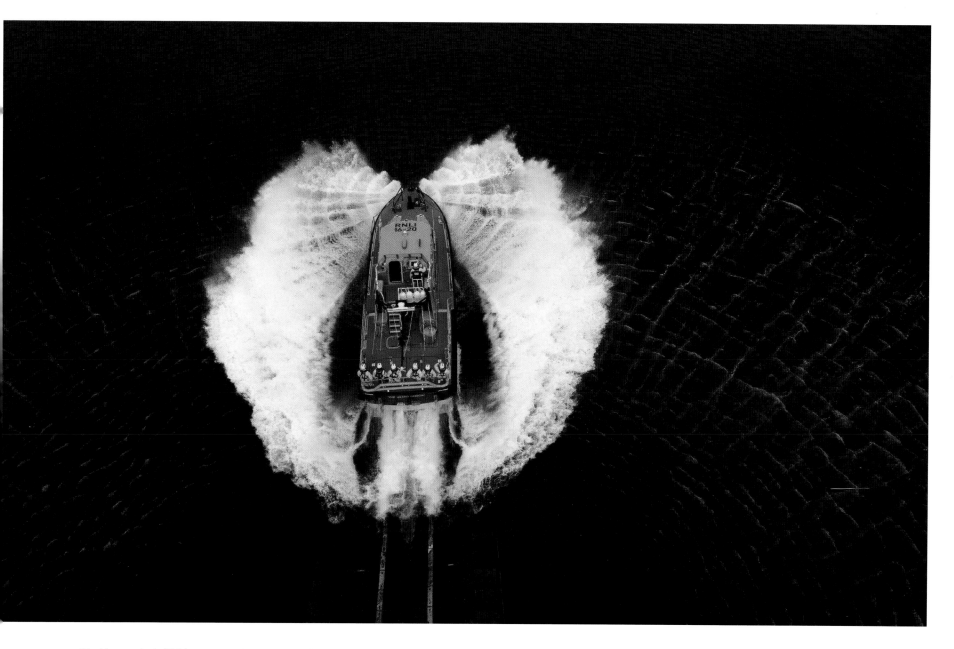

The biggest single RNLI rescue was in 1907, when lifeboats from Cadgwith, Coverack, The Lizard and Porthleven rescued 456 people from the White Star liner *Suevic*, which had run aground off the Lizard in foul weather. The lifeboat crews worked all through the night, pulling hard on their oars in waters whipped up by the storm. Meanwhile, women from villages on the Lizard lit fires on the beach, sometimes rushing into the water to help children to safety. Today's all-weather lifeboat at The Lizard is a Tamar class *Rose*, launched down a slipway from its award-winning new boathouse.

Slipway launching looks spectacular but is an incredibly precise and controlled process. The crew board the lifeboat while it is still in its boathouse. The chains holding the boat in position are released at the right moment and the boat slides down its slipway into deep water. To recover a slip-launched lifeboat, it has to be carefully manoeuvred so that its keel rests on the bottom of the slipway; a cable is then attached to it by the shore crew and it is winched stern first up into the boathouse. In tough weather, launch and recovery is fraught with difficulty, but when lives are at stake the best is expected of RNLI crews.

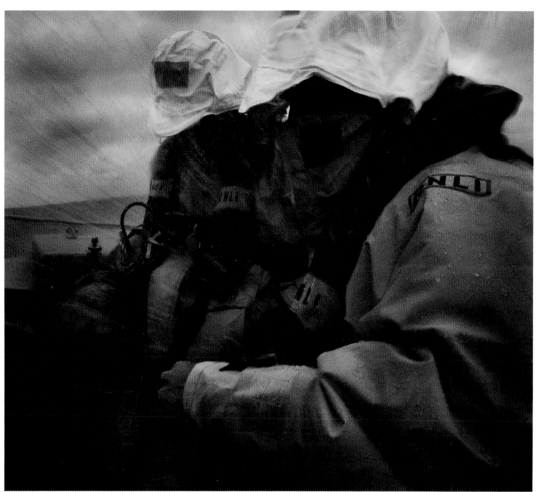

One of the biggest expansions of RNLI operations in the last decade has been through the success of the beach lifeguard units. RNLI lifeguards now patrol more than 200 beaches and no where are they more in demand than the busy coastline of Cornwall.

RNLI lifeguards are qualified in lifesaving and casualty care, highly trained, strong and fit. They must be able to swim 200 metres in under 3 ½ minutes, and run 200 metres on sand in under 40 seconds. The lifeguards monitor sea conditions and set up the appropriate flags, watch the people on the beach and offer safety advice both on the beach and in classrooms in schools across the country. Off Hayle's golden sands, a lifeguard rescue water craft and an Arancia rescue boat respond to a casualty in the water.

Above: Three miles off the Lizard, the crew exercise in heavy seas, not unusual here all through the year.

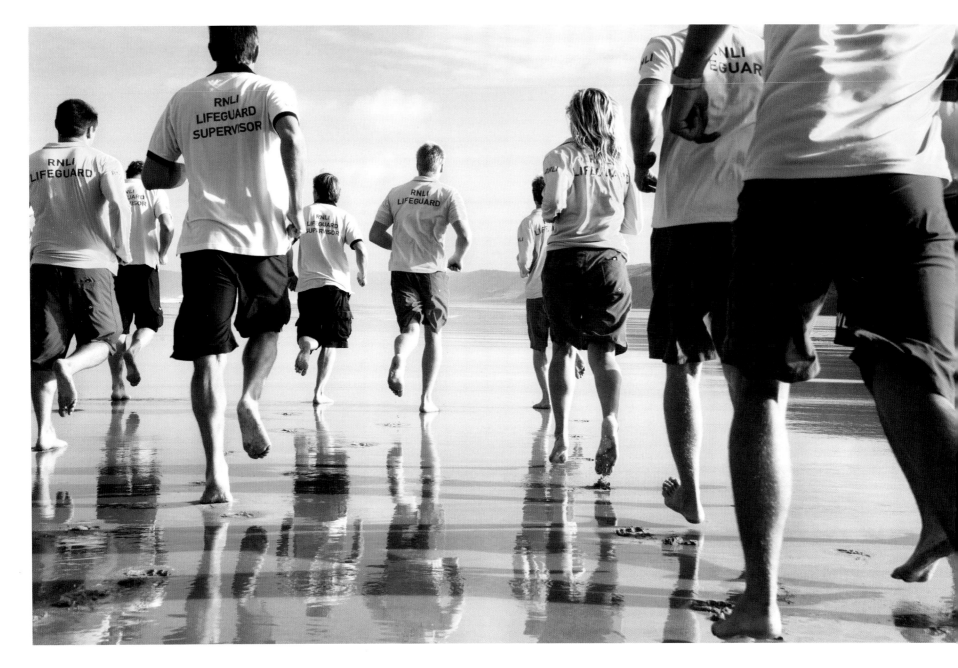

Up early for a morning's training session on Perranporth beach, before going on duty for the day.

Opposite top left: Fundraisers Holly Wallace and Sophie Warren are part of the RNLI's 'Face to Face' team.

Opposite bottom left: At Praa Sands, Becki Morris and Leah Smith watch swimmers from their truck at the water's edge.

Far right: At Poldhu Cove on the Lizard, RNLI lifeguard Alex Wake draws his lookout chair down the beach as the tide falls.

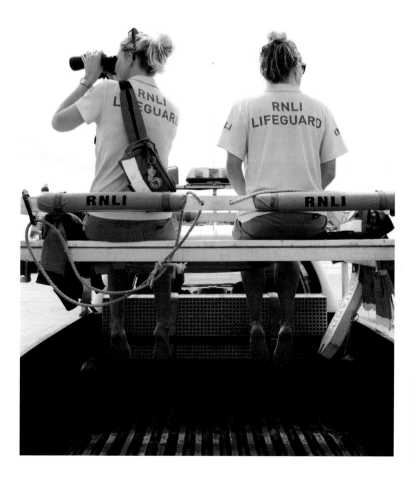

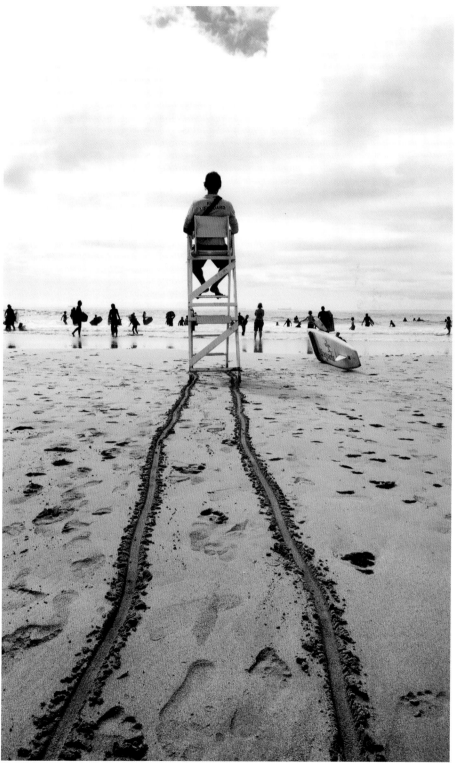

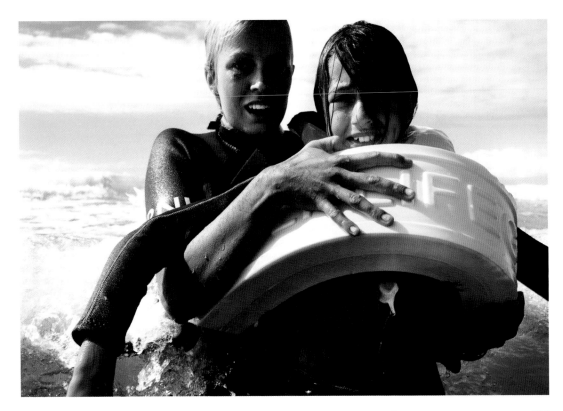

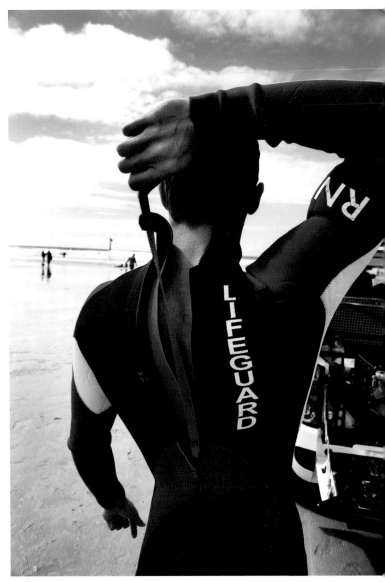

Throughout the summer in Cornwall, RNLI lifeguards watch over some of the busiest stretches of our coasts as holidaymakers make the most of the rare sunshine. Emilie Williams at Watergate and Louis Darrock at Constantine both have their hands full.

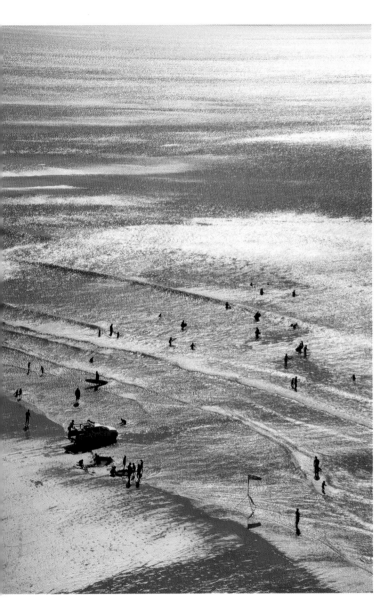

From the cliff-top at Wheal Coates mine, we gaze down on the golden sands of Chapel Porth, where the lifeguards have just set up their safe swim zone.

At low tide the causeway at St Michael's Mount brings visitors over in their thousands on the busiest summer days. Yet, as the tide advances, it quickly disappears beneath the waves.

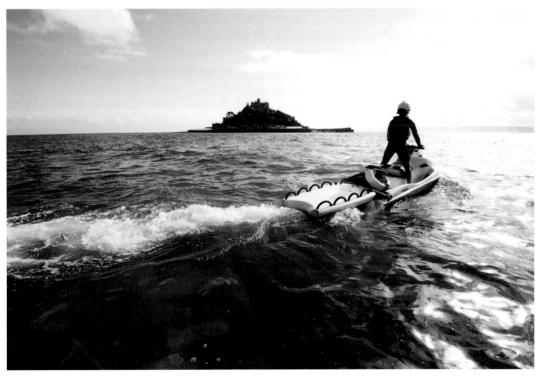

In 1981 Mousehole was a close-knit fishing community, at the heart of which was the Penlee lifeboat. On the night of 19 December the village was all set for Christmas. As people were enjoying themselves, warm in their homes, outside the weather had deteriorated rapidly from strong winter winds to a wild gale. As the weather worsened, out at sea a ship was struggling with engine failure.

The coaster *Union Star* was on her maiden voyage, carrying fertiliser from Holland to Ireland. On board with skipper Henry Moreton and his four-man crew were his pregnant wife and her two daughters. Moreton had picked his family up en route so they'd all be together for Christmas. A few miles off Land's End, near the Wolf Rock lighthouse, the ship's engine cut out and Moreton put out the news on the radio. A nearby tugboat offered help but negotiations over salvage broke down and the captain refused assistance. It was a decision that would prove fatal.

As the storm worsened, and still unable to start the engines, Moreton put out a distress call to the Falmouth Coastguard as his ship was washed increasingly closer to the jagged rocks off the southern Cornish coast. In gusts of nearly 100 mph, a Sea King helicopter was dispatched from RNAS Culdrose but, such was the ferocious state of the sea, it was unable to lift a single person to safety. By this point the tug was also in the vicinity, but Moreton held out and, in any case, the *Union Star* was now in such a position near the coast, in waves upwards of 50 feet, that the tug's

skipper felt it impossible to get close enough to establish a link and was unwilling to risk the lives of his crew in the attempt.

At this point, the *Solomon Browne*, the 47ft wooden Watson-class lifeboat raced down its slipway into the raging seas of Mount's Bay. Aboard were eight men, all volunteers from the village of Mousehole, under the command of coxswain Trevelyan Richards. He had chosen his crew carefully; with him were his very best. It took the lifeboat more than an hour to reach the scene, and repeatedly it steered alongside the pitching ship. Then horrified locals on the clifftops saw one giant wave pick up the lifeboat like a toy and dash it across the cargo hatches of the *Union Star*. In the darkness and chaos of the enormous swell a few were seen running out across the deck, jumping for the lifeboat where open arms hauled them inside. After it slid off again, the lifeboat sent a simple radio message. They had rescued four and were going back for more. Then there was silence.

The Coastguards kept on calling through the night, but there was no response. The morning light revealed the upturned hull of the cargo ship, still being pounded relentlessly by huge seas. And, along the shore and in the waters, were the splintered remains of the wooden lifeboat. Everyone involved was dead, sixteen souls in all. The eight men of Mousehole, all volunteers, had made the ultimate sacrifice.

A helicopter pilot who witnessed the rescue attempt told a later inquest: 'Truly, these were the bravest men I have ever seen.'

The inquest revealed the details of the tragedy. *Union Star*'s engines had flooded with water and the lifeboatmen had done all that they could, saving four and then making a second attempt that took all their lives. The storm had a violence and power that was unprecedented. Only the cruel sea was to blame.

As Christmas approached, the disaster became headline news. A whole country mourned the loss, the nation grieved. Penlee became known round the world as a byword for sacrifice, their names added to the long roll of courageous volunteers who gave their lives for those in peril on the sea. In the end only eight bodies were recovered: four from the Union Star and four from the *Solomon Browne*. On Christmas Eve and Boxing Day the people of Mousehole buried their dead.

Coxswain Trevelyan Richards was posthumously awarded a Gold Medal and Bronze Medals were awarded to his crew: Stephen Madron, Nigel Brockman, John Blewett, Charles Greenhaugh, Kevin Smith, Barrie Torrie and Gary Wallis.

The old boathouse at Penlee Point stands empty today, a permanent memorial to those brave few who gallantly gave their lives. Each year in Mousehole they turn off their Christmas lights for an hour on the anniversary of the tragedy. Some wounds may never heal, but the men will always be remembered. Wreaths and flowers are tied to the railings beside the old boathouse each year. On one family's handwritten message is this simple tribute: 'Shine on you crazy diamonds. Gone but never forgotten.'

Janet Madron has just been awarded the British Empire Medal for her services to the RNLI. Janet lost her husband Stephen in the Penlee disaster but has been fundraising ever since.

Dudley Penrose and Raymond Pomeroy draw back the doors in the old Penlee boathouse. Dudley was head launcher that fateful night, with Raymond as his winchman. They both waited for their boat, but it never came back.

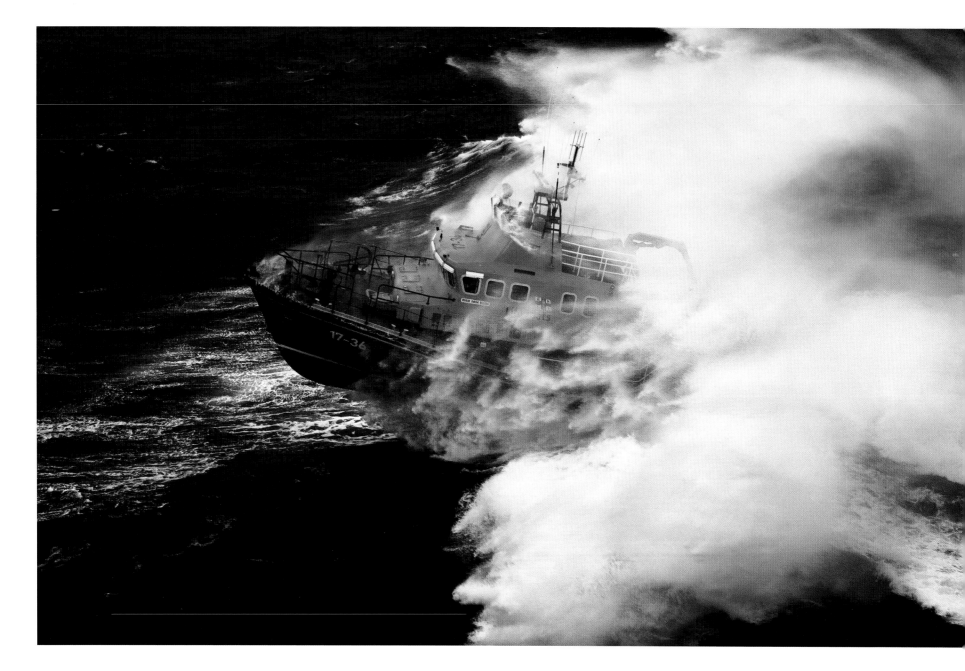

Today's Penlee lifeboat, the Severn class *Ivan Ellen*, charges through the rough waters of Mount's Bay, out into the English Channel. Another day, once the storm has passed, she stops for a while in the beautiful harbour of Mousehole.

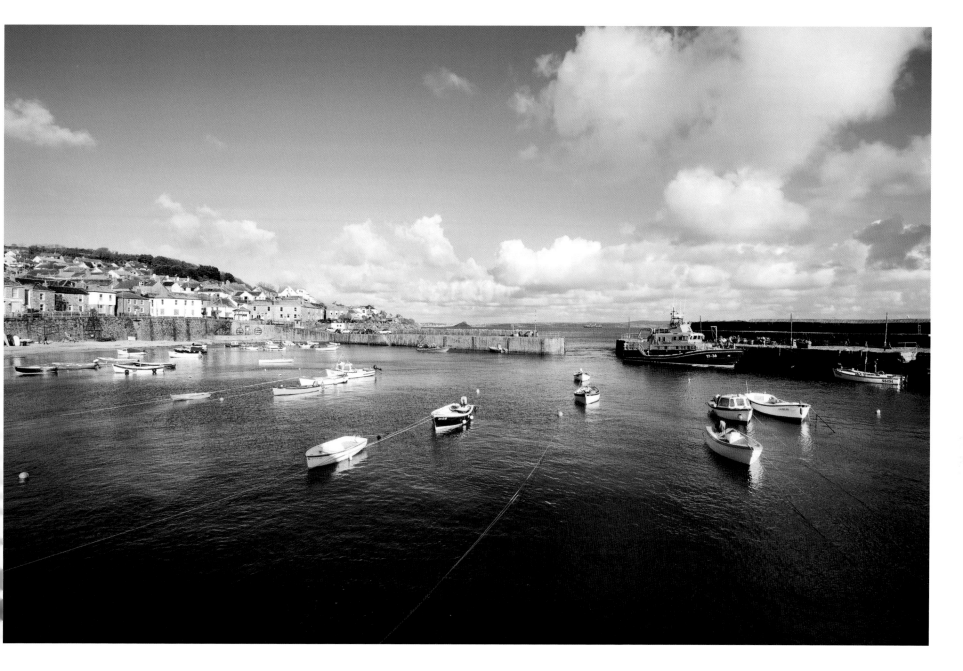

Following pages: In gale force conditions off the lighthouse at Bishop Rock, the westernmost point of the Isles of Scilly, the St Mary's Severn class *The Whiteheads* powers through the Atlantic swell. Islanders and visitors alike here are grateful for the presence of the lifeboat.

173

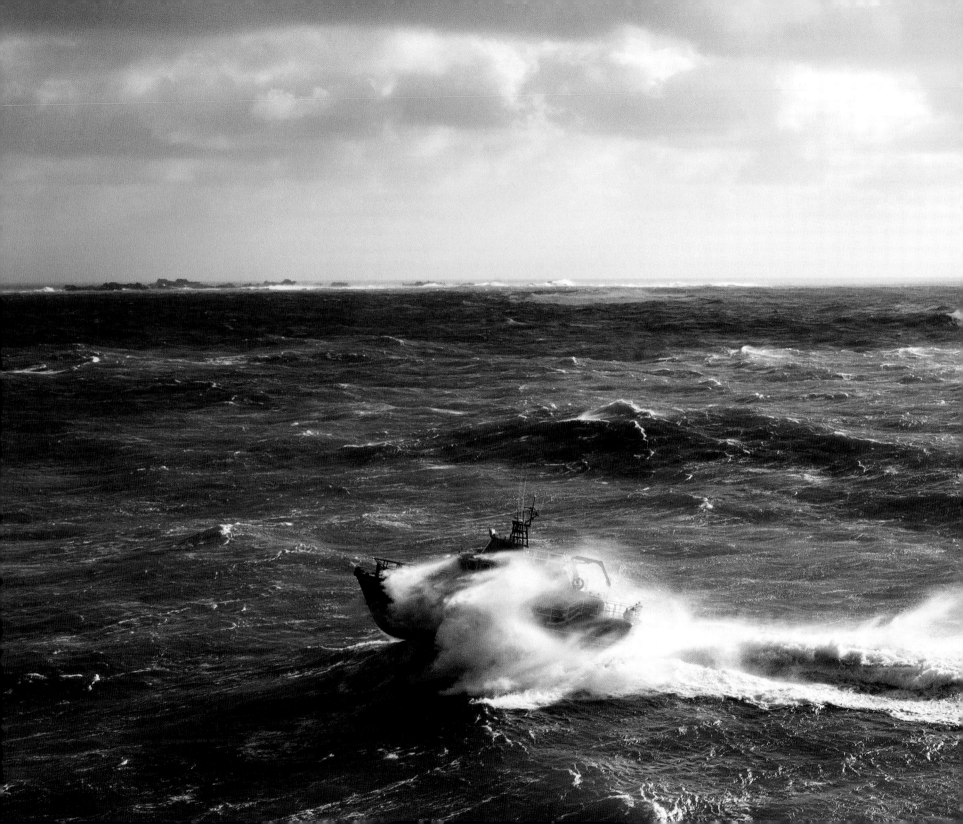

It is often said that Britain's south-west coast gets the best and
the worst of the weather. On a sunny day in St Ives, the beach
lifeguards at Porthmeor still have a lot on their hands.

Former St Ives coxswain Tommy Cocking comes from a legendary lifeboat family. His father was coxswain 22 years before him and in the tragedy of 1939, when the St Ives lifeboat capsized, his great-grandfather and grandfather were drowned. Tommy's daughter sometimes drives the tractor that launches the lifeboat and his brother Robert is now the coxswain here.

Tommy served at the station for almost four decades and in his time has helped to rescue countless lives. He received Vellums for his part in the rescues of the yacht *Ladybird*, and the coaster *Lady Kamilla* during which the lifeboat capsized. In 'retirement' he is now one of a number of coxswains putting the new Shannon class protoype through its paces. After such dedicated service, Tommy says his most memorable rescue was a child. 'The boy was washed out of Hayle Estuary in the dark and we picked him up in the middle of St Ives Bay,' he says. 'He was washed out about one mile and it was his eleventh birthday.' They had heard the boy screaming and used a flashlight to locate him. 'If our lifeboat never saved anyone ever again, she paid for herself that night.'

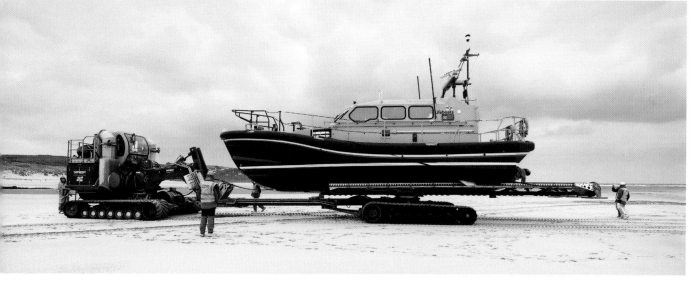

On the beach at Hayle, with Tommy as its coxswain, the RNLI Trials team practises launch and recovery with the Shannon class prototype. St Ives will be one of the first stations in the country to receive this innovative new lifeboat when their current Mersey class comes to the end of her operational life.

Above: We meet Stephen Bassett inside one of the St Ives shelters for fishermen. From a family of seafarers, Stephen is now the Harbour Master here and supports the RNLI as a tractor driver on the shore crew.

Right: The St Ives D class *Colin Bramley Parker* works in tricky conditions inshore off Carn Everis at the eastern end of Porthmeor beach.

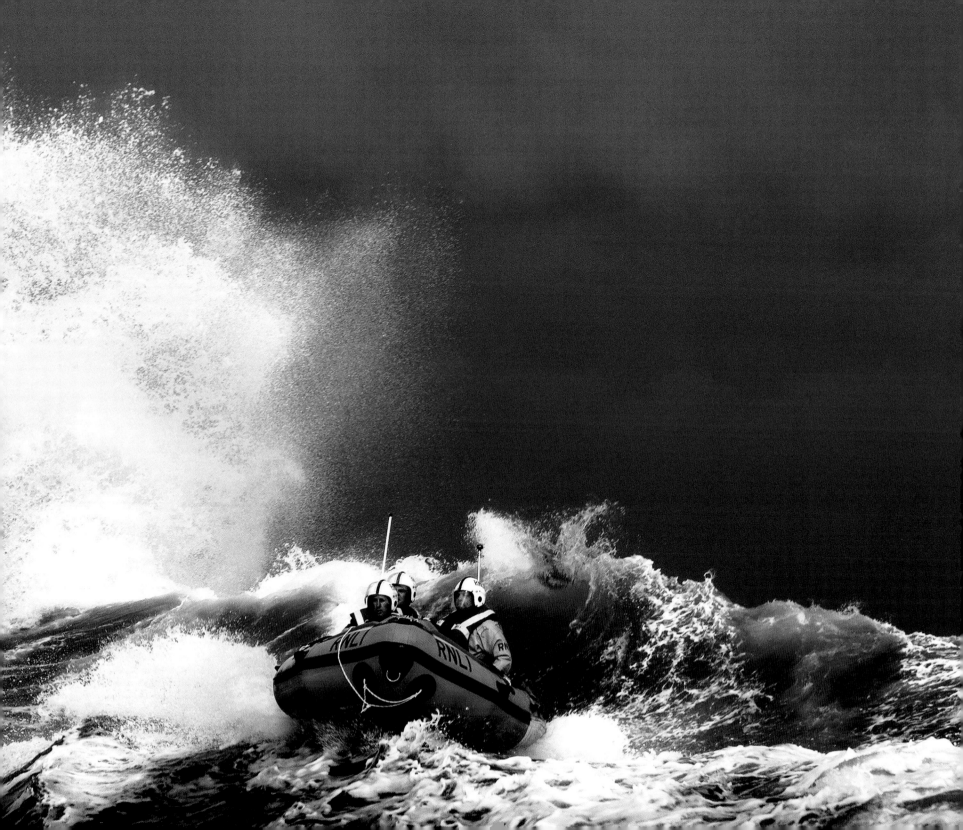

Up the coast in St Agnes, the fundraisers are out in force during their Lifeboat Day.

Fundraiser Chrissie Davies came to Cornwall from Wales five years ago and has been supporting the RNLI ever since. She's also an active member of the Perranporth surf lifesaving club, and when she's not teaching at Truro school, she assists the RNLI on the beach during the holidays, volunteers for the St Agnes lifeboat station as treasurer and helps out in their shop on weekends for good measure. 'It sounds like a lot, but I wish I had the time to help even more', she tells us. 'I'm surrounded by passionate and energetic people, it's a community really, so it's a whole lot of fun. Every penny we can raise is vital to the crews, you know. We want to make sure they've got the best kit, and that people can enjoy their holidays down here and feel safe on the water. Being part of something like this is reward in itself.'

Her Majesty The Queen has been the Patron of the RNLI for 60 years and with her support the charity has gone from strength to strength. She recently visited the boathouse in St Ives and was greeted by hundreds of locals who lined the seafront in glorious sunshine.

Newquay's Atlantic 85 *The Gladys Mildred* launches at low water and powers off into the surf off Towan Beach.

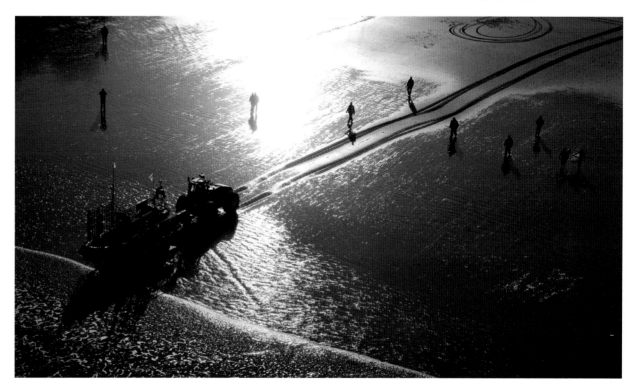

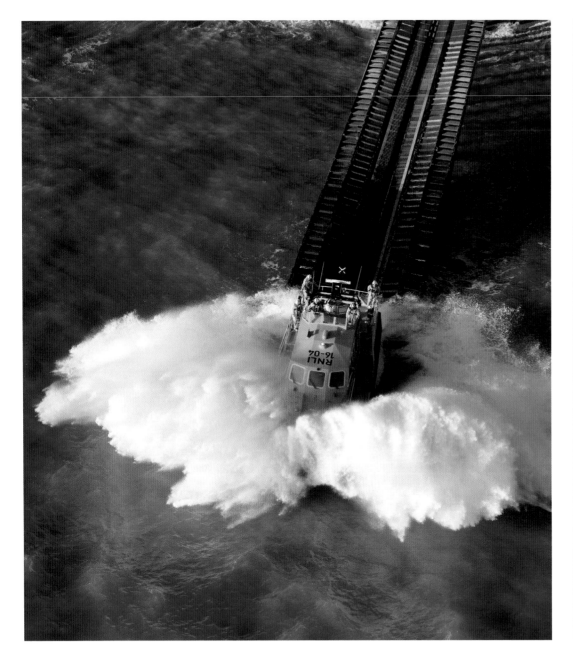

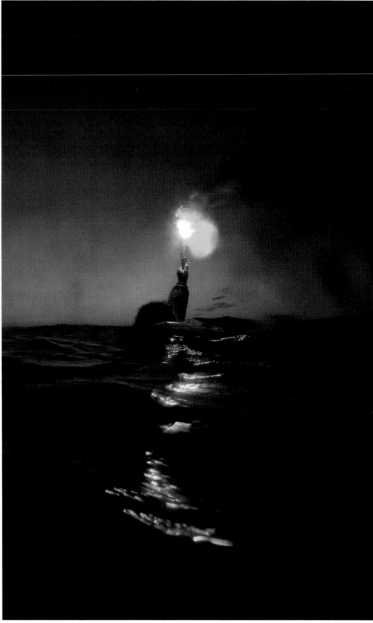

Tamar class lifeboat *Spirit of Padstow* hurtles down the slipway at
its new boathouse at Trevose Head. It can now launch into deep
water at any state of the tide.

When there are casualties in the water in the middle of the night,
you are lucky if you have a flare to guide you. RNLI crews have to
respond as quickly as possible in these situations. Every second
counts and could make all the difference between life and death.

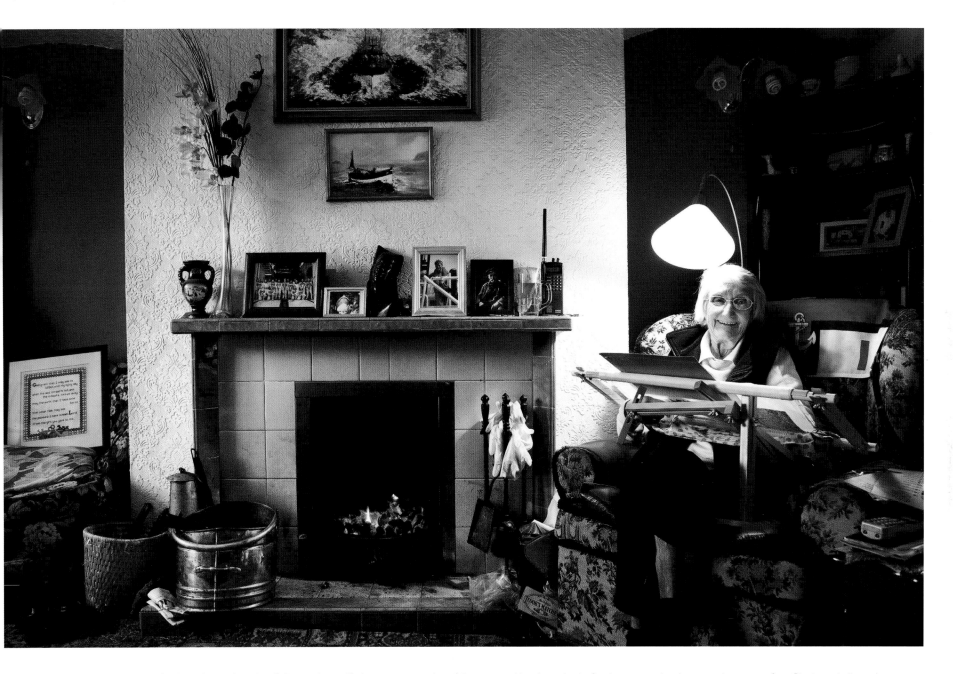

Following a great family tradition where her father and grandfather were coxswains of the Padstow lifeboats, Mary Taylor has supported the RNLI for over 70 years. 'Lifeboat Mary', as she is affectionately known here, raises thousands of pounds each year — through knitting, embroidery, making toys, collections and selling lottery tickets. And, not to forget, she bakes biscuits and cake for the crew and makes countless cups of tea. She is as dedicated as any crewmember and has a heart of gold. She's a talented cross-stitcher too and her works now grace the walls of the Padstow boathouse.

Three members of the RNLI Flood Rescue Team were awarded Bronze Medals for bravery following the rescue of a woman from a swollen Devon river during the severe flooding there in 2012. It was the very first time that Flood Rescue Team volunteers have received RNLI medals. Boat Team Leader Paul Eastment and

helmsman Chris Missen are both volunteers at Porthcawl lifeboat station, and crewman Martin Blaker-Rowe is an RNLI trainer based in Poole. They launched their rescue boat in the middle of the night, two days before Christmas. Vanessa Glover had been swept from her car after it was forced off a road by surging waters,

leaving her husband and their seven-year-old son clinging to the car roof. She managed to catch hold of a branch and was in the water for almost an hour before she was hauled to safety.

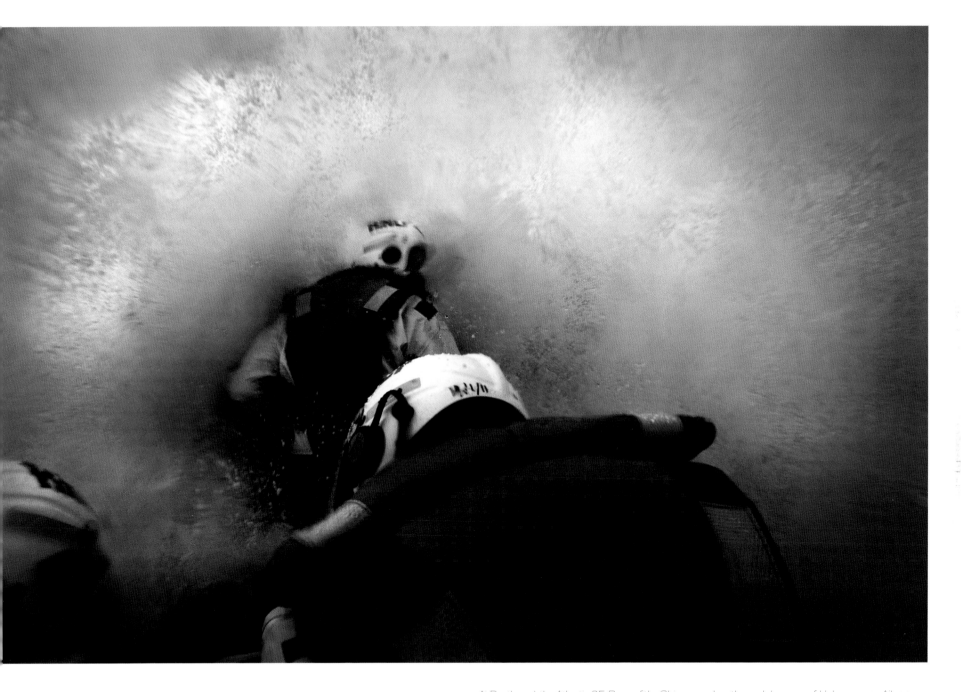

At Porthcawl, the Atlantic 85 *Rose of the Shires* punches through heavy surf. Helmswoman Aileen Jones from Porthcawl became the first female crew member to be awarded a Bronze Medal, for her part in rescuing the crew of a fishing vessel in the summer of 2004. In horrendous conditions, 20ft swells and strong tides, she managed to bring the boat to safety before it was lost on the sandbanks.

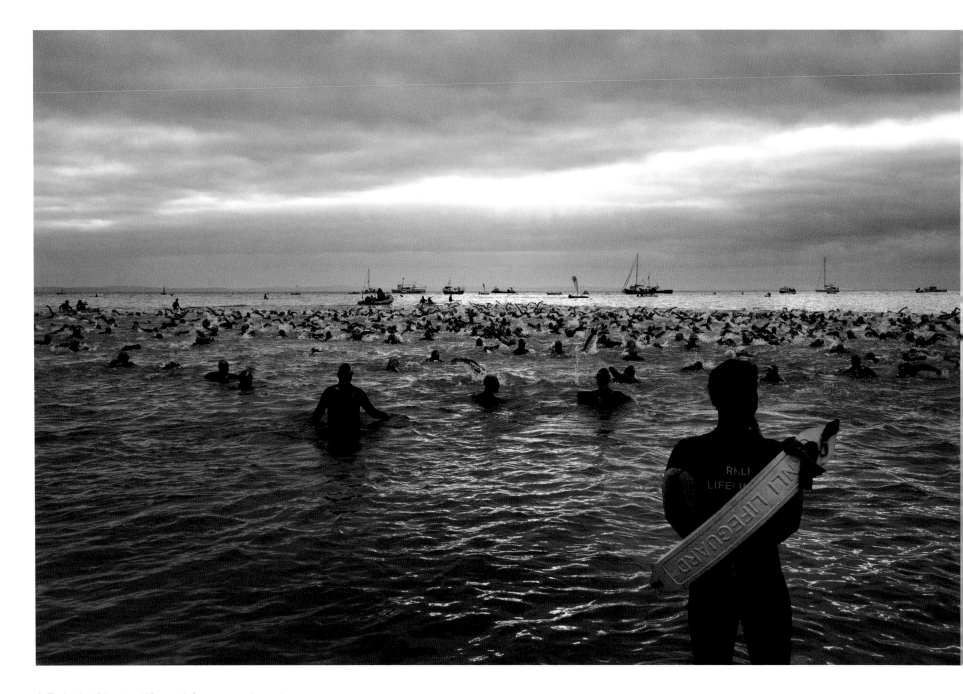

At Tenby, the lifeboat and lifeguards from across the region
came together to provide safety cover for the annual Ironman
triathlon event.

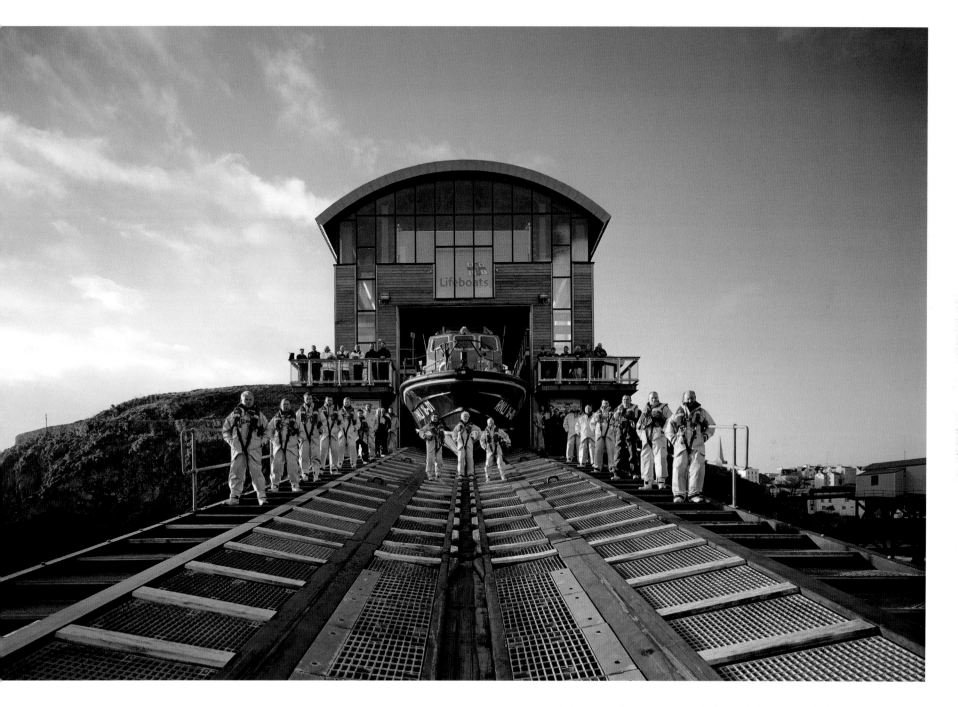

Tenby was the first station to get the first of the Tamar class lifeboats in April 2006, designed to launch from a slipway and achieve a maximum 25 knots. The *Haydn Miller* is rightly the pride of the station.

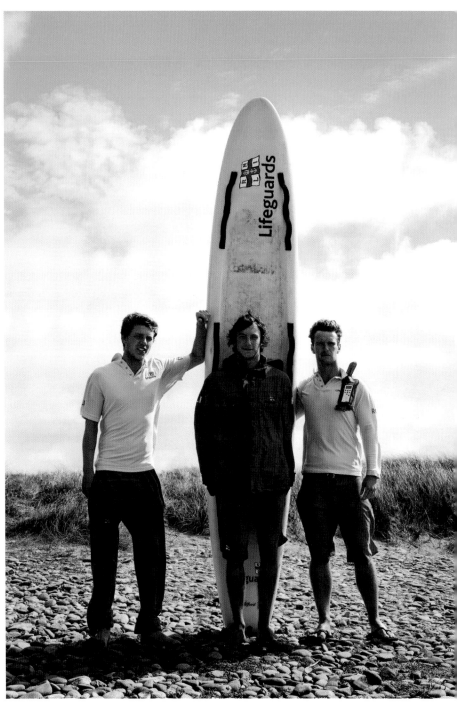

Dan James, beach lifeguard at Broadhaven in Pembrokeshire

The lifeguards of Freshwater West: Jack Abbott, Sam Trevor and
Oliver Davies-Scourfield.

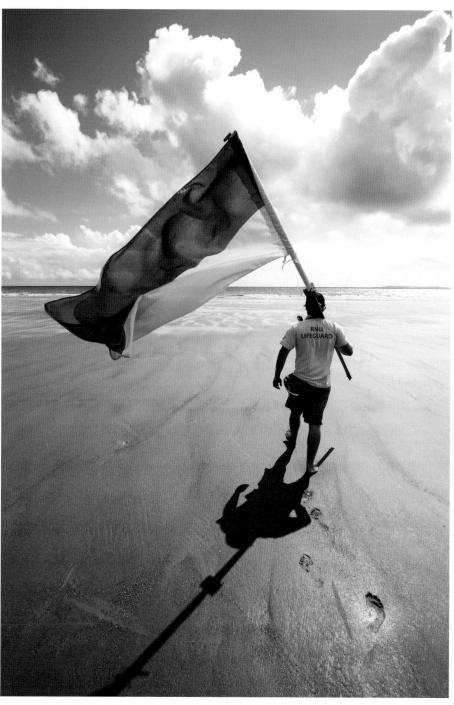

At Tenby's south beach, lifeguards Holly Watkin-Rees and Samuel Lewis are too busy for ice-cream.

In the morning at Amroth, lifeguard Ben Ablitt begins his day's work by setting out the safe-swim flags.

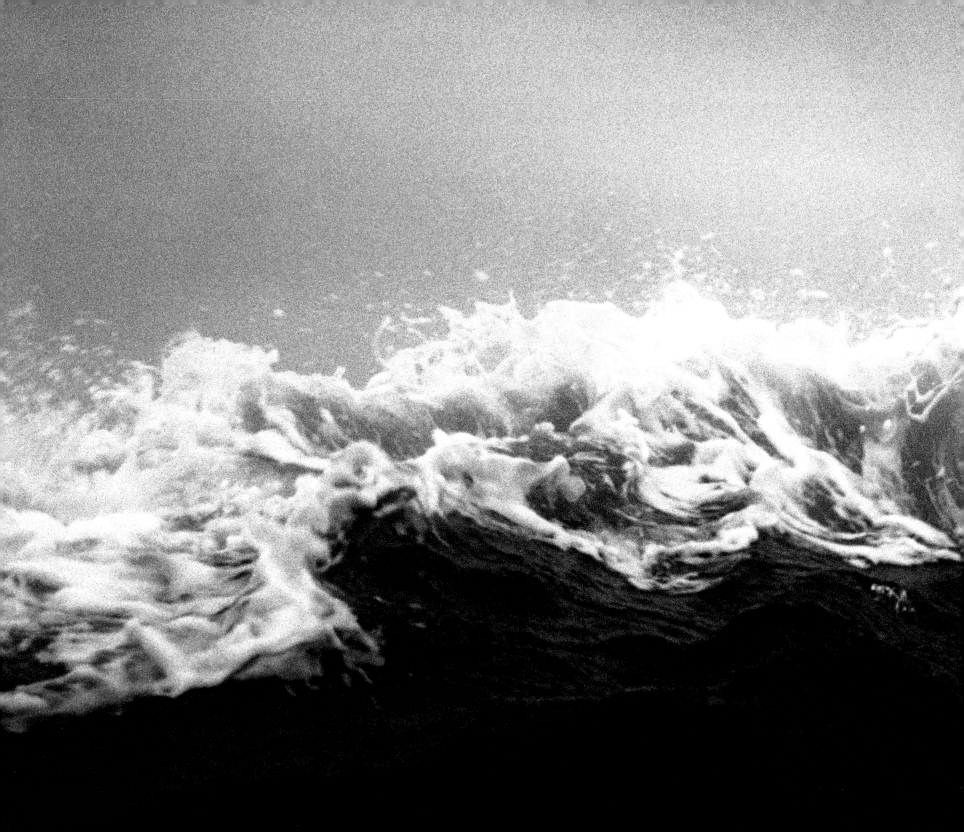

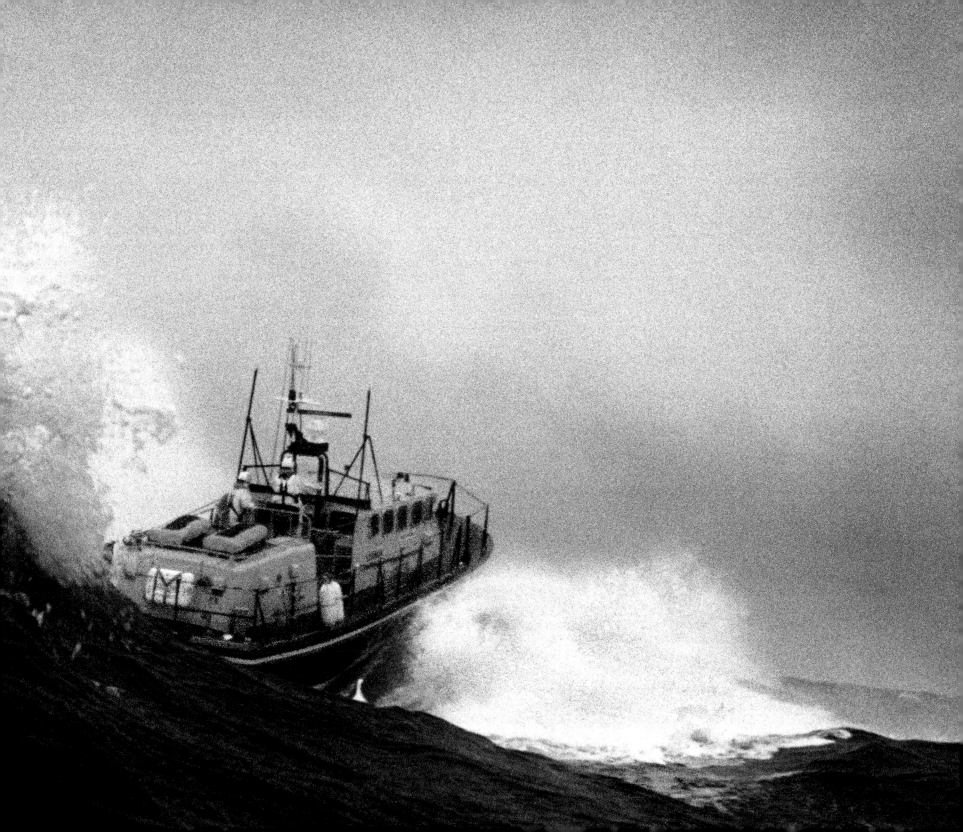

Previous pages: In Ramsey Sound, St Davids Tyne class *Garside* powers through the waves.

In October 1910, in an effort to rescue the crew of the Barnstaple ketch *Democrat*, the St Davids lifeboat rowed out into the teeth of a savage gale. On their return to shore that fateful night, Coxswain Stephens realised that they were being swept broadside onto a treacherous row of rocks known as 'the Bitches'. As she struck, the crew were thrown into the sea. Some managed to cling to the rocks themselves. As daylight approached one man set fire to his oilskins to attract attention and they were eventually plucked from the rocks by open boats sent out once the waves abated. Stephens and two other crewmen had drowned in the darkness. A wooden oar from the *Gem* hangs in the St Davids boathouse, recovered as wreckage finally washed ashore.

St Davids is now one of four stations across Wales to be getting a new £2.7 million Tamar class boat. The lovely old boathouse at St Justinian in Ramsey Sound has been home to the lifeboat since 1911, but it may have to be knocked down to make way for a new boathouse. More than 300 lives have been saved by lifeboats based at St Davids over the years and they will continue to do so when the new, improved Tamar comes on station. Named the *Norah Wortley*, it is being funded by the generous bequest of Diane Mary Symon who died in 2010.

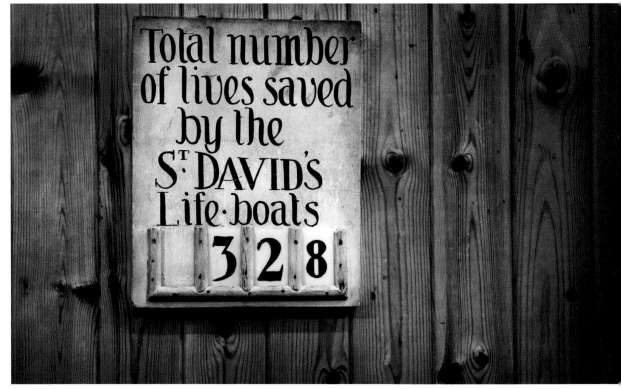

Total number of lives saved by the St DAVID'S Life-boats 328

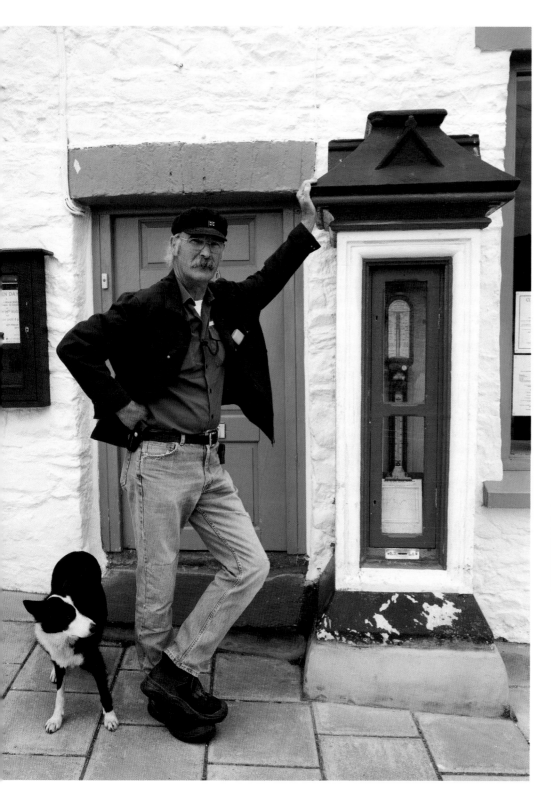

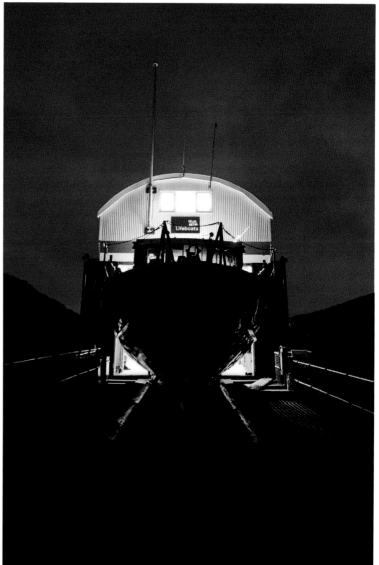

Former coxswain Malcolm Gray MBE records changes in the barometer each day before raising the RNLI flag in the small memorial garden in the centre of St Davids.

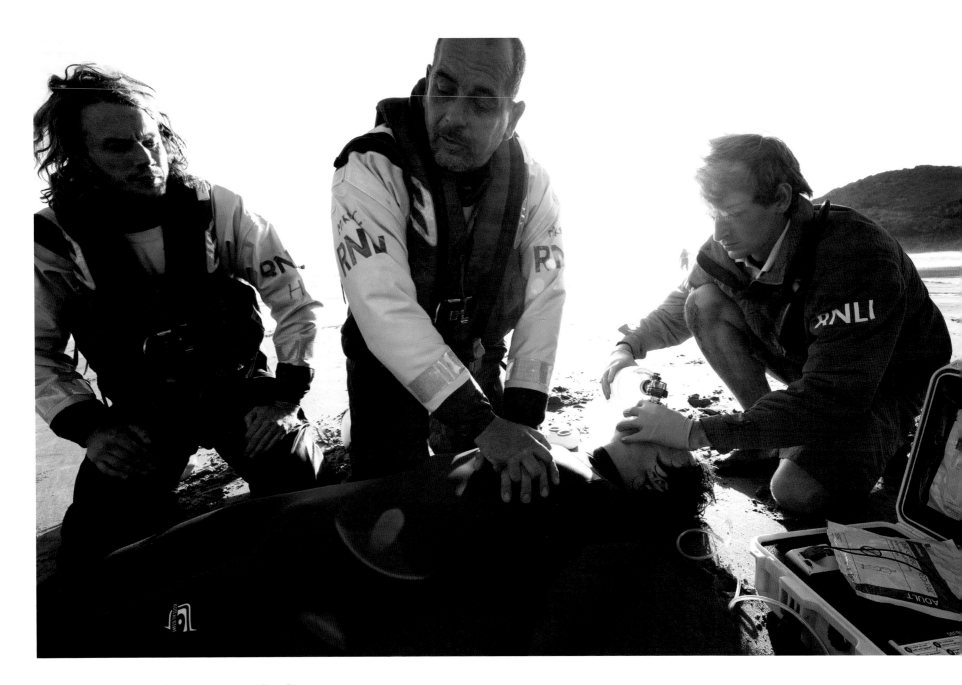

During a training exercise at Whitesands, lifeguard Sean Ellison
works in tandem with crewmen from St Davids inshore boat,
resuscitating a 'casualty' pulled from the surf.

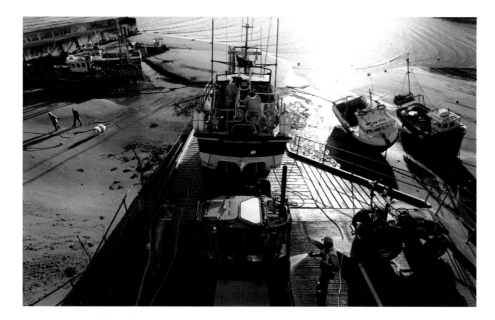

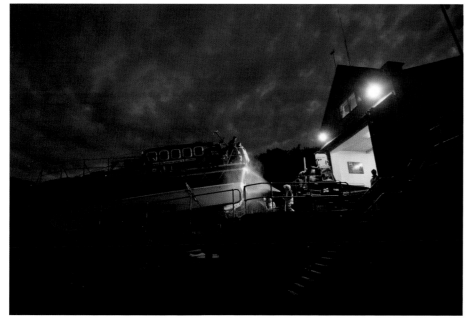

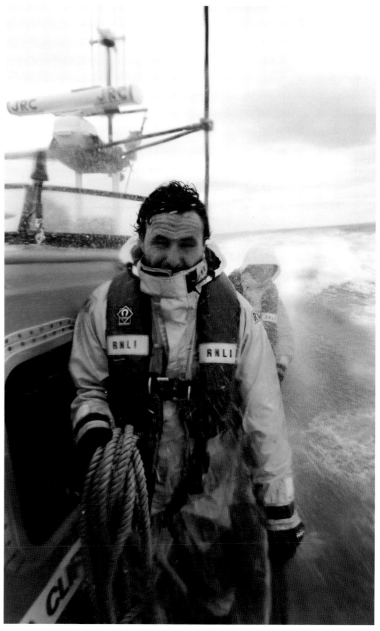

At New Quay on the Ceredigion coast, there has been an RNLI lifeboat since 1864, when it was a thriving fishing and boat-building port. The current boat is the Mersey *Frank and Lena Clifford of Stourbridge*, named after the industrialist Frank Clifford whose legacy paid for it. Fundraisers in Stourbridge in the West Midlands continue to support the station.

New Quay crewman Ceri Knapgate.

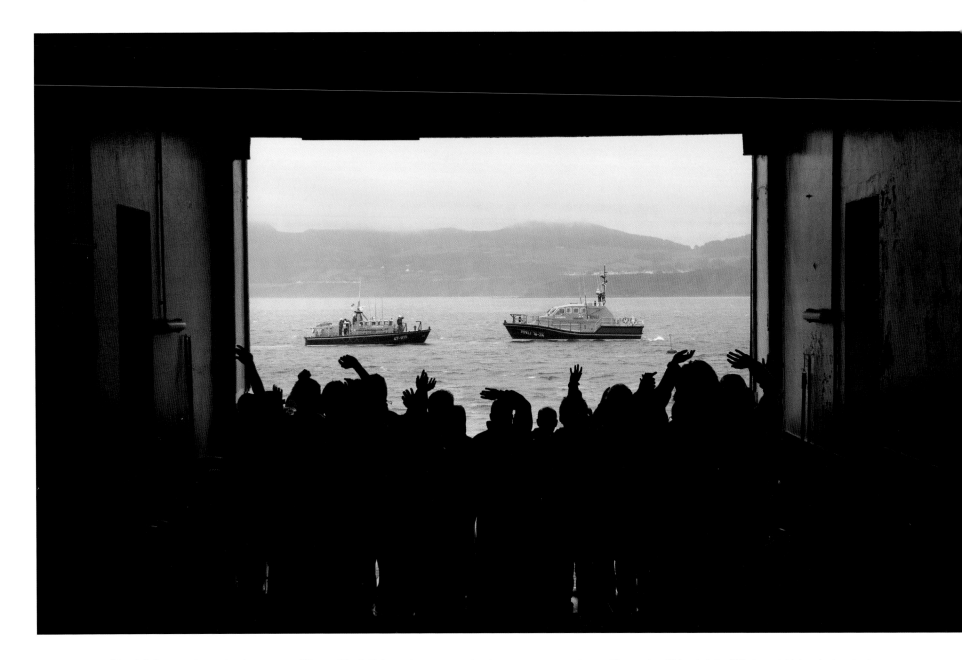

The tiny village of Porthdinllaen nestles under the western cliffs near Morfa Nefyn and, when the weather is kind, there are fine views across Caernarvon Bay up to Anglesey with Snowdonia in the distance. When we arrive here the fog is rolling in and it has started to rain. But it's a very special day indeed. Beyond the cheering arms of the crowd gathered in the boathouse, you can see the new Tamar class lifeboat *John D Spicer*, which has just arrived on station. She replaces the Tyne class *Hetty Rampton*, which had served here proudly since 1987. The two boats meet briefly before she is sailed away up the coast.

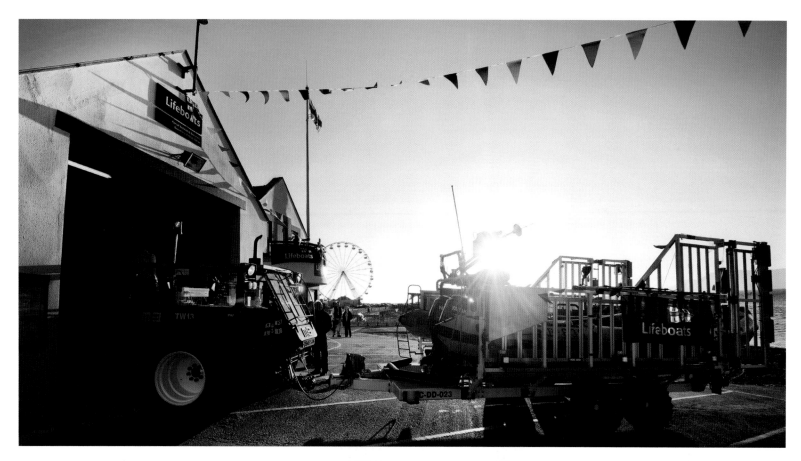

At Beaumaris the bunting is out as the new Atlantic 85 inshore boat is wheeled into position. Crowds are gathering as the Olympic torch is arriving today on its incredible tour around the country. Later that day the RNLI crew had the honour of taking the flame across the Menai Strait, accompanied by a flotilla of local boats and a rescue helicopter from RAF Valley hovering overhead.

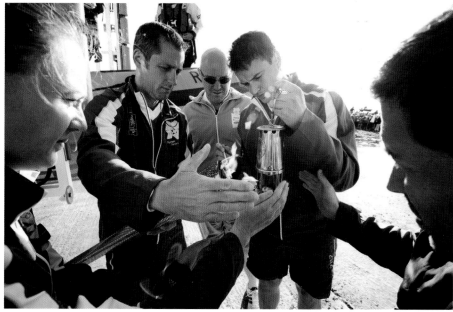

MOELFRE TO DOUGLAS

CHAPTER FOUR
MOELFRE TO DOUGLAS

A statue (opposite) now overlooks the sea at Moelfre, raised in tribute to a man – a double Gold Medallist – who justly earned himself the reputation as an RNLI 'legend'. Born in Moelfre in 1905, Dic Evans was destined to be a lifeboatman, through and through. His father, a sea captain, volunteered when he was on home leave. Both his grandfathers had also been on the crew, one of them as second coxswain. It was in his blood.

His first outing on the pulling lifeboat had come when he was only sixteen, joining the crew when called to a schooner adrift in a gale. Over the next three decades he progressed from bowman to second coxswain and eventually to coxswain when his uncle retired in 1954. His first Gold was awarded in 1959 for the rescue of the crew of the *Hindlea* in hurricane force winds. When they approached the *Hindlea*, her thrashing propellor was actually above the heads of the lifeboat crew. Gusts of over 100mph were recorded and despite these difficulties Dic made ten separate runs-in before the coaster's crew could be taken off. It was a baptism of fire indeed for one of the lifeboat crew, Hugh Jones. It was his first time in the boat.

On 2 December 1966, the crews of Moelfre and Holyhead were called to the aid of the Greek ship *Nafsiporos* as it drifted without power in the Irish Sea in hurricane force winds. Between them, the two crews rescued all fifteen sailors from the stricken ship, constantly running the risk of being crushed against its sides in the enormous waves. Evans later described the experience as being 'like a ball thrown against the gable end of a house.' All lifeboat crew involved were awarded medals for their bravery and coxswain Evans and Lieutenant Commander Harold Harvey, Divisional Inspector, were awarded Gold Medals.

In later life Evans ran a butcher's shop in Moelfre and married Nancy, a farmer's daughter. He was a courageous man, yet also decent and modest. 'It's not your own life, it's the crew,' he recalled. 'When I thought I could do something spectacular and very risky I had to remember that I was risking other lives as well.'

The north-east coast of Anglesey has seen its fair share of maritime disaster. On 26 October 1859 the steam clipper *Royal Charter* was wrecked on the rocks not far from Moelfre, in one of the fiercest storms to hit the British Isles that century. A total of 133 ships were sunk, according to records of the time, and as many as 800 people lost their lives. At Moelfre, the *Royal Charter* was battered against the rocks by huge waves whipped up by winds over 100mph. Most of the passengers and crew, perhaps as many as 450 people, died that night. A century later, the *Hindlea* struck the rocks in another tremendous storm. This time however, with the redoubtable Dic Evans at the helm of the lifeboat, the sea did not claim more lives.

Following spread left: Moelfre's Tyne class *Robert & Violet* will soon be replaced by a new Tamar, which will be kept on a mooring whilst work to construct its new home begins. The Tyne has been here since 1988 and has rescued over 250 people. Moelfre's new Tamar has been funded by the generous bequest of the late Reginald James Clark, who died in June 2004. Clark, who was a merchant seaman, had been rescued by the RNLI after his ship was torpedoed during the war. He originally came from New Zealand and his family have requested that the lifeboat be named *Kiwi* in his honour.

Previous spread: In the boathouse at Moelfre, Michael Williams enjoys a quick brew after a good exercise at sea. On the wall behind him are heroes past from the station's illustrious history.

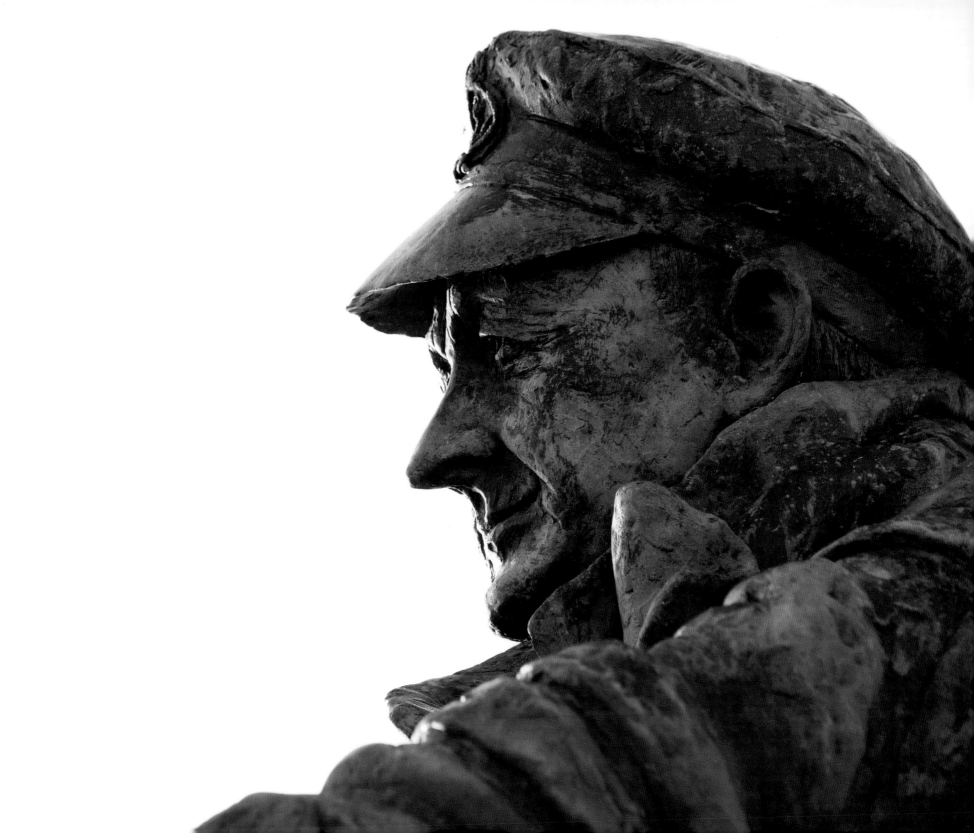

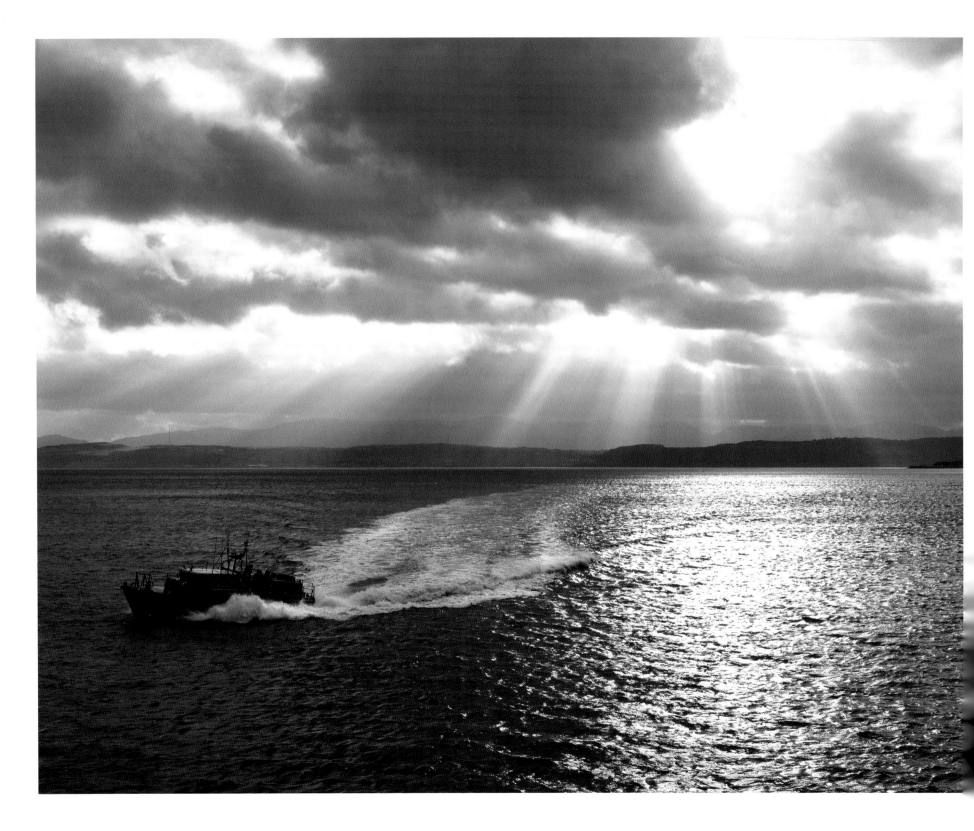

Above: The Mersey class *Andy Pearce* makes its way back to the boathouse along the Llandudno seafront after another successful outing. The boathouse in Llandudno is unusual in that it sits right in the centre of town, positioned so that it can be launched from both the north and west shores. But this was the case in 1903, before modern traffic made such launches a real logistical headache for the crew! Plans are in hand for a new boathouse to be built on reclaimed land on Llandudno Promenade close to the current slipway, and there is no time to lose, for Llandudno is scheduled to gain a new Shannon class lifeboat in 2015.

A craft designed in-house with the co-operation and expertise of crew members, the Shannon is currently undergoing sea trials. Propelled by water-jets, the first will be operational in 2014 and their speed and seaworthiness will be crucial in continuing to save lives as effectively and safely as possible. Two 13-litre 650hp engines will help the Shannon easily achieve 25 knots and her new hull shape also means the smoothest possible ride — or, as smooth as is possible, in rough seas. Get them there faster, bring them home safer, that is the key and at Llandudno, where it currently takes as much as fifteen minutes to get the boat in the water, traffic withstanding, a new boathouse is a must.

Next-door neighbours on the promenade, the members of the East Parade Bowling Club are among the first to know when the Rhyl lifeboat roars to the rescue!

Gwyneth Atkinson has been helping raise funds for the Rhyl lifeboat for over ten years. 'She's such a nice lady', one of the crew tells us. 'The work that all our fundraisers do, week in, week out, really helps us. They're all part of our family here.'

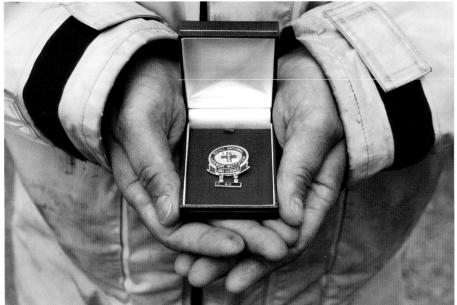

Paul Frost MBE has volunteered with the Rhyl lifeboat for four decades. You know you're in safe hands. He was part of the crew in 1973 when the Bronze medal for gallantry was awarded to helmsman Don Archer-Jones after they rescued two boys who were cut off by the tide, and clinging to a perch marking the sewer outfall between Rhyl and Prestatyn, in a gale force westerly wind and rough seas. And he has been at the centre of things here ever since, as crewman, mechanic, press officer and deputy coxswain combined. Men like Paul are what keep stations around the country going — their spirit of service is crucial to RNLI success.

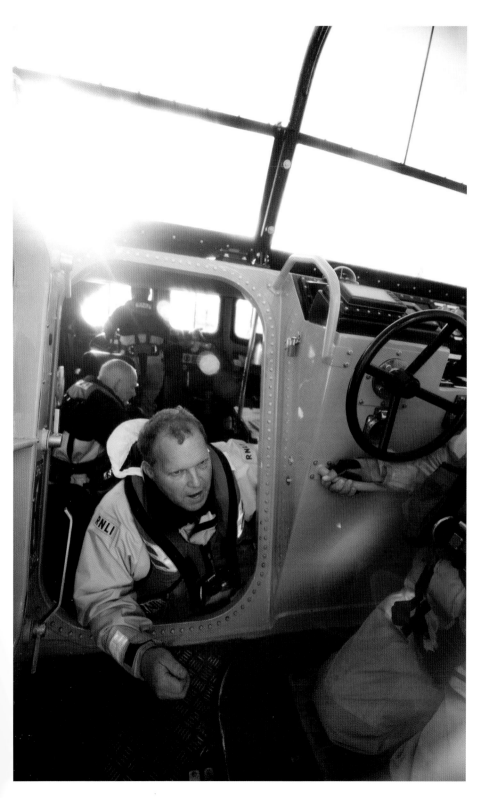

Deputy second coxswain Paul Archer-Jones relays instructions to his team-mates on the Rhyl Mersey class lifeboat *Lil Cunningham*. Back at the station after this successful shout, the lifeboat is washed down and refuelled ready for service.

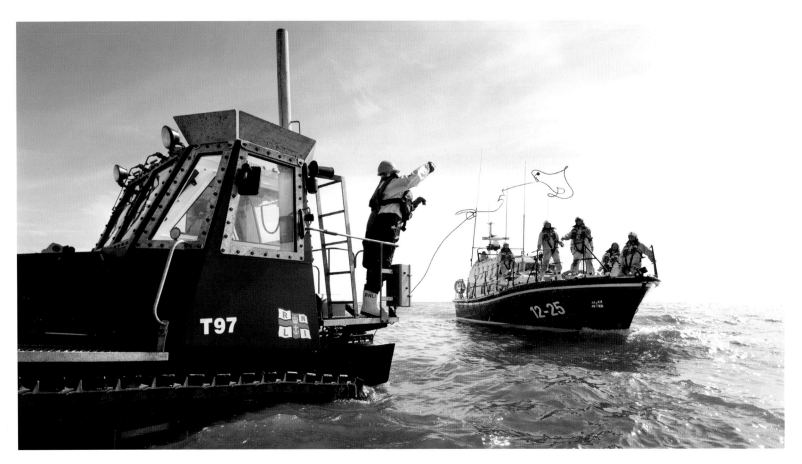

Across the Irish Sea at Clogher Head, the relief fleet Mersey class *Bingo Lifeline* returns to shore with a rescued kayaker on board. The Shannon class will be the replacement for the carriage-launched Mersey. It follows a 50-year tradition in naming all-weather lifeboat classes after rivers and this will be the first named after an Irish one. At 240 miles, the River Shannon is the longest river in Ireland, and longer than any in the UK. It is such a major waterway that the RNLI has three lifeboat stations on the Shannon — Kilrush, Lough Derg and the newly opened Lough Ree.

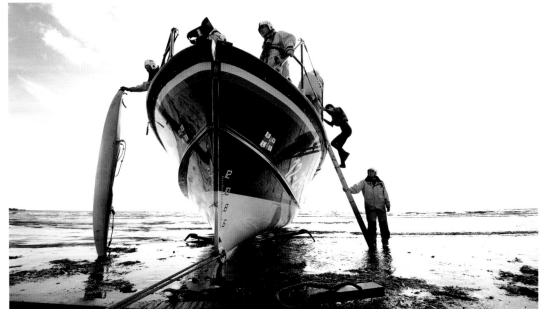

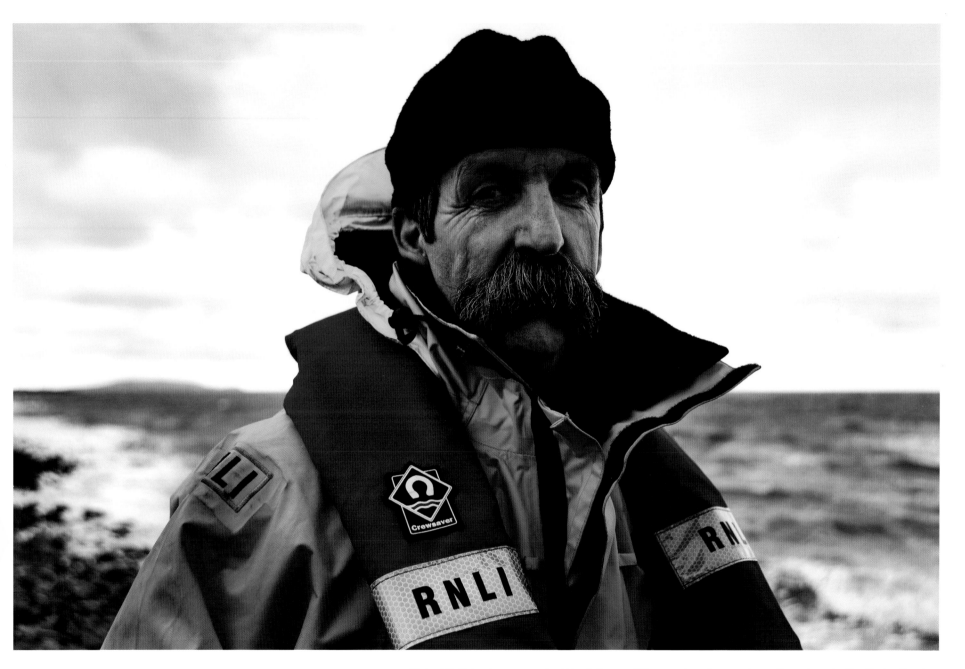

Robert Duffy has been coxswain at Howth for over 25 years, where they now have a Trent class, the *Roy Barker III*, and a D class inshore rescue boat, the *George Godfrey Benbow*. He's a man who knows the Irish Sea well through tough experience, undertaking many arduous rescues over the years. In 1995 he was awarded the 'Thanks of the Institution inscribed on Vellum', for a rescue that winter when he had made fifteen approaches to save five crew from the fishing vessel *Vision*, which was aground, holed and taking on water off Lambay Island, east of the Burren Rocks Beacon. He battled on through rough seas to recover the remaining survivor stranded on the island.

Opposite: Ned Dillon is coxswain at Arklow, the oldest RNLI station in Ireland. Dating back to 1826, a lifeboat came here just two years after the Institution was founded. And the reason — the notorious Arklow Bank, a narrow, treacherous sandbank some fifteen miles long, about six miles off the coast, plus others closer to the shore to the south, which have claimed hundreds of ships over the years. As a fisherman, and now a skipper running a boat to the offshore windfarms here, Ned has weathered many a storm over the years.

Arklow Trent class *Ger Tigchelaar* heads out on a training exercise in the early morning light

Baby Faye doesn't yet know it, but the RNLI saved her daddy's life. Brian O'Carroll had capsized whilst sailing a dinghy off Wicklow and, unaware that the Arklow lifeboat had been launched to his rescue, he felt sure that he would perish without ever knowing his unborn child. 'But when I saw that large bright orange rescue boat', he recollects, 'my spirit soared with a relief and elation that I had never felt in my life. Thank God for the RNLI!' Just a few months later, Brian was able to see Faye come into this world.

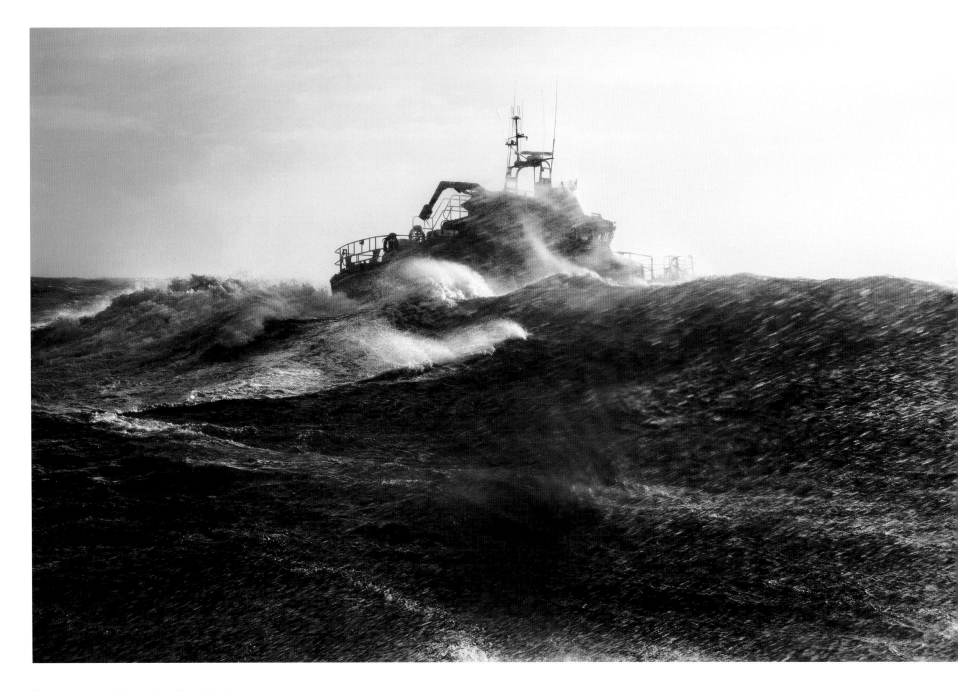

Rosslare Harbour Severn class *Donald and Barbara Broadhead* storms out into the Irish Sea.

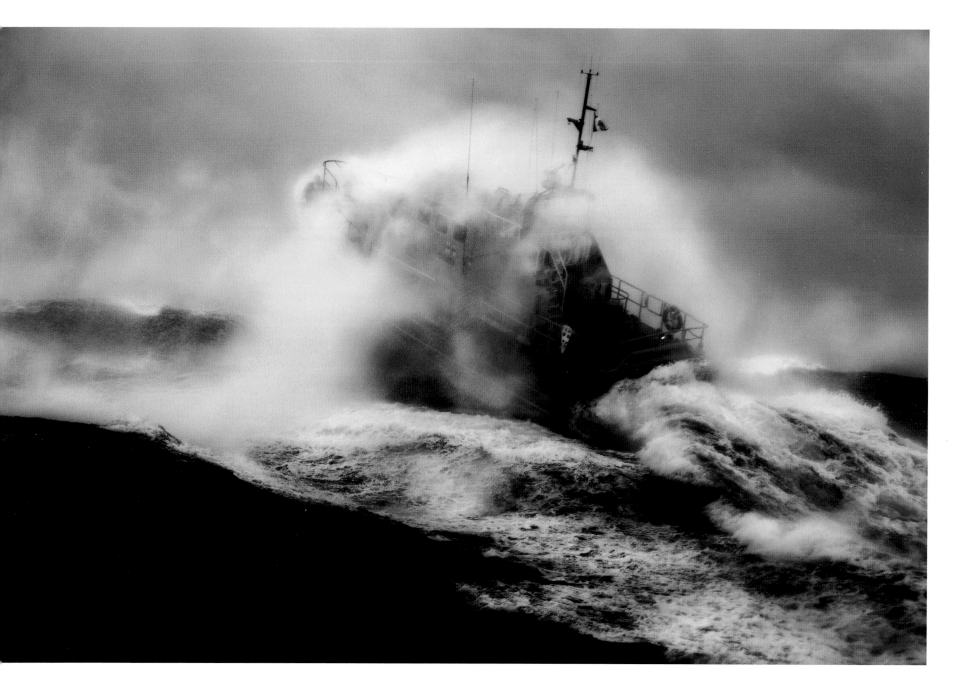

Ireland's first Tamar class, the Kilmore Quay
Killarney has been braving the waters off the
south-eastern coast of Ireland since 2010.

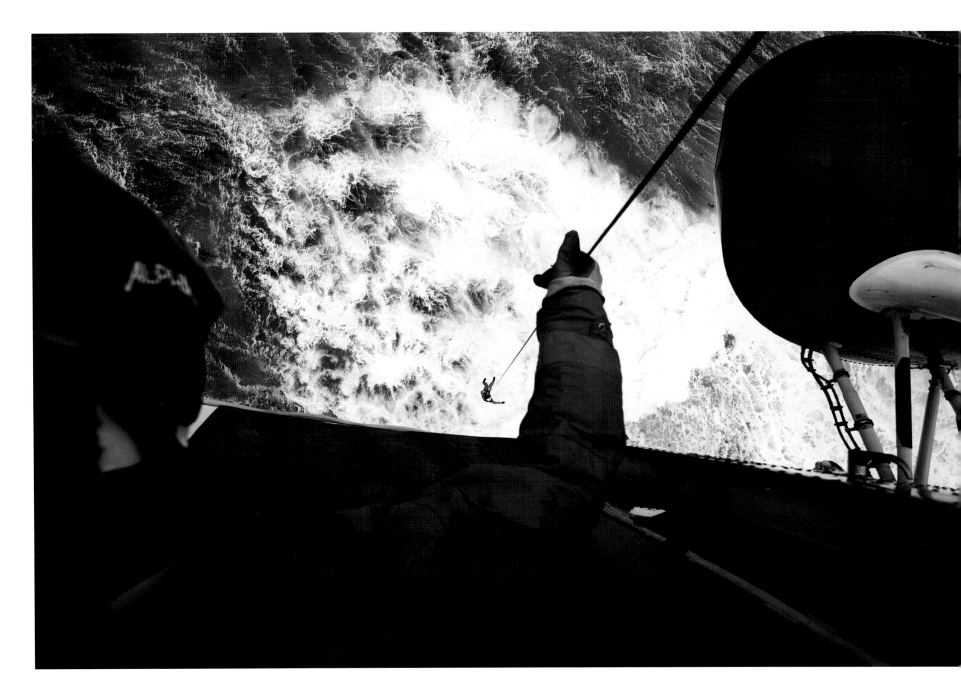

Off Waterford. Neville Murphy is lowered down on the winch from Irish Coast Guard helicopter Rescue 117. In his spare time, Neville is also a volunteer crewman on the Dunmore East lifeboat, Trent class *Elizabeth and Ronald*.

At County Wexford's Hook Peninsula, the Fethard inshore D class *Trade Winds* practises its search patterns as a rescue helicopter from Waterford observes from overhead. In 1914 the Fethard lifeboat *Helen Blake* capsized here on a service to the Norwegian schooner *Mexico*, as she was wrecked on the Keeragh Islands and pounded to pieces by the heavy seas. Nine of the lifeboat crew, all Wexford men, tragically died: Coxswain Christopher Bird, Bowman Thomas Handrick, and crewmen Michael Handrick, James Morrissey, Patrick Roche, Patrick Cullen, William Bird, William Banville and Patrick Stafford. The deceased men left three widows and eight orphans.

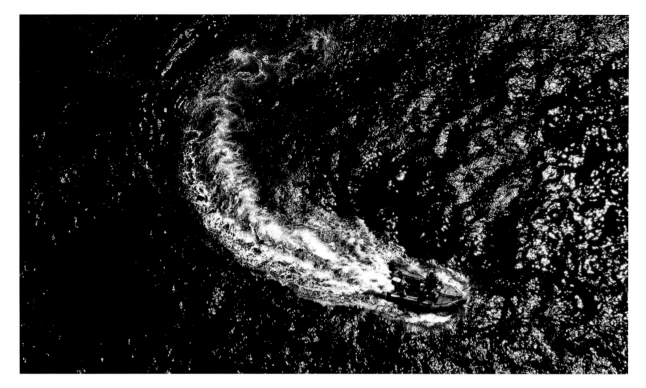

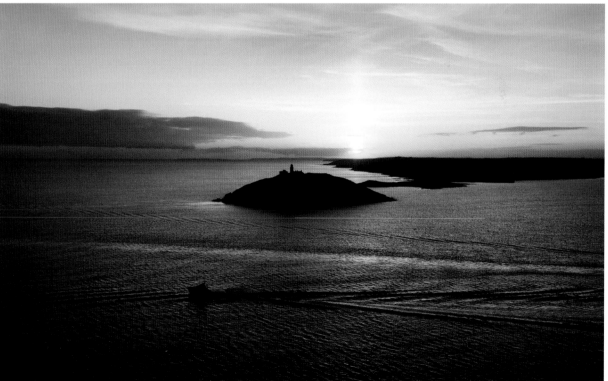

As sun sets on the east Irish coast, the day is not over for the Rosslare Harbour lifeboat as she heads out to sea.

On Ireland's wind-swept southern coast, the small fishing village of Ballycotton is set on a rocky ledge overlooking the Atlantic. At dawn, the serene waters in its harbour belie a ferocious history of storm and shipwreck. The RNLI established a station here in 1858. The first lifeboat had eight crew and six oars, and was launched down the side of a steep cliff.

Irishman Patrick 'Patsy' Sliney is chief among the very many courageous lifeboatmen that have come from these coasts. He finally retired in 1950, after 40-years service to the lifeboat and saving 114 lives. He is famous for being the long-serving coxswain of Ballycotton's *Mary Stanford*, whose entire crew and the boat herself were awarded medals for gallantry at sea.

In 1936, during the worst hurricane in living memory, the Daunt Rock lightship broke away from her moorings in the western approaches to Cork Harbour. The seas were so large that spray was seen flying over the lantern of the lighthouse, some 200 feet in the air. In Ballycotton, gigantic waves were exploding against the harbour wall with such force that stone blocks were being torn from their seating and tossed about on the quay.

The lifeboat was at sea for almost 50 hours and her crew had no food and just three hours sleep, with rain and sleet blowing almost continuously. She returned to the vessel more than a dozen times with mountainous seas sweeping over her, knowing that at any moment the lightship, as she plunged and rolled in the boiling waters, might crash on top of the lifeboat. He brought her alongside six times. On the last run two of the lightship's crew, frozen in fear and unable to jump, had to be seized and dragged to safety. It was one of the most perilous rescues in the history of the service, but not a single life was lost. When Sliney's crew returned home they were so tired they had to be lifted from their boat.

Sliney was awarded another medal in 1941 for rescuing sailors of the sinking ship *Primrose*, in thick fog through a heavy sea choked with mines. He was honoured again for going to the rescue of the steamship *Irish Ash*, braving vertiginous seas on Christmas Eve, 1942. Sliney came ashore covered in salt water burns, his hands bloodied and bruised, his wrists inflamed to twice their normal size and his voice completely gone. All 35 crew had been saved.

The Daunt Rock has always been a hazard to shipping. With modern technologies like satellite navigation and radar, only a buoy is required today to mark this lethal hazard near the mouth of Cork Harbour. In the past century, men were paid to man a lightship, keeping its light ablaze in all weather, every day of the year, resting their faith on its giant anchor and cable to keep them in position. The first lightship was stationed there in 1864, following the wreck of the *City of New York*. During a severe gale in October 1896 the lightship *Puffin* vanished. The wreck was discovered a month later, but the bodies of its crew were never recovered. It was in such treacherous conditions that generations of lifeboatmen like Patrick Sliney ventured out to help those in peril on the seas.

The Ballycotton crew that night included four members of the Sliney family: Patrick's two brothers Thomas and John, and his son William. The rest were drawn from the Walshes, another local family of fine mariners. Grandson of Patrick, fisherman Colm Sliney is now a Deputy Launching Authority here. He served on the boat for 36 years, saving 162 lives. His son Aidan is now a crewman on the boat. Today, Ballycotton Trent class *Austin Lidbury* patrols the waters near the Daunt Rock before heading for home.

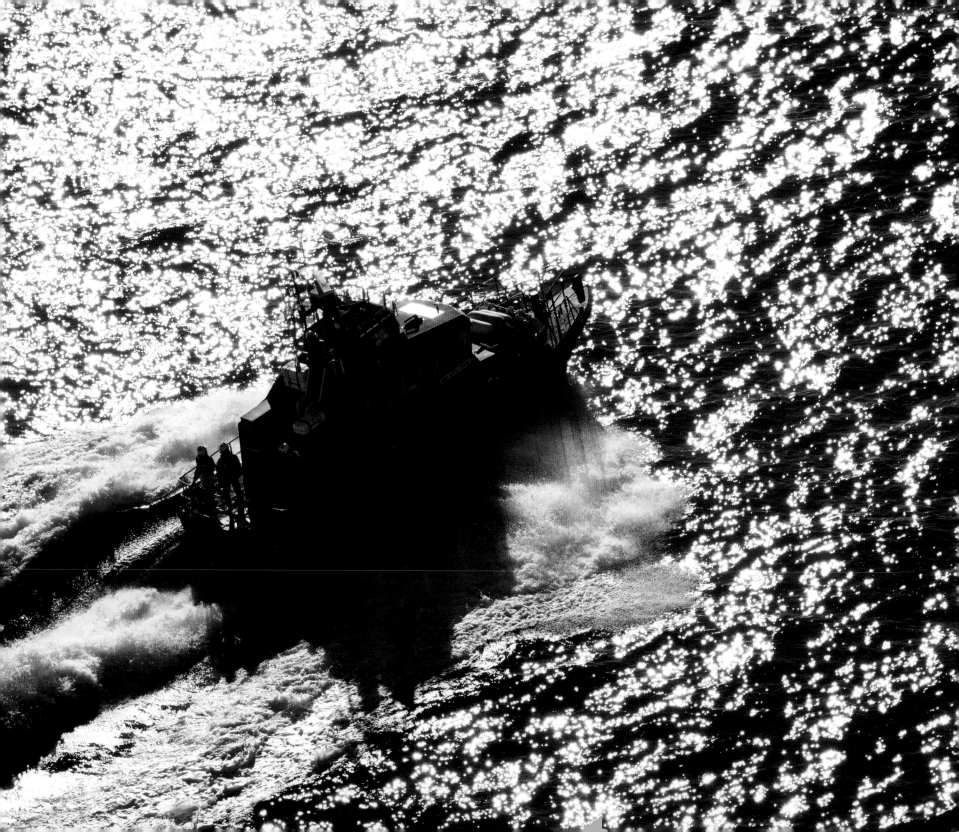

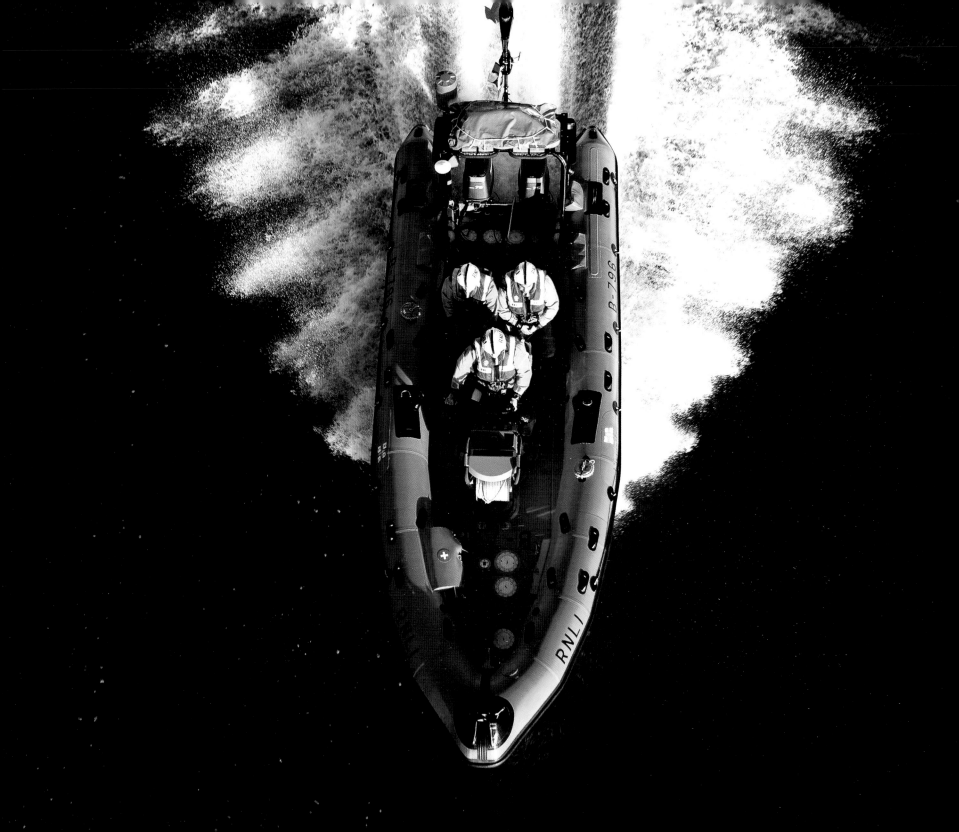

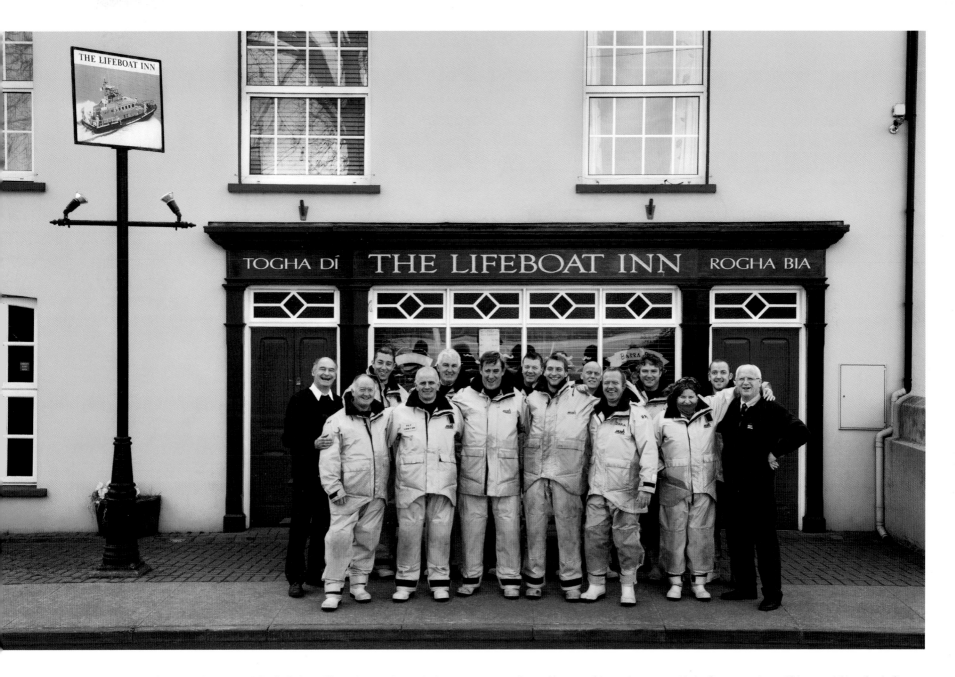

Opposite: Kinsale's inshore Atlantic 75 *Miss Sally Anne (Baggy)* passes beneath the Archdeacon Duggan Bridge at the mouth of the River Bandon.

Above: After a useful exercise at sea with the Courtmacsherry lifeboat and Waterford's Coast Guard helicopter Rescue 117, there is chance for a team photo at the local pub.

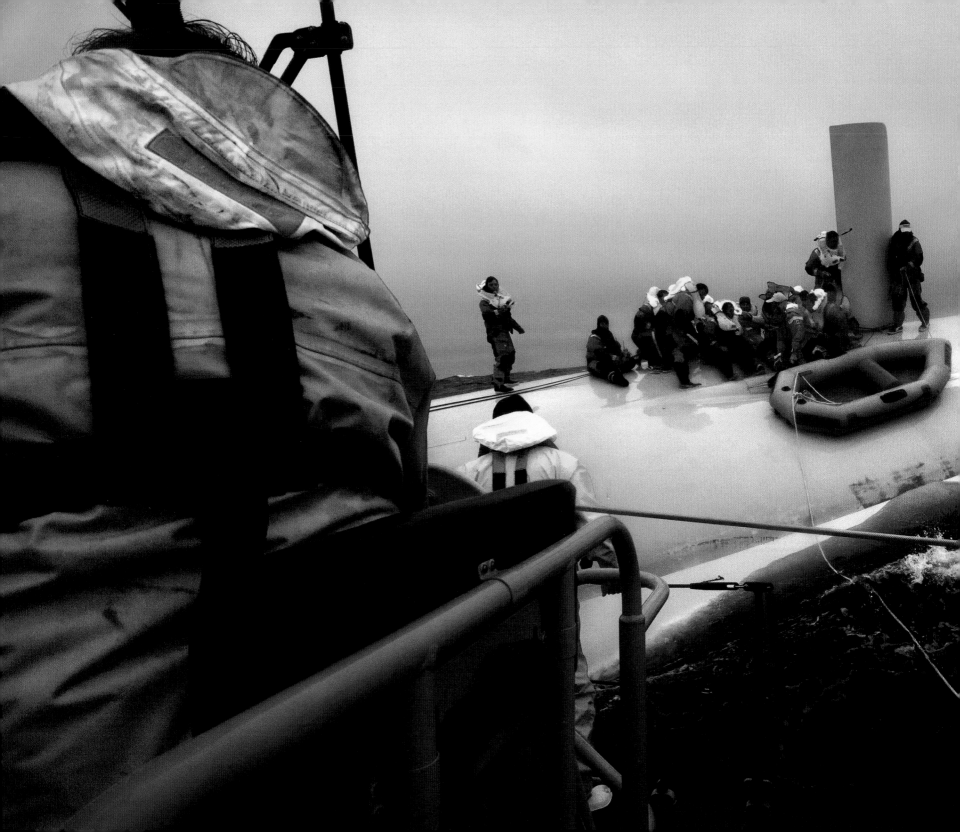

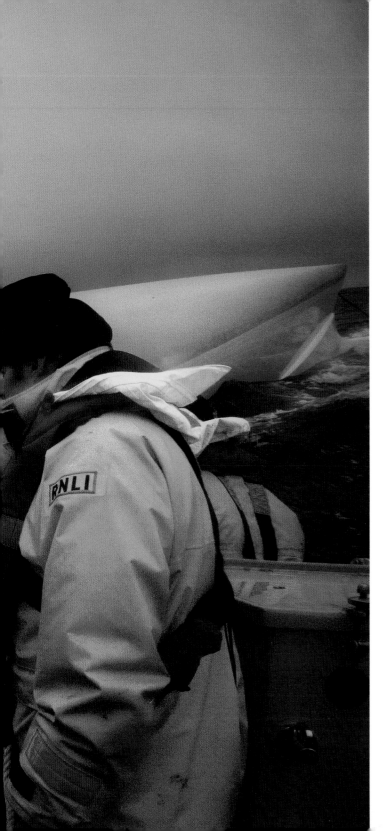

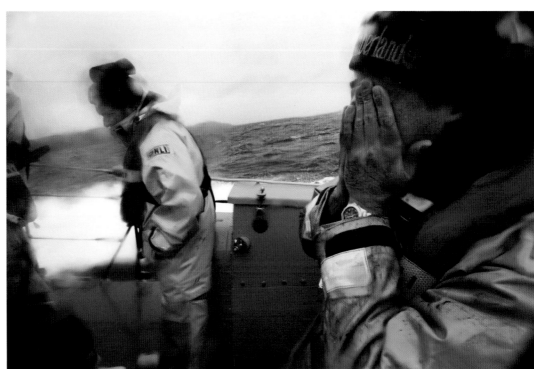

In the 2011 Rolex Fastnet Race *Rambler 100* capsized when the state-of-the-art supermaxi lost her keel. In just 30 seconds the crew were thrown into the water, while others down below had to quickly find an escape route. Their radio beacon's distress signal could not be detected, as all the high-tech safety equipment and other ways of calling for help were also under water. Baltimore's lifeboat eventually located the yacht thanks to a faint light from a good old-fashioned torch. All 21 crew were saved.

After more than a decade of service, the Baltimore Tyne class *Hilda Jarrett* has now been retired and replaced with a new Tamar class all-weather boat, the *Alan Massey*, funded from the legacy of Miss Dorothy Massey, who bequeathed the whole of her estate to the RNLI, requesting a lifeboat be named in honour of her brother, a keen sailor. Faster, bigger, safer and better equipped than the old Tynes, the new Tamar means that yachtsmen of many nations who come to sail in these waters are in very good hands.

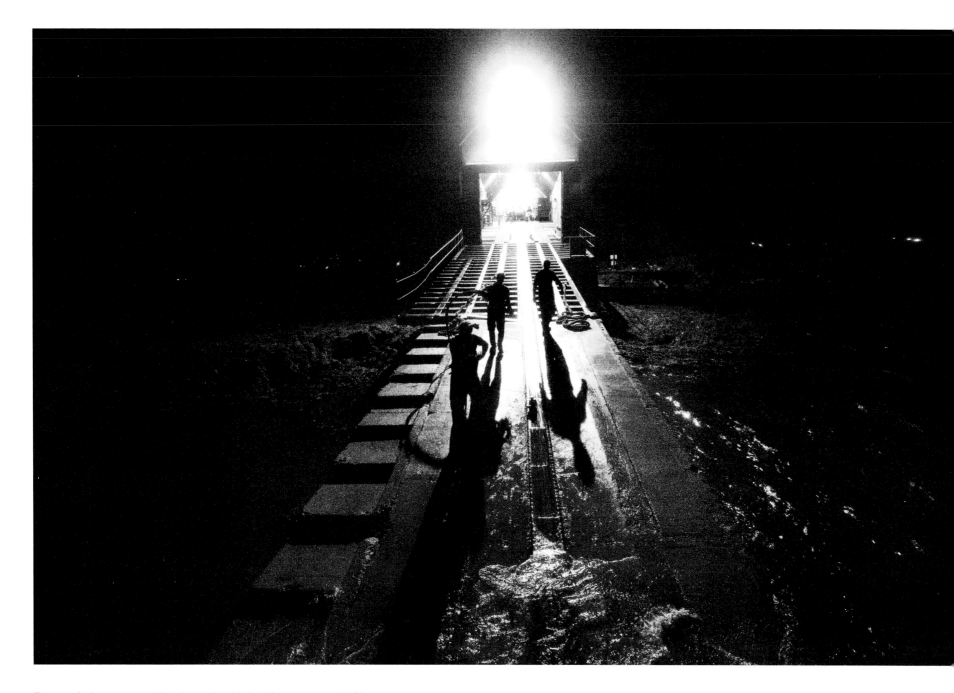

Baltimore's shore crew position the winch cable in order to recover the lifeboat following her successful service to the *Rambler 100*.

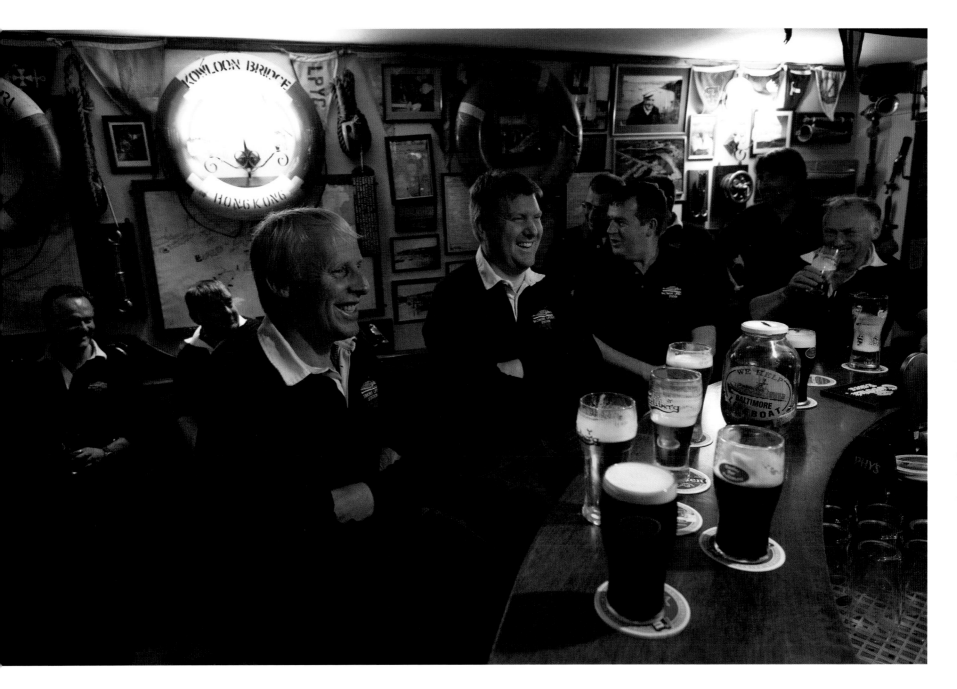

A well-deserved pint, or two, for the Baltimore crew. The pub here is run by the Bushe brothers, long-serving members of the Baltimore boat. Tom is Lifeboat Operations Manager and Aidan is one of the coxswains. Needless to say, with a new boathouse still to be built, there's a fair bit of important business that goes on in here.

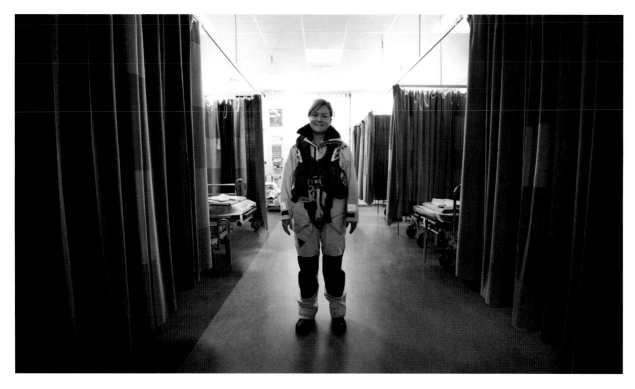

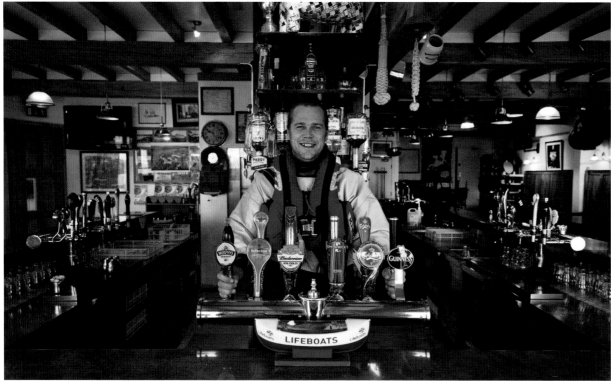

Claire McCarthy, volunteer crewmember at Ballycotton, works as a nurse in Cork while helmsman Youen Jacob stands at the bar of his Baltimore hotel.

In the snug at Bushe's Bar in Baltimore, fundraisers Ros Rourke, Margo O'Flynn, Trevor Whelan and Catherine Field plan out the months ahead.

Along the coast at Castletownbere, the Severn class *Annette Hutton* waits calmly at her mooring in the waters of Berehaven. After fifteen years in a portacabin on Dinish Island, the crew finally have a new boathouse. The lifeboat now has its own custom-made pontoon too.

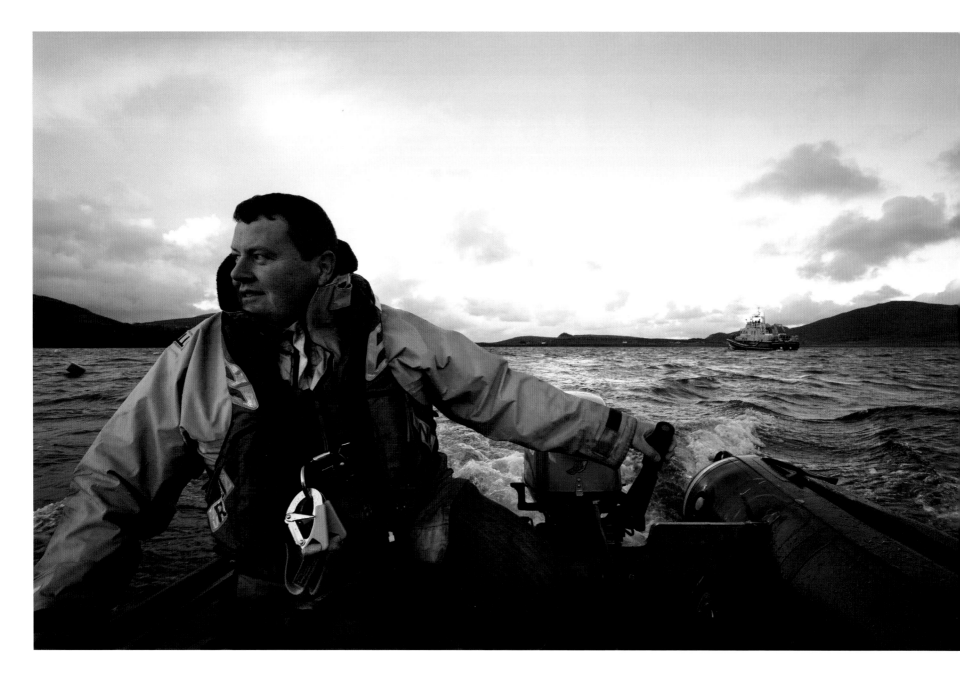

At Valentia Island, in the early morning after a bitter October storm, veteran lifeboat mechanic Leo Houlihan brings the boarding boat back to shore. We've been out to check their Severn class, the *John and Margaret Doig*. For nearly 130 years a lifeboat here has provided rescue cover off the Kerry coast and the Houlihan family is proud to be part of that story. Leo's father Joseph was the mechanic and the local lighthouse-keeper too. He won a Bronze Medal here in 1963, launching the station boarding boat into a northerly gale on his own to go to the rescue of a small dinghy that he'd just seen capsize. He found two men in the water; dragged one, near collapse into the boat and told the other, a large local priest, to hang on to the side of the boat. After much difficulty he eventually landed the two men on shore. For good measure, he also went back out again and recovered their dinghy too.

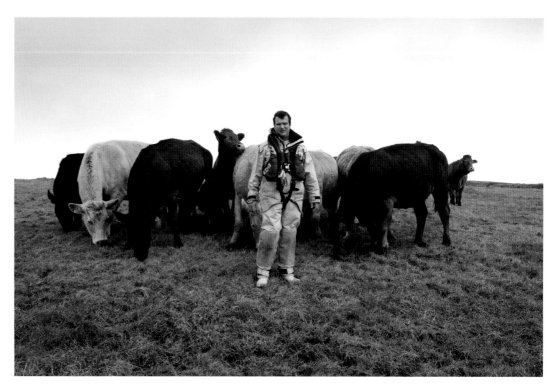

On land and sea. Valentia coxswain Con O'Shea is a farmer. Fenit coxswain John J. Moriarty is a fisherman. On 13 December 2011, with a violent storm force eleven raging, the Trent-class *Robert Hywel Jones Williams*, with Moriarty in charge, headed out into turbulent seas. They battled to the aid of chemical tanker *Forth Fisher* and eventually managed to escort her back into the Shannon Estuary. At one moment a huge swell even knocked the lifeboat down on its port side, temporarily losing steerage and swamping the decks. This was the same day when the highest wave ever recorded on the western shores of Ireland exceeded 20 metres. Lifeboat Operations Manager Gerard O'Donnell recalls: 'These were the most severe weather conditions I can ever remember a lifeboat putting to sea in from Fenit Harbour. Bearing in mind what the crew had just been through, it was unbelievable that their main concern when they returned was whether the lifeboat had suffered any damage. I felt humbled and proud to be part of the Fenit lifeboat team that day.'

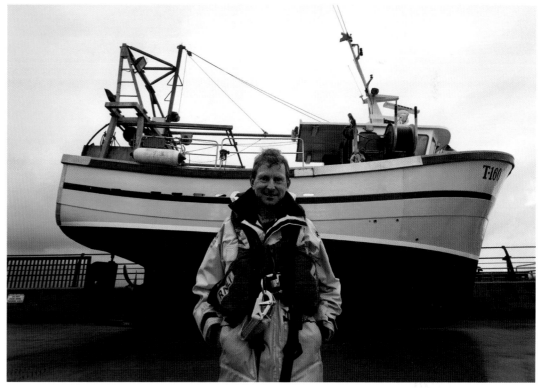

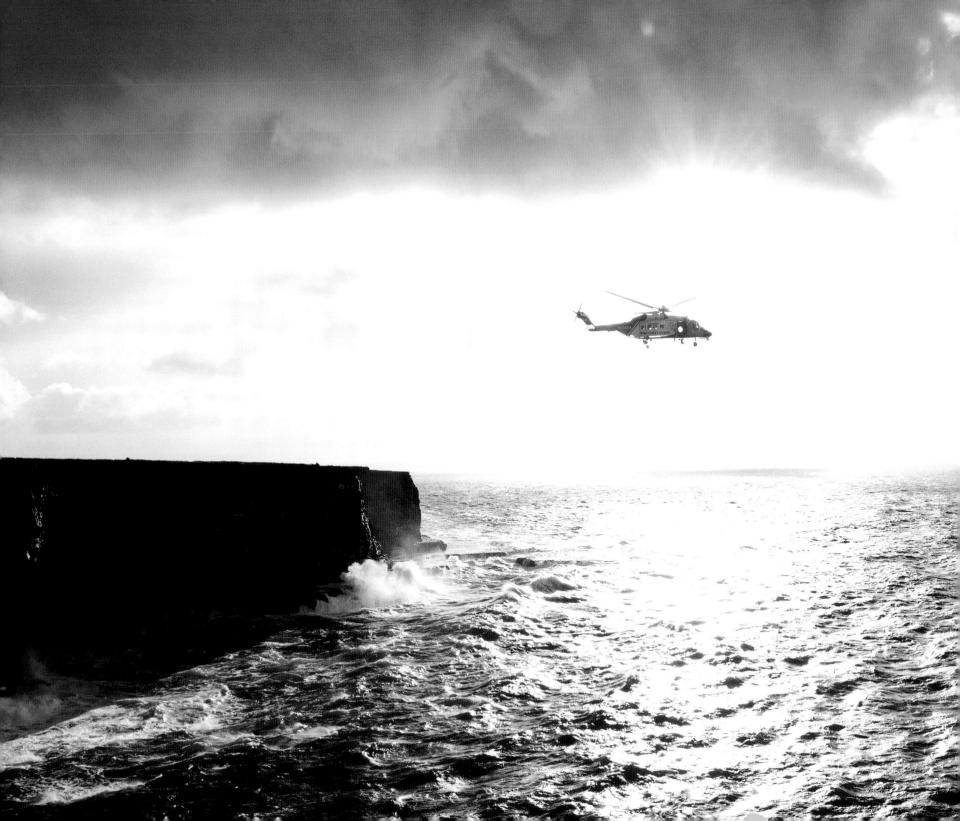

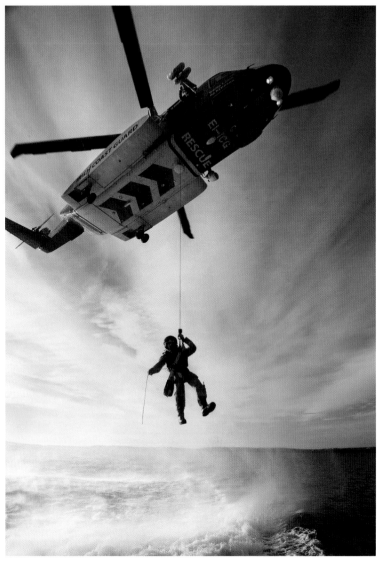

Beyond the dramatic limestone cliffs of the Aran Islands, Irish Coast Guard helicopter Rescue 115 and Severn class *David Kirkaldy* patrol the heaving Atlantic waters at the entrance to Galway Bay. There has been an RNLI station here on remote Inishmór since 1927.

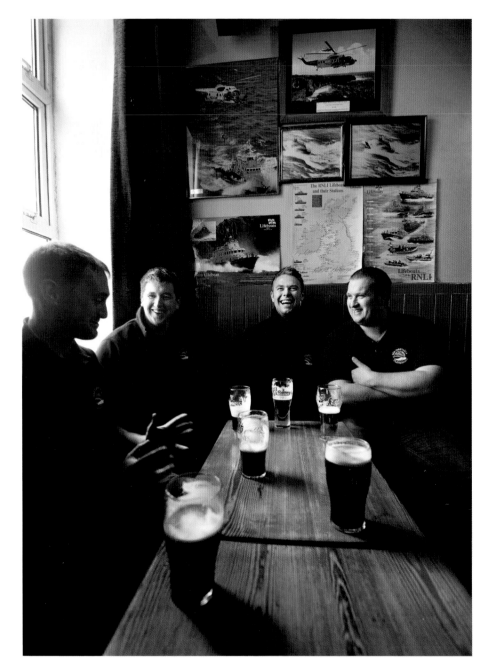

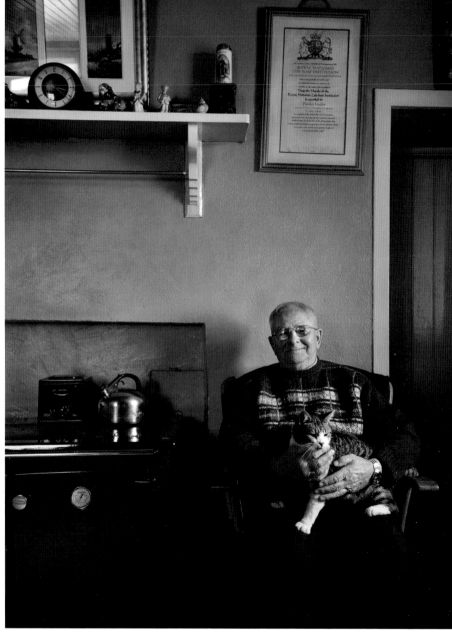

Back in the warmth of Tí Joe Mac's bar, the Aran Islands lads are rewarded with a gentle pint. From left to right, Ronán Mac Giollapharaic, Oisín Roantree, Ciarán O'Donnell, and Máirtín O'Flaithearta. Young men they may be, yet between them they have served almost 30 years on the lifeboat.

Bartley Mullin was coxswain mechanic here and over his 36-year service he helped save 167 lives. In 1962, Mullin with three crew-mates went to the aid of a Rotterdam coaster, which had run aground near the entrance to Galway docks. They launched the Watson class *Mabel Marion Thompson*, and eventually reached the stricken ship, whose crew had taken refuge on a nearby island. Mullin managed to fight through breakers in a small towed boat and brought off six survivors. He was awarded the Bronze Medal.

On Inishbofin, an island off the coast of Connemara, Kitty Concannon spends a morning decorating cakes, doing her bit to help raise money for the RNLI. The islanders here have supported nearby Clifden lifeboat over many years with raffles, cake sales and dinner dances.

229

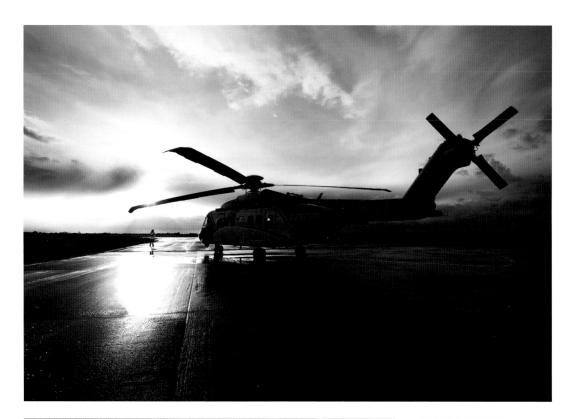

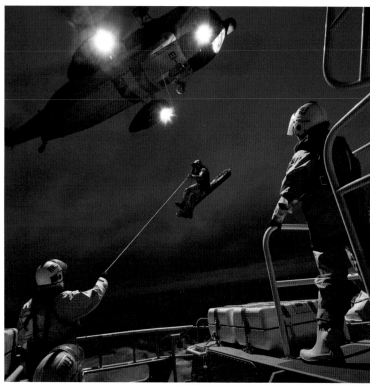

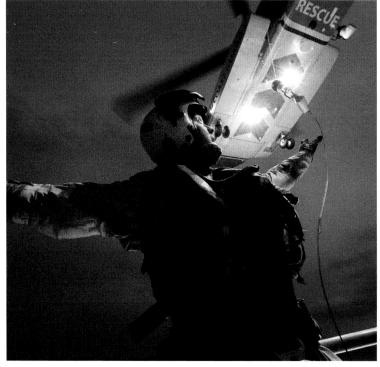

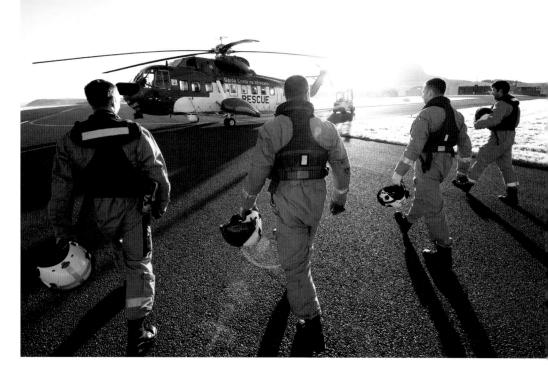

Opposite left and bottom left: Based in Shannon, the Irish Coast Guard Sikorsky helicopter Rescue 115 covers a huge area, almost 40,000 square nautical miles, from Slyne Head lighthouse, County Galway all the way around to Ballycotton Head, County Cork. In 2012, 186 Search and Rescue missions were carried out from the base and it's looking like another record year with over 200 missions for 2013. The helicopters of the Irish Coast Guard are regularly involved with RNLI lifeboats on joint rescues.

Opposite right & bottom right: Based at Sligo airport, Coast Guard helicopter Rescue 118 lowers winchman Darren Torpey onto the aft deck of Arranmore lifeboat. Darren is also a volunteer crew member of Sligo Bay lifeboat and heads out the next day with the helicopter crew at sunrise for more training.

The crew of the Portrush lifeboat look after a stretch of coastline that includes the impressive Giant's Causeway.

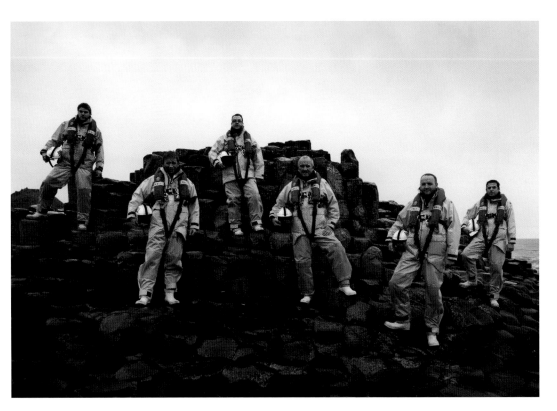

Lough Swilly Tyne class *Mariners Friend*, helped by their counterparts from Portrush in Northern Ireland in the Severn class *William Gordon Burr*, come to the aid of a fishing boat that was drifting with engine failure.

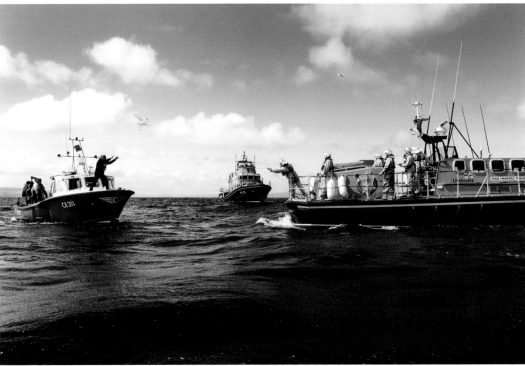

Nearing the end of our journey, now on the County
Down coast, we join the Mersey class *Eleanor
and Bryant Girling* as she heads out on exercise.
In Dundrum Bay, where the Mountains of Mourne
sweep down to the sea, lifeboat men have been saving
lives since 1825, just a year after the RNLI
was founded.

As another day draws to a close, lifeboats around our
coasts are heading out once more to bring hope to
those in need.

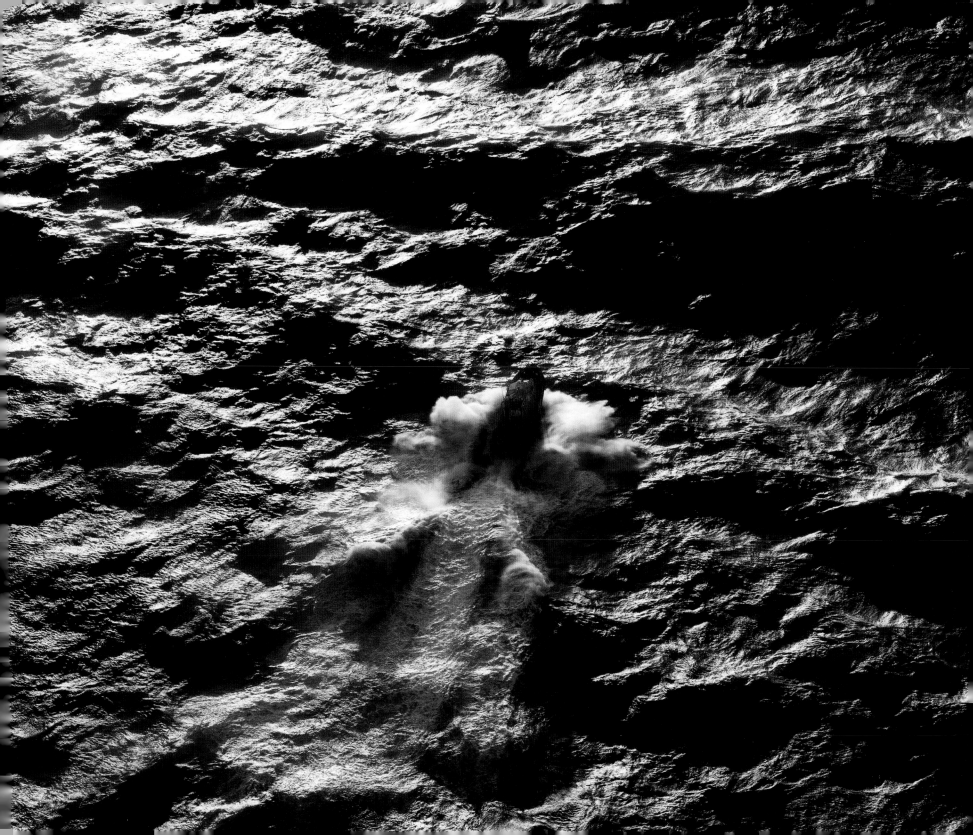

Christmas is fast approaching. In Belfast city centre, crew from Bangor, Donaghadee and Newcastle later join forces to bring some cheer to weary shoppers. .

The RNLI Trials team punch the new Shannon class lifeboat easily through the swell. This is an innovative boat up for the new challenges that lie ahead, yet much remains the same. Though technologies change, courage is timeless. All around our coasts, every day of the year, there will always be a lifeboat ready to race to duty's call.

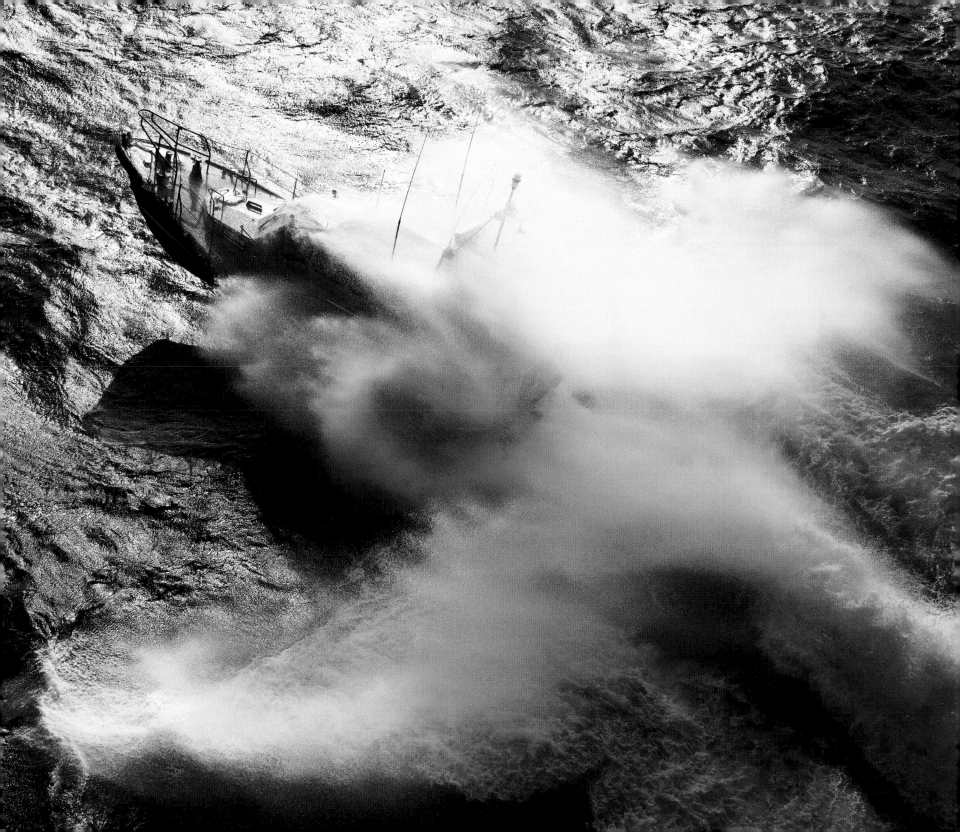

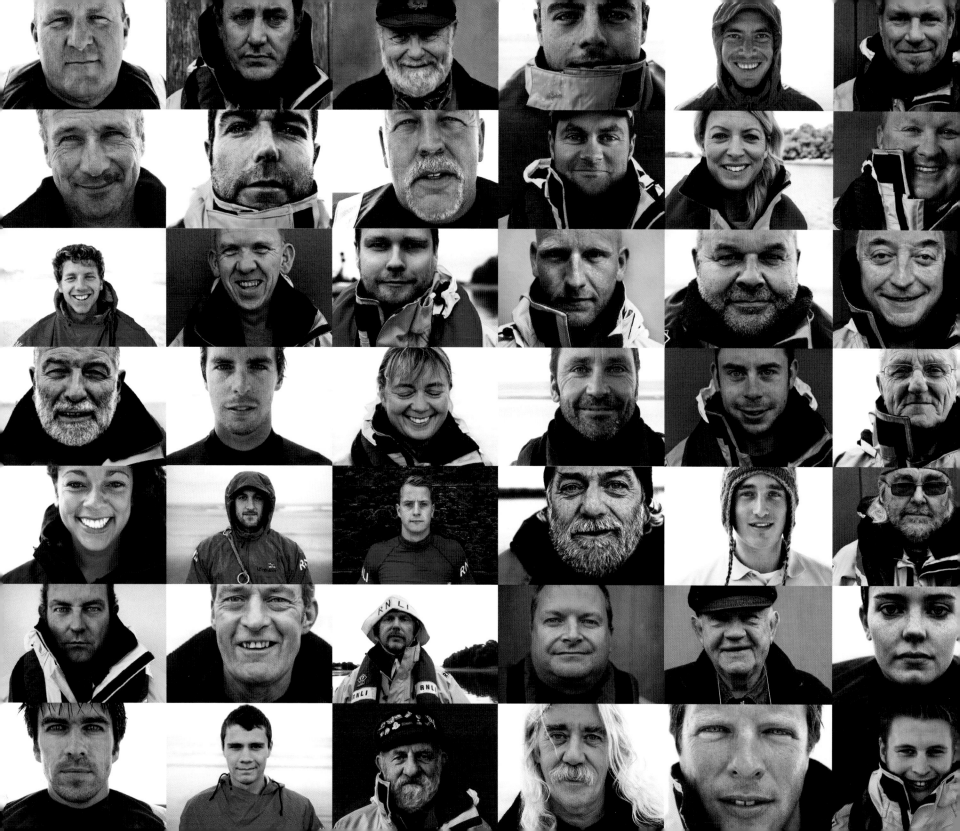

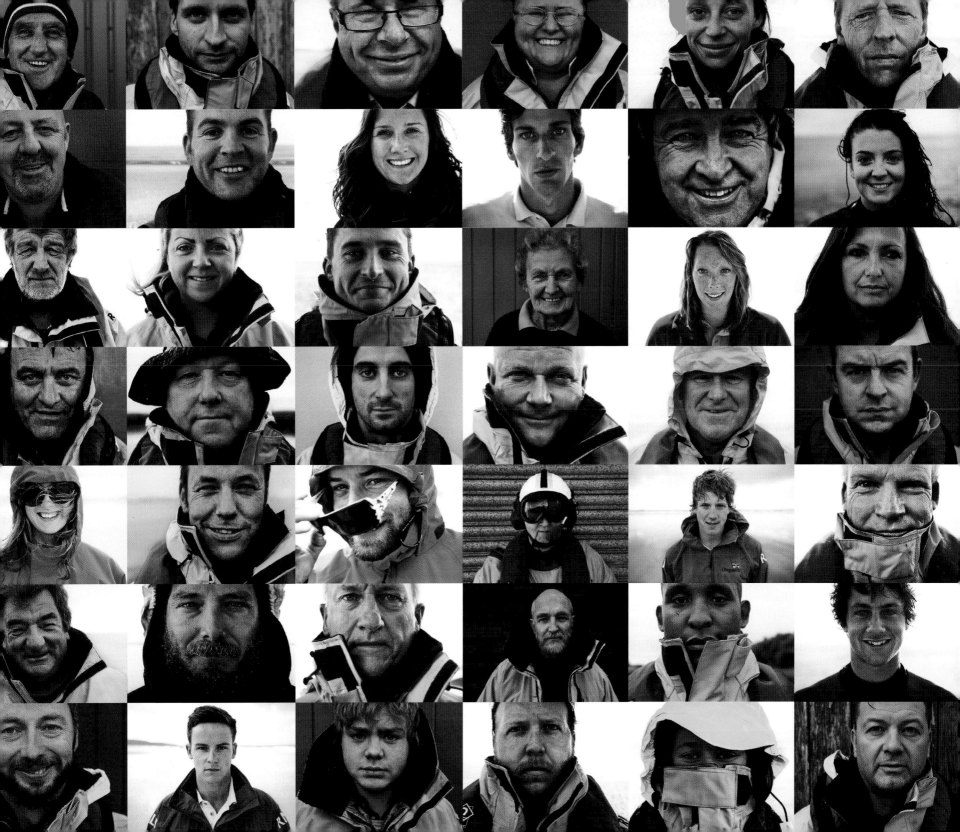

CONCLUSION

Storms in the twenty-first century are every bit as dangerous as they have been in the past. Ships are still pounded to destruction on our coasts and lost beneath the waves in the dead of night, but there is now hope for those in danger at sea — and this hope often appears as the sight of a small orange boat, fighting its way through mountainous waves. Though sail and oar have given way to high-powered engines, to be a lifeboatman today continues to be a considerable undertaking, fraught with danger and hazard. And, to be a crew member today is something that brings out the very best in people.

The RNLI's lifeboat crews and lifeguards have now saved more than 140,000 lives since the charity's foundation in 1824. Summoned day or night by the sound of a pager, and ready to respond in an instant, it takes a certain kind of person to want to do this every day of the year. Selfless and undaunted, this commitment is the lifeblood of the RNLI and it is this commitment that sustains its future success.

Lifeboat stations are clearly more than just dots on the map. They are places that have become the heartbeat of communities; they are places where the human spirit still shines brightly. We've tried to show something of this spirit and to encourage you to want to learn more about the cause. Go and visit a station next time you're near the coast, speak to a lifeguard on the beach, or stop for a moment when you next see that bucket being shaken on the street, and you'll experience a little of this lifeboat spirit for yourself. It is seen every day in acts of bravery at sea. It can be seen on the happy faces of families when the lifeboat returns safely home. It can be read in letters and cards written to crews in appreciation of their efforts, stuck on the fridge or proudly pinned to the wall in the boathouse. And, it can be heard in the words of countless survivors who describe that special moment when, as all hope seems lost, a flash of orange appears on the horizon.

Heroism isn't something that lifeboat crews talk about; it's not a word you'll often hear them use. RNLI volunteers aren't there for glory or for fame, though they certainly deserve our admiration and our generosity too. They do not ask for anything in return. These are the people, now drawn from every walk of life, who are prepared to offer their time and even, in the most extreme cases, to give their lives to help others. These are the special few.

Sir William Hillary's dream has grown into something quite remarkable. New boats are being built, and yet more are in design, new stations are being constructed and volunteer crews are receiving the very latest in kit and training. The RNLI is as strong in heart and body as ever and its crews remain ready to go to the help of strangers, whatever the conditions, whatever the time, without hesitation. Though we began our journey in Douglas, at a refuge tower that stands on the rocks of St Mary's Isle, Hillary's memorial actually lies in the courage and dedication shown by crews all along the coast of Britain and Ireland today, some of whom are this very moment rushing down to the sea to go to those in need. With courage, it is said, nothing is impossible; and nothing truer can be said of the crews of our RNLI.

There has been a lifeboat at Douglas in the Isle of Man for almost two centuries. It has always depended on the financial support of the public. Do drop a coin the box if you happen to visit the boathouse there.

NIGEL MILLARD

NIGEL MILLARD is an international photographer and a lifeboat crew member at Torbay in Devon. He is best known for his ongoing commissions for the Royal National Lifeboat Institution and for his special issue Royal Mail stamps. His corporate clients include multinational companies in the financial, automotive and travel sectors. He has been working with the RNLI now for almost a decade. In 2010 Nigel was awarded the Individual Supporter Award for his exceptional work for the charity.

HUW LEWIS-JONES

DR HUW LEWIS-JONES is a historian and editor with a PhD from the University of Cambridge. Huw was Curator at the National Maritime Museum and is now an award-winning author who writes and lectures widely about maritime history, exploration and the visual arts. His books include *Arctic, Ocean Portraits, In Search of the South Pole,* and *Mountain Heroes,* which won Adventure Book of the Year at the World ITB Awards in Germany. Huw is currently Editorial Director of the indie publisher Polarworld and lives in Cornwall.

ACKNOWLEDGEMENTS

Thank you to the RNLI family across Britain and Ireland. Without your courage and commitment nothing would be possible, least of all a book and exhibition like this. Thanks then to the Lifeboat stations and their crews, management, shore crews and fundraisers; the RNLI staff and volunteers at headquarters in Poole, particularly Liz Cook, Mark Dunne, Tim Robertson, Rory Stamp, James Vaughan and Nathan Williams; to the Divisional Inspectors and Lifeguard Managers in the regions, especially Martyn Smith, Allen Head and Adrian Carey; the RNLI Public Relations Managers, of special note, Tamsin Thomas and Niamh Stephenson; RNAS Culdrose and 'Kenners'; CHC Helicopters and George Hutchison; and the Irish Coast Guard and Declan Geoghegan. Thanks to my sponsors Jenny at Cameras Underwater, Ewa-Marine, and Nick and everyone at Epson, and to all at Torbay Lifeboat especially Mark Criddle, Simon James and Richard 'Greasy' Fowler.

My special thanks are to our author Huw Lewis-Jones, for his friendship and guidance throughout the years, and for being the kind of bloke that makes things happen; to our Publisher John Lee and the team at Conway for supporting us; and to Eleanor Driscoll RNLI Film and Image Manager, for her humour and boundless enthusiasm. Without you all, this project would not have been possible. And finally, to my Mum and Dad for buying me my first camera, and my wife Caroline for her endless support, encouragement and love.

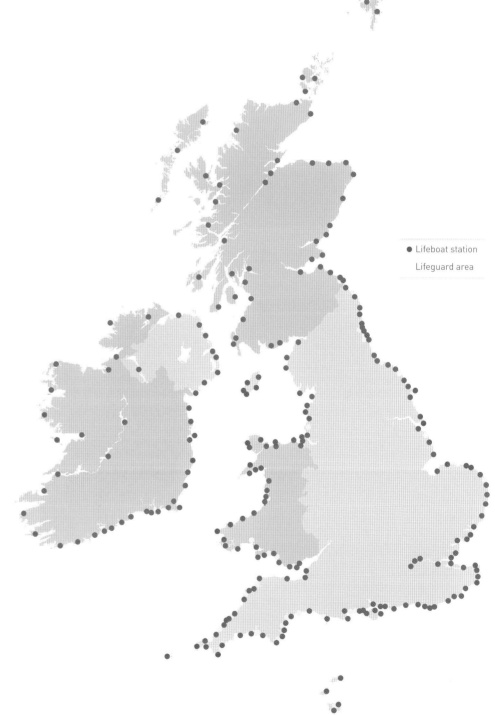

● Lifeboat station

Lifeguard area

AL·LIFEBOAT·TR
LIAM·HILLARY

·AS FOUNDED THE R.N.L.I
HAT OF HIS VOLUNTEE